Mathematics in Twentieth-Century
Literature and Art

Mathematics in Twentieth-Century Literature and Art

Content, Form, Meaning

ROBERT TUBBS

Johns Hopkins University Press
Baltimore

© 2014 Johns Hopkins University Press
All rights reserved. Published 2014
Printed in the United States of America on acid-free paper
2 4 6 8 9 7 5 3 1

Johns Hopkins University Press
2715 North Charles Street
Baltimore, Maryland 21218-4363
www.press.jhu.edu

Library of Congress Cataloging-in-Publication Data

Tubbs, Robert, 1954–
Mathematics in twentieth-century literature and art :
content, form, meaning / Robert Tubbs.
pages cm
Includes bibliographical references and index.
ISBN 978-1-4214-1379-2 (hardback) —
ISBN 978-1-4214-1380-8 (paperback) —
ISBN 978-1-4214-1402-7 (electronic)
1. Mathematics in literature. 2. Mathematics and literature.
3. Literature—20th century—History and criticism.
4. Mathematics in art. 5. Art—20th century. I. Title.
PN56.M36T83 2014
700'.46—dc23 2013036942

A catalog record for this book is available from the British Library.

Special discounts are available for bulk purchases of this book. For more information,
please contact Special Sales at 410-516-6936 or specialsales@press.jhu.edu.

Johns Hopkins University Press uses environmentally friendly book materials,
including recycled text paper that is composed of at least 30 percent
post-consumer waste, whenever possible.

*To all of those artists and writers who saw that
mathematical ideas and mathematical thinking could be
relevant to the creative arts; and to my wife, Vesa,
for supporting me while I enjoyed and
wrote about those creations*

CONTENTS

In its original conception this book was based on a single premise: that mathematical ideas guided the aesthetic visions of many twentieth-century artists and writers and that a survey of their creations would reveal a great deal about twentieth-century art and the role of mathematics in twentieth-century thought. That premise, while sounding quite broad and proving to be correct, turned out to be too narrow and simplistic to accommodate the diversity of mathematical concepts and methods that guided, assisted, or inspired artists and writers throughout that century. To fairly represent this diversity, I greatly expanded the scope of this book beyond its original conception. I do discuss artists and writers who explicitly employed mathematical ideas to express their aesthetic ideals or to create their works, but I also examine two other types of creative activities: (1) artists' and writers' use of mathematical images or forms or methods in the creative processes even though those processes seem to have no affinity with mathematical thinking; and (2) the use by theoreticians of mathematical concepts to examine those innovations.

Although the topics covered in this book are fairly wide-ranging, I think it is fair to place the creators of these artistic and literary objects into four categories—reflecting whether they brought mathematical thinking, broadly construed, to their works or just employed mathematical images or symbols in their creations. These four categories may be described as follows:

- artists who employed mathematical imagery, shapes, forms, or methods because these best allowed them to express their highly nonmathematical aesthetic ideals;
- artists who employed mathematical ideas to provide innovative structures for their pieces;

- artists who put mathematical thinking that is closely allied with the notions of chance or randomness at the center of their work; and
- analysts of both twentieth-century and more classical creative innovations who turned to mathematical ideas in their analyses.

Examples of the first type, those artists who employed mathematical elements in their work, abound in this book. These range from André Breton's experiments with automatic writing that featured mathematical imagery, to Man Ray's paintings involving mathematical surfaces, Alfred Jensen's large canvases offering almost dizzying arrays of numbers and equations, Max Bill's sculptures based on mathematical surfaces, and Charles Bernstein's poem containing mathematical symbols.

The second category—artists and writers who used mathematical ideas to structure their work—is less well represented in this book but includes uses of the Möbius strip, both its purely mathematical version and its physical model, by John Barth, Albert Wachtel, and Gabriel Josipovici to provide narrative structures; Paul Fournel and Jean-Paul Énard's simple application of mathematical graph theory to produce a play that requires the audience to choose between one of two outcomes at the end of each scene; and Ad Reinhardt's large, seemingly monochrome black canvases with subtle grid structures.

The third category includes the use of chance, randomness, or algorithms in the production of artistic pieces. Examples are Tristan Tzara's instructions to produce a poem with words and sentences randomly chosen from the newspaper, Daniel Spoerri's description of the clutter on a table in a hotel room in Paris on October 17, 1961, at 3:47 p.m., and Jackson Mac Low's algorithmic poetry.

Finally, we will examine several examples of mathematical thinking in discussions of literature or art. Thus, Raymond Queneau explores the meaning of the modern axioms for geometry when applied to literature, Troels Andersen attempts to understand the role of the square in Kazimir Malevich's suprematist paintings, and Richard Hertz discusses the relative importance of an artist's theories and artwork.

What are we to take away from all of these activities? Clearly, artists and writers are not mathematicians, and the enterprise in which they are engaged—trying to understand what it means to be human and to make sense of our place in the universe—is not that of mathematicians, which is to prove new theorems. However, all of these creative spirits turned to mathematical ideas or symbols or figures. To ask *why* is to ask the wrong question. By the turn of the twentieth century, mathematical ideas were widely accepted as being relevant to our under-

standing of both the physical universe and our place in it. Mathematical thinking was no longer the private domain of mathematicians; mathematical ideas, although not necessarily their technical details, entered into the daily discourse of artists and intellectuals. So it is only natural that artists, writers, and others would incorporate mathematical thinking into their attempts to express their artistic ideals—especially into their attempts to provide alternatives to the artistic ideals that had been dominant for a millennium. These creative expressions, infused with mathematical content, offer us the opportunity to explore not only art and literature but also the related mathematical ideas.

This brings us to the question of which creative developments are examined here. This is where my bias shows. I discuss only artists and writers whose ideas or works are intellectually interesting, and this includes the possibility that they might be baffling but entertaining. And, as the reader will discover, these ideas and works range from simple to complex to subtle: from Malevich's use of flat, geometric shapes to represent (or rather, *present*) emotion or thought, to the modeling of Alain Robbe-Grillet's novel *In the Labyrinth* by a multidimensional analogue of the Klein bottle, to Paul Braffort's collection of twenty poems where interconnections between the poems are determined by a mathematical theorem concerning the Fibonacci numbers.

I have not discussed computer-generated art or literature, nihilistic appeals to chance, or abstract expressionistic splashes of paint that may or may not reveal some sort of fractal patterns. I have looked only at hands-on applications of mathematical ideas or the incorporation of mathematical images. All of the examples in this book may seem a bit naive from our hypertexted, superconnected twenty-first-century perspective, but they reveal genuine attempts to bring mathematical ideas to the most human of all endeavors—the creative arts.

Intended Audience and Prerequisites

This is book is written for anyone genuinely interested in ideas, and especially in connections between ideas in seemingly unrelated disciplines. In particular, I hope this book will appeal to non-mathematicians interested in literature or the arts who are curious about twentieth-century trends and the occasional glimpses of mathematical ideas in those trends. This book is also written for mathematicians with an interest in art or literature or in just seeing how simple mathematical ideas were used in the creative arts in the twentieth century.

For such a broad range of readers, I have kept the mathematics presented in this book elementary. Anyone reading this book must be willing to read and re-read some short passages and ponder them a bit before moving on. The only

mathematical background I have assumed is a bit of high school geometry and algebra. The primary requirement is that the reader not have an aversion to mathematical ideas. As for the artistic or literary prerequisites, a reader would benefit from some familiarity with the major movements in twentieth-century art and an openness to all literary styles, especially what might be called experimental ones, even if only to admire their novelty.

This book could not have been completed without the assistance, advice, and support of many people. I first want to thank the writers and translators Amaranth Borsuk and Gabriela Jauregui, Billy Collins, Paul Fournel, Amy Levin, Warren Motte, and Albert Wachtel for allowing me to publish portions of their work. At Johns Hopkins University Press I thank my editor Vincent Burke for his steadfast support and wise counsel. Many individuals assisted me in obtaining the images for this project: Linda Henderson (UT-Austin), Jade Myers (Matrix Arts), Wendy Grossman (The Philips Collection), Heather Monahan (The Pace Gallery), Maria Murguia (ARS), Kajette Soloman (Bridgeman Gallery), and Man Ray images. I would be negligent if I did not thank Tim Swales for research help during the beginning stages of this book and the anonymous reviewer for invaluable insights.

The following creative works are discussed or mentioned in the text or notes. The title of the translation is given where appropriate.

1904	Charles Howard Hinton	*The Fourth Dimension* (book)
1908	Velimir Khlebnikov	"Incantation by Laughter" (poem)
1910	Raymond Roussel	*Impressions of Africa* (novel)
1912	Umberto Boccioni	"Technical Manifesto of Futurist Sculpture" (essay)
1913	Marcel Duchamp	*Bicycle* (readymade)
	Velimir Khlebnikov	"Two Individuals: A Conversation" (essay)
	Velimir Khlebnikov and Aleksei Kruchenykh	"Word as Such" (essay)
	Aleksei Kruchenykh and others	"Let's Grumble" (pamphlet)
		"Victory over the Sun" (play)
	Kazimir Malevich	*Arithmetic* (lithograph)
1915	Kazimir Malevich	*Quadrilateral (The Black Square)* (painting)
		Painterly Realism of a Boy with a Knapsack: Color Masses in Four Dimensions (painting)
1916	Hugo Ball	"Sea Horses & Flying Fish" (poem)
	Velimir Khlebnikov	"We Climbed Aboard," "Dream," and "The Scythian Headdress: A Mysterium" (essays)
1917	Marcel Duchamp	*Fountain* (readymade)

1952	John Cage	*4'33"* (music)
1954	Salvador Dalí	*Crucifixion (Corpus Hypercubus)* (painting)
	Jackson Mac Low	Number Poems
1955	Salvador Dalí	*The Sacrament of the Last Supper* (painting)
	Robert Rauschenberg	*Bed* (combine)
1956	Elizabeth Bishop	"Sestina" (poem)
1958	Jasper Johns	*Grey Numbers* (painting)
1959	Alain Robbe-Grillet	*In the Labyrinth* (novel)
1960	Alfred Jensen	*The Apex Is Nothing* (painting)
	Pierre Restany	"The Nouveau Réalistes Declaration of Intentions" (essay)
1961	Jean Lescure	S + 7 method (algorithm)
1962	Alfred Jensen	*Light Color Notes* (painting)
	Jackson Mac Low	Acrostic and diastic methods (in poetry)
	Ad Reinhardt	"Art as Art" (essay)
	Marc Saporta	*Composition No. 1* (novel)
	Daniel Spoerri	*An Anecdoted Topography of Chance* (book)
1963	John Barth	"Frame Tale" (short story)
	Julio Cortázar	*Hopscotch* (novel)
	Allan Kaprow	"Guideline for Happenings" (essay)
	Claes Oldenburg	*Bedroom Ensemble* (construction)
	Ad Reinhart	*Abstract Painting* (painting)
1964	Andy Warhol	*Brillo Boxes* (constructions)
1967	Raymond Queneau	"A Story As You Like It" (short story)
1969	Georges Perec	*A Void* (novel)
1972	Raymond Queneau	"X takes Y for Z" (theory)
1974	Gabriel Josipovici	"Mobius the Stripper" (short story)
1976	Raymond Queneau	*The Foundations of Literature (after David Hilbert)* (essay)
1978	Emmett Williams	"Like Attracts Like" (poem)
1979	Paul Braffort	*My Hypertropes: Twenty-One Minus One Programmed Poems* (poems)
	Alfred Jensen	*The Ionic Order* (painting)

*Mathematics in Twentieth-Century
Literature and Art*

Surrealist Writing, Mathematical Surfaces, and New Geometries

Mathematical Imagery and Images

Shall I go to A, shall I return to B, shall I change at X? Yes,
naturally, I'll change at X. If only I don't miss the connection
with boredom! Here we are: boredom, neat parallels, oh how neat
parallels are beneath God's perpendicular.

—Andre Breton, *Soluble Fish* (1924)

Our look at the appeal to mathematical concepts in twentieth-century art and
literature begins with the activities of a few artists and writers in the century's
tumultuous second decade. Marked by a war in Europe that straddled a revolu-
tion in Russia, that decade witnessed an unprecedented outpouring of artistic
and literary innovations by those who sought ways to express aesthetic ideals that
challenged the dominant ones of the previous two millennia. In this first chapter
I discuss some writers and artists, mostly centered in Paris, who were later associ-
ated with what is known as surrealism. There are two reasons for starting here.
First, we get a glimpse of how some artists and writers who began their work with
conceptions far removed from mathematics turned to mathematical ideas to help
them realize their artistic ambitions—hinting at the important role of mathemat-
ical thought on the early twentieth-century's worldview. Second, the work of the
Parisian surrealists illustrates that some of the mathematical ideas influencing art-
ists and writers were not simple geometric or numerical notions; instead, they
were sometimes fairly sophisticated and even highly abstract modern mathemati-
cal concepts.

We first consider the activities of two French writers, André Breton (1896–
1966) and Philippe Soupault (1897–1990), that culminated in the October 1919

publication of the first installment of their novel *The Magnetic Fields* (*Les Champs magnétiques*).[1] These soon-to-be surrealists had written *The Magnetic Fields* during a six-week period of intense activity in May and June using a cooperative approach: one of them would dictate the narration and the other would record the spoken words on paper. They continued in this way every day of the week, some days for ten to twelve hours. Breton and Soupault chose their approach not because they wanted to share the workload in their collaboration but because it would allow the dictating person to offer a narrative born of a special sort of freedom—the freedom to provide an uninhibited narrative, free of any distraction and, ideally, almost free of any conscious interference with the workings of the subconscious mind. Breton later wrote that while dictating to Soupault he had sought to give "a monologue spoken as rapidly as possible without any intervention on the part of the critical faculties, a monologue consequently unencumbered by the slightest inhibition and which was, as closely as possible, akin to *spoken thought*."[2] Breton dubbed an author's attempt to write by allowing subconscious words and phrases to impinge upon the conscious mind *automatic writing*; this approach to writing became one focus of the group of surrealists who orbited around Breton a couple of years later.

Both in its conception and in its realization automatic writing has no apparent affinity with any mathematical ideas. Yet the whole idea behind automatic writing was to allow the subconscious to make new connections or reveal new images. As we will see, these new connections and images were very eclectic; they were as likely to be ordinary as they were to be dreamlike or mathematical. Before we see how mathematical ideas, or at least mathematical terminology, enriched Breton's automatic writing, let's look some of the other descriptions that appeared in *The Magnetic Fields* when Breton and Soupault published the complete text in 1920.[3] As an example, consider the opening lines of the book's seventh chapter, "White Gloves": "The corridors of the grand hotels are unfrequented and cigar-smoke keeps itself dark. A man descends the stairs of sleep and notices that it is raining: the window-panes are white. A dog is known to be resting near him. All obstacles are present. There is a pink cup, an order given and the menservants turn round with haste."[4]

As can perhaps be discerned from these few sentences, the language of *The Magnetic Fields* offers unusual, at times extraordinary, images—for instance, window panes made white from rain sheeting down them. Less successful than the novel's imagery, at least for a reader, are the discontinuities between sequential sentences that make the narrative difficult to follow. Yet these discontinuities do indicate that Breton and Soupault achieved part of what they had hoped

for—to overcome "*logical* obstacles (narrow rationalism not letting anything pass that hadn't received its stamp of approval)."[5] Elsewhere, Breton even offered advice to any would-be surrealist on how to proceed in overcoming these obstacles: once you are in a comfortable place, get into "as passive, or receptive a state of mind as you can." Then, letting go of any self-consciousness, write "quickly, without any preconceived subject, fast enough so that you will not remember what you're writing and be tempted to reread what you have written."[6]

When Breton provided this prescription, he was reflecting not only on his collaboration with Soupault but also on some of the nascent surrealist group's activities in 1922. In that year Breton and several writers, artists, and others began to meet and experiment in automatist sessions that were inspired both by Breton's practice of automatic writing and by a séance that another member of the group, René Crevel (1900–1935), had attended. At their very first meeting, on September 25, 1922, Crevel fell into what Breton called a hypnotic slumber and began to speak about a woman who had fulfilled her husband's request that she kill him.[7] Following Crevel's recitation, another attendee, Robert Desnos (1900–1945), began to scratch at the table in what others at the session thought might be his attempt to write or draw. At the second session two days later, while in his trance, Desnos was handed a pencil and paper upon which he wrote "14 July," which of course is the date of the storming of the Bastille in 1789. In these and later sessions Desnos would often slip into a trance and recite poetry and prose; he also produced some automatic drawings, the most successful of which are more sophisticated than children's scribbles.[8] (I will discuss one of these in this book's last chapter.)

Desnos appears in several places in this book, but for now I only want to expand on something Breton wrote about him: "Desnos *speaks Surrealist* at will."[9] Breton was not just complimenting Desnos's ability to recite poems and narratives that did not obey traditional literary forms. Breton thought, at least in the early 1920s, that Desnos was able to escape the logical or moral constraints of society and history, the constraints Breton believed writers needed to overcome in order to achieve something they had been failing to do—represent *the marvelous* (*le merveilleux*). This became one of the primary aims of the surrealists, and they came to understand that the marvelous could be perceived by someone reading a poem, or observing a piece of artwork, only if that person was first somehow disoriented or placed in an unfamiliar situation (experiencing *dépaysement*). A visual artist could instill this feeling in the observer by presenting an object that had incongruous elements, a writer by providing hallucinatory or dreamlike images.

To support this last point let's look at some imagery from one of Breton's most successful automatic texts, *Soluble Fish* (1924). The narrative opens with a description of a fourteenth-century chateau. The landscape is bathed in late afternoon sunlight and the estate's shrubbery, or the land's undulating topography, casts long, fluid shadows over the terrain. Breton wrote: "The park, at this time of day, stretched its blond hands over the magic fountain. A meaningless castle rolled along the surface of the earth."[10] These images are closely followed by others wherein Breton employed mathematical terminology that further the hallucinatory or dreamlike aura of the narrative. For example, near the beginning of the first chapter a phantom enters the chateau and, after inspecting one of the towers, "descends the triangular staircase." Later, "isosceles wasps" fly outside the tower.[11]

In other places Breton appealed not only to mathematical language but to more abstract mathematical concepts. In the short second chapter, the narrator considers suicide and reflects upon the people who have been close to him. He consults a timetable at a train station, discovers that the names of the cities have been replaced by the names of the people he knows who live in those cities, and considers an itinerary he could follow to visit them, which is the quotation introducing this chapter: "Shall I go to A, shall I return to B, shall I change at X? Yes, naturally, I'll change at X. If only I don't miss the connection with boredom! Here we are: boredom, neat parallels, oh how neat parallels are beneath God's perpendicular."[12] In these few sentences, the narrator seems to be commenting on the insignificance of human activity, restricted to relatively small movements on the surface of the earth, when considered in the vastness of the cosmos. But more significant for the present discussion is the mathematical imagery Breton employed: that of parallel lines and of a dimension perpendicular to those of our existence.

The latter of these hints at an idea that had become rather fashionable among early twentieth-century literati—that there exists an additional, fourth dimension beyond human perception. We return to a discussion of the fourth dimension in chapter 5, but Breton's allusion to it does reveal an important component of his thinking: that there exist truths beyond our immediate perception. Breton's appeal to "neat parallels" refers to a nineteenth-century mathematical development which, he came to argue, artists should strive to replicate.

By the late 1920s Breton began to express his dissatisfaction with the visual arts and their reliance on objects and forms from external reality. In 1928 Breton wrote that the underlying assumptions of traditional Western art are based on a fallacious belief that different individuals perceive any given object in similar ways. He continued: "There is what others have seen, or claim to have seen, and

that by means of suggestion they are able or unable to make me see; there is also what I see differently from the way in which anyone else sees it, and even what I begin to see which *is not visible*."[13] Eight years later Breton expanded on this observation in his influential essay "Crisis of the Object" (1936). In that essay Breton called on artists to seek new objects to represent; he believed that if artists uncovered inventive objects, they would lessen the significance of the objects "which clutter up the so-called real world." This "depreciation" of real-world objects was "a prerequisite for the unleashing of the *powers of invention*."[14]

Breton explained that both poets and mathematicians had reenvisioned their basic images and objects in the nineteenth century and that it was time for artists to "break down the barriers in art which divide familiar sights from possible visions, common experience from conceivable initiation."[15] Thus, he challenged artists to rethink the objects of art as dramatically and thoroughly as geometers had reimagined the objects of geometry in the nineteenth century. These discoveries are examined in more detail later in this chapter, but appreciating Breton's argument requires at least a short overview of them.

The first geometric discovery Breton mentions occurred in 1830, when two mathematicians, independently, focused on the role of parallel lines ("neat parallels") in geometry. They showed that it might be possible for there to be a version of geometry different from the one codified by Euclid in the third century BCE, which for over two millennia had been thought to be not only the geometry of physical space but also the most natural geometry for us to imagine. In particular, these mathematicians assumed a different behavior for parallel lines than had Euclid, as is discussed later in this chapter, and did not reach any contradiction to the other assumed geometric truths: they had discovered a non-Euclidean geometry.

Breton says the second geometric discovery occurred in 1870, when "mathematicians elaborated a 'generalized geometry' that included Euclidean geometry as part of a comprehensive system."[16] This elaboration was probably the unified framework mathematicians developed to explain classical Euclidean geometry, the non-Euclidean geometry discovered in 1830, and another, non-Euclidean version of geometry that had been discovered in the intervening years. As I will discuss below, the central notion of this framework concerns whether the underlying surface upon which lines and other geometric figures are conceived is flat or curved.

Breton offered two ways artists could discover new art objects. The first was to search for images in their subconscious thought, reflecting the same thinking

that had led Breton to automatic writing. And although surrealists did experiment with automatic drawing, Breton suggested another approach; artists should fabricate objects that are perceived only in dreams—that is, they should provide the "objectification of the very act of dreaming, its transformation into reality."[17] This search for dreamed objects became the search for material objects that reveal the marvelous by producing *dépaysement* in the viewer, a feeling that we would now describe as being *surreal*. This is perhaps the best-known surrealist idea, as evidenced, for example, by the paintings of Salvador Dalí (1904–80), who was loosely affiliated with Breton's group after 1930; I discuss two of Dalí's paintings in chapter 5.

Secondly, Breton allowed for "diverting" an object from its assumed destiny. The artist whom Breton credited for having taken an object from the real world and "reclassifying it by the exercise of choice" was Marcel Duchamp (1887–1968).[18] Duchamp's activities in this direction began simply: "In 1913 I had the happy idea to fasten a bicycle wheel to a kitchen stool and watch it turn."[19] Duchamp took the front fork of a bicycle, with the wheel still attached, turned it upside down, and mounted it onto a stool. He modified other objects over the next decade and sometimes displayed, or attempted to display, these creations as one might a carefully painted canvas or sculpted block of marble.

Duchamp came to call all of these productions *readymades*, of which he distinguished two types—those that were manufactured objects "promoted to the dignity of an object of art through the choice of the artist"[20] and those that were *readymades aided*, meaning that they were constructed out of two ordinary objects, like a bicycle wheel and a stool. His most famous, and notorious, unaided readymade was produced in 1917.[21] This unaided readymade was a urinal of the sort that is found in a men's public restroom. He signed the urinal "R. Mutt 1917" and, calling his creation *Fountain*, submitted it under the name Richard Mutt for inclusion in an art exhibition. The urinal was not accepted into the show, and Duchamp published a protest that demonstrates he had anticipated Breton's desire to divert objects from the real world to become art objects: "Whether Mr. Mutt with his own hands made the fountain or not has no importance. He CHOSE it. He took an ordinary article of life . . . [and] created a new thought for that object."[22]

There is evidence that Breton also wanted artists to divert objects from the world of mathematics to become art objects. "Crisis of the Object" was published in a special issue of the art journal *Cahiers d'Art* (1936) that also included photographs of an exhibition of surrealist objects at the Galerie Charles Ratton in Paris. The photographs that accompanied Breton's essay show a modestly sized

room with objects in glass display cases along its perimeter; other objects sit on stands, and artwork and masks hang from the walls. Breton claimed that the room contained about two hundred pieces, including what he called *natural objects*—"minerals, plants, animals (a giant ant eater)"—*interpreted natural objects, disturbed objects*, and *mathematical objects*, which he described as being "surprising concretizations of the most delicate problems of space-geometrics."[23] These "space-geometrics" are precisely the geometries imagined on curved surfaces that exist in three-dimensional space, as opposed to the flat plane of Euclidean geometry; and these surfaces were elevated to the status of art not by Breton but by another artist-writer who was loosely affiliated with Breton's Paris group, the American Man Ray.

Man Ray and Mathematical Surfaces

> Any attempt to oppose those mathematical objects categorized
> by their makers in arid terms . . . would be to fall into the trap set
> by hidebound rationalism.
> —André Breton, "Crisis of the Object" (1936)

Man Ray (1890–1976) moved to Paris in 1921 and was immediately introduced to Breton and others by Duchamp, whom Man Ray had met in New York. While in Paris, from 1921 until 1949, Man Ray remained on the periphery of Breton's surrealist group, but he was always aware of their activities, as they were of his. And throughout the 1930s, Man Ray was involved in both organizing and participating in many of the surrealist exhibitions; according to its catalogue, he contributed five pieces to the Galerie Ratton exhibition, and he took the photographs of the room that were published in *Cahiers d'Art* along with Breton's "Crisis of the Object."

Sometime in the mid-1930s, Man Ray went to a mathematical research center on Paris's Left Bank, the Institute Henri Poincaré. There, in a room adjacent to the library, dozens of abstract-looking, modernist forms were on display. To the contemporary eye these forms might appear to be models for large-scale sculptural pieces of the sort that dot public parks and plazas or models of buildings such as the airport in Denver, Colorado, or the Guggenheim Museum in Bilbao, Spain. Man Ray, of course, could not have imagined these late twentieth-century trends in public art and architecture, so he was perhaps more curious, and even a bit more amazed, than our contemporaries would be by these forms.

The objects in the room were models of mathematical surfaces that had been constructed out of wood and plaster. To appreciate these surfaces we must think back to high school algebra, where we learned to graph certain equations on the Cartesian xy-plane. For example, the equation $x^2 + y^2 = 1$ has as its graph the circle centered at the origin whose radius is one unit. The correspondence between the algebraic equation and the geometric circle is given by a simple relationship: the geometric circle corresponds to all points (a, b) in the plane where the coordinates a and b of the point satisfy the relationship $a^2 + b^2 = 1$. Almost all high school and beginning college mathematics courses are devoted to understanding the graphs that correspond to equations in two variables, which may be drawn in the two-dimensional plane.

From the early eighteenth century on, mathematicians sought to understand the graphs of equations that require three dimensions to visualize. In principle these are easy to understand; such a graph will correspond to an equation not just in the two variables x and y but in three variables, x, y, and z. For example, the equation $x^2 + y^2 + z^2 = 1$ corresponds to the sphere centered at the origin—that is, at the point $(0, 0, 0)$—whose radius is one unit. In general, any such graph will be a surface or a bounded three-dimensional object (like the sphere), as opposed to a finite collection of points or a curve in space. And these surfaces can have fairly exotic geometric attributes—such as curvature, sharp corners, and holes.

Many of the surfaces at the Institute Poincaré were defined by algebraic equations, but some were derived from ideas in other branches of mathematics—including geometry and calculus. In his autobiography, *Self Portrait* (1963), Man Ray wrote of these objects that their formulas "meant nothing to me, but the forms themselves were as varied and authentic as any in nature." His photographs of some of these surfaces were published in *Cahiers d'Art* in 1936. Plate 1.1 shows Man Ray's photograph of the model representing a surface that is mathematically related to what is known as a pseudo-sphere. (We will look more carefully at the pseudo-sphere and its role in non-Euclidean geometry below.)

It was important to Man Ray that these objects were models or representations of the mathematical surfaces that were "man-made" because they "could not be considered abstract as Breton feared when I first showed them to him."[24] In other words, these objects were every bit as real as Duchamp's urinal or the Eiffel Tower. It was an additional benefit that these objects could induce *dépaysement* in whoever viewed them—all the more so owing to their origins in mathematical formulas. And we know how Breton felt about these photographs because in the quotation introducing this section, which is from the closing paragraph of "Crisis of the Object," Breton wrote that anyone who set "mathematical objects categorized by

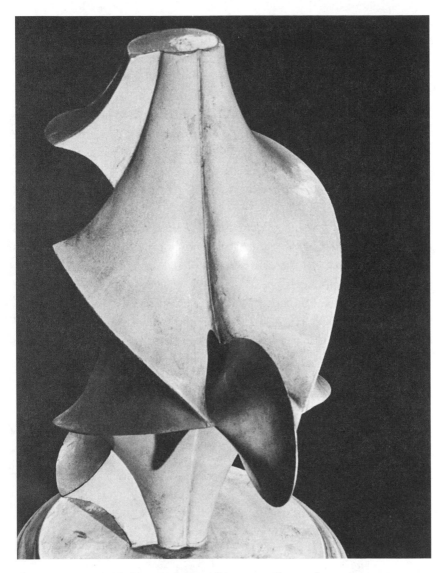

Plate 1.1. Man Ray, *Mathematical Object* (*Enneper surfaces with constant negative curvature, derived from the pseudo-sphere*), 1934–36. © 2013 Man Ray Trust / Artists Rights Society (ARS), New York / ADAGP, Paris.

their makers in arid terms" (in opposition to poetic objects that had more "seductive descriptions") was falling into the "trap set by hidebound rationalism."[25]

Twelve years after the publication of his photographs of mathematical surfaces, Man Ray reinterpreted some of the surfaces as paintings he called the

Shakespearean Equations. In the foreword to the catalogue for an exhibition of these paintings, Man Ray wrote a letter to Breton that opened with the sentence, "Let me assure you, I have always been in accord with you on the necessity of perverting the legitimate legends of the mathematical objects, if we are to consider these as a valid source of inspiration."[26] But Man Ray went further than simply changing these surfaces' names or formulas, their *legends*: "In returning to the mathematical objects as a source of material . . . I proposed to myself not only to take liberties with the legends, but with the forms themselves. . . . I was as free to do this as any painter of fruit or faces is free to choose his subject."[27] We will see below that perverting the titles of these objects was accompanied by Man Ray's reinterpretation of them.

Man Ray called his reinterpretation of the mathematical surface shown in plate 1.1 *Antony and Cleopatra*, after Shakespeare's play. However, not all of his *Shakespearean Equations* were based on unfamiliar, exotic mathematical surfaces. For example, his painting *As You Like It* was the image of a sphere represented as if it were being viewed through a window or a picture frame. What Man Ray probably did not know is that both the pseudo-sphere and the sphere played important roles in the nineteenth-century geometric developments that Breton alluded to in his essay. Understanding these roles requires that I provide at least

Plate 1.2. Man Ray, *Antony and Cleopatra*, 1934. © 2013 Man Ray Trust / Artists Rights Society (ARS), New York / ADAGP, Paris.

an outline of how Euclidean geometry has traditionally been presented, a style that can be traced back to Euclid in the third century BCE.

Geometries, Flat and Curved

> One geometry cannot be more true than another, it can only be more convenient.
>
> —Henri Poincaré, *Science and Hypothesis* (1905)

Euclid's text, the *Elements*, purported to provide a rigorous, axiomatic formalization of geometry, meaning that Euclid attempted to begin with clear, unambiguous *definitions* of the basic objects of geometry; a list of *common notions* that are the basic principles that should apply to any mathematical system; and *postulates*, the self-evident truths, or axioms, about geometric objects. The theorems of geometry were then deduced from the axioms using the commonly accepted principles of logic, which were assumed to hold without comment. As we are mostly concerned with Euclid's axioms, which are his common notions and postulates, we quickly dispense with his definitions.

Book I of the *Elements* offers twenty-three definitions; there are additional definitions in the other twelve books. Euclid's definitions are not intended to introduce novel entities into his study; these definitions are simply descriptions of objects, like a point or a line, whose existence is already assumed. For example, a point is defined as "that which has no part"; a line, which includes the notion of a curved line, is defined as "a breadthless length"; and a straight line is defined as a "line which lies evenly with the points on itself."[28] None of these definitions would help us understand what a point or a curve or a straight line is if we were not already familiar with the concepts.

Euclid's five common notions are general mathematical principles. The first three common notions are the familiar rules from algebra. For example, the first is

Equals added to equals yield equals,

which also has an obvious geometric meaning (just interpret *add* as *append*). The fourth common notion,

Things that coincide with one another are equal to one another,

is more geometric, while the fifth is more general:

The whole is greater than the part.

This fifth common notion, when transferred to other areas of mathematics, led to the well-known paradoxes of infinity and had to be reinterpreted before the modern conception of mathematical infinity could be developed (I discuss this in chapter 4).[29]

One of Euclid's postulates is central to the geometric developments Breton mentioned. There are five postulates in the thirteen books of the *Elements*, all stated at the beginning of book 1. The first three say, respectively, that two points determine a line segment, that a line segment may be extended in length without limit, and that a center and radius determine a circle. Euclid's fourth postulate,

All right angles are equal,

is needed because Euclid did not use measurement to define a right angle: according to Euclid's definition, a right angle is an angle formed when two straight lines cross so that all of the resulting angles are the same. Each of these four postulates do seem to be self-evidently true—meaning that anyone sufficiently intelligent or informed to understand them would believe them.

The fifth postulate of Euclid's *Elements*, called the parallel postulate, is less self-evident, and as it does not hold in either version of non-Euclidean geometry, it deserves the most attention:

> **If a straight line falling on two straight lines makes the interior angles on the same side less than two right angles, the two straight lines, if produced indefinitely, meet on that side on which the angles are less than the two right angles.**

We can better understand this postulate if we imagine having two horizontal-looking lines, L_1 and L_2, which may or may not be parallel, that are crossed by a third line, L_3 (in Euclid's language this third line *falls* on the first two). It follows from the above postulate that if L_3 is perpendicular to L_1 but not perpendicular to L_2, then L_1 and L_2 are not parallel.

As early as the fifth century CE, Proclus (412–85), in his commentary on the *Elements*, wrote that Euclid's parallel postulate had long been viewed with some suspicion. Even from a purely syntactical point of view, this postulate is less simple, so perhaps less fundamental, than the other postulates. Moreover, it is not an elementary assertion of existence or equality. Instead, it is a criterion for determining whether two lines are parallel—the criterion is to draw a third line crossing the two lines and then examine the angles formed by the intersections—and as such reads more like a theorem than an axiom. Proclus believed the parallel postulate could be an as-yet unproven theorem; he tried to derive it from the other four postulates without success.

Proclus's attempts to derive the parallel postulate from the other postulates of geometry were doomed because of something that was not discovered until the nineteenth century; this is the first nineteenth-century development in geometry Breton so admired. In the 1820s two mathematicians—a Russian, Nicolai Ivanovich Lobachevsky (1792–1856), and a Hungarian, János Bolyai (1802–60)—independently studied a geometric system in which Euclid's first four postulates were assumed to hold but the parallel postulate was not. Instead of taking the parallel postulate as an axiom, they assumed a different behavior for parallel lines. In Euclidean geometry if the lines L_1 and L_2 are parallel, then any line that crosses one of them will cross the other. However, in both Lobachevsky's and Bolyai's geometry there can be two intersecting lines that are both parallel to a third line.

Although Lobachevsky and Boylai did not find any contradictions when they assumed their version of the parallel postulate, the lack of contradictions did not mean that their geometry had any geometric meaning: they might have been exploring an interesting area of pure mathematics but one with no connection with anything anyone would usually think of as being a geometric object. In 1868 the Italian mathematician Eugenio Beltrami (1835–1900) removed this possible blemish from non-Euclidean geometry when he showed that if one were to "do geometry" on the surface of the pseudo-sphere, which is related to the surface that Man Ray reinterpreted as the painting *Antony and Cleopatra*, then that geometry is precisely the one described by Lobachevsky and Bolyai.

Before Beltrami could investigate any such geometry, he had to decide what he meant by a straight line on the pseudo-sphere. To provide this meaning he bypassed Euclid's nondefinition of a straight line and used a definition attributed to the widely acknowledged greatest mathematician of antiquity, Archimedes (ca. 287–212 BCE): a line (segment) defined by two points follows the shortest path between the two points. Such a path always exists between any two points on the pseudo-sphere—it is called a *geodesic*—and Beltrami took this to be the line segment between the two points. On the pseudo-sphere shown in plate 1.3 there are several lines (geodesics) that illustrate two important features of the Bolyai-Lobachevsky geometry. The first of these features is that the three lines M, N, and l violate the behavior of parallel lines in Euclidean geometry but manifest Bolyai's and Lobachevsky's assumption: No matter how far these three lines are extended, neither M and l nor N and l will meet. This means, according to Euclid's definition of parallel lines, that both the line M and the line N are parallel to l, so the crossing lines M and N are parallel!

The second notable feature of geometry on the pseudo-sphere concerns the sum of the angles in a triangle. High school geometry teaches that the three

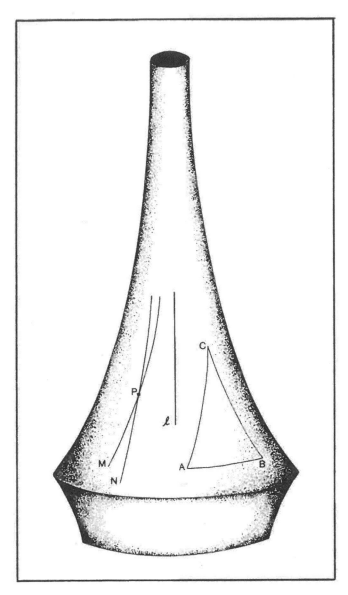

Plate 1.3. Geodesic lines on a pseudo-sphere. From Linda Henderson, *The Fourth Dimension and Non-Euclidean Geometry in Modern Art* (Princeton: Princeton University Press, 1983); drawing by Samuel Carruthers.

angles in a triangle always add up to 180 degrees. This may be correctly deduced from Euclid's axioms, so it is indeed a theorem in Euclidean geometry.[30] In the early nineteenth century the mathematician Adrien-Marie Legendre (1752–1833) discovered that if you remove the parallel postulate from Euclid's five postulates and replace it with a new axiom,

Axiom 5*. The sum of the angles in a triangle equals 180 degrees,

it is possible to derive the parallel postulate as a theorem. And although Axiom 5* is perhaps not as self-evident as the parallel postulate, the two of them are equivalent—you may assume either as your fifth postulate and you will be describing the same geometry in the sense that the geometric theorems you may deduce from your axioms will be the same in either case.

Since in the non-Euclidean geometry developed by Lobachevsky and Bolyai, the parallel postulate explicitly does not hold, then neither can Axiom 5*. Indeed, just looking at the triangle with vertices at the points *A*, *B*, and *C* on the pseudo-sphere of plate 1.3, we can see that its angles are a bit sharp; the angles are smaller than if the triangle had been drawn on a flat surface. And this is exactly the point: the pseudo-sphere is not flat—it is curved—and the sum of the angles in any triangle drawn on this surface in less than 180 degrees.

Even though the pseudo-sphere is self-evidently curved and not flat, so we can see that geometry performed on this surface is not the geometry described by Euclid, we need a slightly more sophisticated understanding of the curvature of a surface to appreciate the geometric development Breton said occurred in 1870. We first note that it is possible for a surface to have, at a point on the surface, positive curvature, zero curvature, or negative curvature. If a surface is a flat plane, as Euclid assumed for his geometry, the curvature of the surface is zero at every point. One way to start to think about the nonzero curvature of a surface at a point is to imagine standing on the surface. If you were standing at a point on the surface of a (small) sphere, you would notice that the surface seems to fall away from you in all directions. This is called positive curvature. (It is easy to see that the larger the sphere, the less it will seem to fall away from you, so the less it is curved. This means that there is an inverse relationship between the radius of the sphere and its curvature; indeed, the curvature of a sphere of radius *r*, at any point on its surface, is $1/r$.) Next imagine that you are standing on a surface, like the pseudo-sphere, that seems to rise up in all directions. Then the surface has negative curvature; the curvature of the pseudo-sphere at any point equals −1. Besides having nonzero curvatures, the sphere and pseudo-sphere have another important property that is implicit in the numerical values we have already given

for their curvatures: their curvatures are everywhere the same (so they are each a surface having constant curvature). This is not true of an arbitrarily chosen surface—for example, a surface that looks like a saddle—which may twist and turn and have different curvatures and different points.

If Euclidean geometry corresponds to geometry on a flat surface (a surface with zero curvature) and if the Bolyai-Lobachevsky non-Euclidean geometry corresponds to geometry on a surface with constant, negative curvature, then it seems reasonable to speculate that there could be another type of geometry on a surface with constant, positive curvature. Such a geometry was discovered by the mathematician Bernard Riemann (1826–66) about thirty years after Bolyai and Lobachevsky investigated their form of geometry. We have already seen that when geometry is done on the pseudo-sphere, Axiom 5* does not hold, and the sum of the angles in a triangle will always be less than 180 degrees. In Riemann's geometry the sum of the angles in a triangle is always greater than 180 degrees.

One way to see an almost-model for Riemann's geometry is to "do geometry" on the surface of a sphere, which, as we have said, is a surface with a constant, positive curvature. The reason the sphere is not quite a model for this sort of non-Euclidean geometry is because a line, which on the sphere is a great circle (i.e., a circle that separates the sphere into two equal hemispheres), cannot be extended indefinitely, as required by Euclid's second postulate. Nonetheless, we can see that on the sphere, and in Riemann's geometry, any two lines will intersect, so in this geometry a parallel postulate would state that there are no parallel lines. (Indeed, any two lines will intersect in exactly two antipodal points, which is another reason just using the sphere to model this geometry is slightly misleading.) We can also see how the angles in a triangle can add up to more than 180 degrees: just imagine a triangle with one vertex at the north pole and its other two on the equator. Each of these two equatorial angles will measure 90 degrees, so the sum of the angles will be 180 degrees plus the measure of the angle at the pole. It is a result of advanced geometry that the sum of the angles for any triangle on the sphere exceeds 180 degrees.

LOOKING AHEAD

There are two important ideas buried in this short discussion of Euclid's *Elements* and the nineteenth-century discoveries that influenced the modern conception of mathematics. The first is that geometry is not some sort of collection of empirical truths, but of theorems about the objects of geometry. Since different choices of axioms can lead to the same collection of theorems, as when Axiom 5* is used in

place of the parallel postulate, the notion that an axiom should be a self-evident truth is weakened. Instead, an axiom need only be seen as an assumed truth, one whose veracity need not be obvious.

The second idea buried in our discussion of geometry also bears on the meaning of the word *axiom*. Following the discovery of non-Euclidean geometries, mathematicians set about developing a more general geometry in which there would be no assumption about the behavior of parallel lines (so no assumption about the total measure of the angles in a triangle). This is rather easily accomplished, at least in principle—one simply assumes the axioms of Euclidean geometry but not the parallel postulate and derives theorems, being careful to use only what is being explicitly assumed. This gives what is frequently called *neutral* or *absolute geometry*, a geometric system which one would hope would include as special cases the geometries of Euclid, Bolyai-Lobachevsky, and Riemann: if you additionally assume Euclid's version of the parallel postulate, you obtain Euclidean geometry; if you additionally assume the Bolyai-Lobachevsky version of the parallel postulate, you obtain Bolyai-Lobachevsky non-Euclidean geometry; and if you additionally assume Riemann's version of the parallel postulate, you would expect to obtain Riemann's non-Euclidean geometry. Unfortunately, the situation is not that simple because the axioms of Euclidean geometry, without assuming anything about the parallel postulate, imply that parallel lines exist. So Riemann's geometry is truly different from Bolyai-Lobachevsky geometry; in order for it to work, one must relax some of the other axioms from the *Elements*.

It follows from what we have seen that a geometer is free to choose which geometry to study or apply to a particular situation. This is what the French mathematician Henri Poincaré (1854–1912) was referring to in the quotation, above: "One geometry cannot be more true than another, it can only be more convenient."[31] In the next chapter we will see that this point of view was fully developed around the turn of the twentieth century. But we will also start to see that artists and writers increasingly offered their own self-evident truths in discussions of their aesthetic ideals and that often these self-evident truths—axioms, if you will—had interesting mathematical elements.

Objects, Axioms, and Constraints

Black Squares and Axioms

The square = feeling, the white field = the void beyond this feeling.
—Kazimir Malevich, "Suprematism" (1927)

One of the first artists to turn to geometric forms to express his aesthetic ideas was the Russian painter Kasimir Malevich (1878–1935). I open this chapter with an extended look at Malevich's use of these forms for several reasons. The first reason (and this is a point I frequently return to in later chapters) is that we want to understand *why* Malevich employed mathematical objects or concepts in his work. The second is that we want to understand how theorists and others reacted to, or attempted to explain, the meaning or significance of Malevich's paintings. And the third is that even though his paintings scream modernity at any viewer, the way in which Malevich used the square in his art reveals that his ideas are more analogous to Euclid's classical conception of geometry than to the modern, twentieth-century one discussed in this chapter.

Malevich's early paintings, those displayed between 1903 and 1912, seem to have been inspired by the work of others; some of these paintings are reminiscent of those of Pissarro, Sisley, Matisse, and Chagall.[1] By the spring of 1912, as evidenced by the paintings he displayed at the Donkey's Tail exhibition in Moscow, Malevich was transitioning towards a cubist style. Then, in the fall of 1913, at the Union of Youth exhibition, Malevich premiered paintings of people with strong geometric forms against cubist backgrounds crowded with cylindrical and conical shapes illuminated from various angles. These stylistic shifts reveal that Malevich seems to have been searching for his artistic style, perhaps for something that would set him apart from the artistic innovations sweeping Europe. Within two years he had found it in basic geometric forms.

Malevich first displayed his paintings containing geometric shapes in December 1915 at the infamous Last Futurist Exhibition of Paintings 0, 10 (Zero-Ten) in Saint Petersburg. He was one of several artists in this exhibition who were given their own galleries, more to keep those who had conflicting aesthetic ideas separate than to honor anyone. A widely published black-and-white photograph of one corner of Malevich's room shows twenty-one of the thirty-nine paintings he entered into the show. Instead of being hung in an orderly fashion, as one would expect in an art exhibit, the paintings were splayed across the walls in a seemingly haphazard fashion from floor to ceiling. These canvases contained images of squares, rectangles, circles, and other geometric shapes.

One painting, an image of a solid black square on a slightly larger square white canvas, was hung in the most prominent position in the room—the way religious icons were usually hung in Russian homes—near the ceiling, straddling an edge where two walls met. This painting is one of the best-known, and first, uses of a solitary geometric figure in a painting. Malevich called this painting *Quadrilateral* (1914–15). It is more commonly known as *Black Square*, and its position in the room reflects the centrality of this image in Malevich's thinking, a role he explained several years later in his essay "Suprematism." In that manifesto Malevich explained that he did not seek to provide objective representations because such an aim "has nothing to do with art." He continued with his reason (often quoted later) for turning to the solitary, black square: "In my desperate attempt to free art from the ballast of objectivity, I took refuge in the square form . . . a black square on a white field."[2]

Although Malevich's *Black Square* does not have a basis in the external world of material objects, he did describe it as representing, or presenting, something innately human. In the quotation at the beginning of this chapter he identified the square with feeling and the white field around the square with "the void beyond this feeling." So, rather than seeking to represent an outpouring of images and emotions, as the surrealists were going to attempt a few years later with their automatic writing experiments, Malevich sought to offer a single feeling, emotion, or thought. And to represent a pure single feeling, emotion, or thought, Malevich turned not to a swatch of color or abstract form but to something he must have thought of as being even more basic—the black square.

Malevich published his equivalences "the square = feeling, the white field = the void beyond this feeling" several years after the Zero-Ten exhibit, so they are most likely after-the-fact explanations of what he intended to convey with *Black Square*. It is possible, however, that these equations, or at least the equivalencies

they provide, had guided Malevich as he conceived of and executed that painting. Even if we study Malevich's writings, it is not possible to decide which came first, Malevich's use of a solitary geometric image or his explanatory equations. Yet we can gain some insights as to which is primary—the square or the properties Malevich ascribed to it—by looking at another of his paintings and, in this case, what others later wrote about it.

Even a casual viewer of a painting containing a single black square would probably not imagine it to represent any material object. But a more elaborate nonobjective painting—say, one containing multiple lines or forms—might be construed to be an abstract painting of something, in the same way that we "interpret" a Rorschach ink blot. So what are we to make of Malevich's paintings at the Zero-Ten show that contained multiple elementary geometric forms? To see how some of these can also be understood to present a single primitive concept, we can focus on one of the most widely discussed of these paintings. This painting is of two squares—a large black one, roughly centered in the top half of the taller-than-wide rectangular canvas, and a smaller red one, just below the center of the canvas and a bit off to the right. The black square's sides are parallel to the sides of the canvas, and the red square is slightly tilted. In contrast to the straightforward title he gave his black square, Malevich called this painting *Painterly Realism of a Boy with a Knapsack: Color Masses in Four Dimensions*; it later came to be known as *Suprematist Composition (Red Square and Black Square)*.

The twentieth-century theorist W. J. T. Mitchell described taking his thirteen-year-old son to the Museum of Modern Art in New York and how, while there, they came upon Malevich's painting with the black and red squares. According to Mitchell, his son quipped, "I suppose you're going to tell me how great and full of significance *this* one is, too." Mitchell reports that as he formulated a response to his son, several possibilities occurred to him. Among these was Malevich's self-stated desire, we saw earlier, to free himself of the ballast of objectivity. But Mitchell also thought of explanations that had been formulated by academics and art theorists, such as an analysis of the painting based on the "Hegelian dialectic," another based on its use of color, and yet another based on the relative positioning of the two shapes. Mitchell wrote that instead of lecturing his son, he simply asked him to describe the painting. The boy responded, "There is a small tilted red square below a larger black square." According to Mitchell, this short sentence captures much of what could be said about the painting: it is not a representation of anything but is a "direct presentation" of the figures, with the tilted red square being the "hero" of the painting.[3]

Another scholar, Charles Altieri, has provided a more elaborate description of the red square's hero status that is a synthesis of the last two ideas that occurred to Mitchell but that he refrained from telling his son—one involving color and the other involving position. Altieri explained that the relative positions of the two squares allow the red square to be more active because "its tilt denies the coordinates established by the black square." Moreover, because it is painted a monochrome, primary red, in contrast to the white canvas and the large black square, the small red square "leaps forward from the canvas."[4] Thus, the juxtaposition of the stable, large black square with the tilted smaller red square represents, or perhaps we should say presents, the primal feeling of motion.

If we were to attempt to represent this conclusion through equations, as Malevich did for *Black Square*, we might be led to the following:

$$\text{black square} = \text{stability},$$
$$\text{(tilted) red square} = \text{denial of that stability.}$$

This would, of course, ascribe a different meaning to the use of a painted black square than Malevich had claimed for it in *Black Square* and so could not be used as an explanation for its use in both of the above paintings. Moreover, this would also imply that the square in *Black Square* is more fundamental than the equations he used to describe its meaning. Although Malevich did not offer these second equations, there is evidence for the conclusion we drew from them in the writings of at least one art scholar, Troels Andersen.

Andersen wrote that in Malevich's writings, his view of the square "vacillates" from document to document. This implies that any attempt to ascribe a single purpose to Malevich's use and reuse of squares in his paintings could be misleading, or even incorrect. Andersen followed his observation with something that might strike us as odd; he wrote that Malevich "chose to regard the square as an axiom, as his attempt to rid painting of all irrelevant elements by presenting the surface area as an axiomatic point of departure."[5] In the first part of this quotation Andersen might appear to be misusing the term *axiom,* or at least using it differently than it is used in geometry, where an axiom is a statement that is a self-evident truth about the objects on a curved or flat surface. But the idea is that for Malevich the square was like a point in Euclidean geometry. Although he may have explained it through his equations, the square preceded those equations. And just as in Euclid's *Elements* the geometric point is taken to be a primitive, fundamental object, Malevich took the elements of his paintings as being more fundamental than the written expressions of his artistic ideals.

The second part of Anderson's quotation connects Malevich's use of the square with the presentation of geometry I discuss in the next section. This presentation attempts to rid geometry of its "irrelevant elements" not by simplifying its axioms or clarifying the nature of some underlying surface but by abandoning any attempt to understand what is meant by a point or a line. This geometry simply provides the axiomatic assumptions that builds a geometric system on these unspecified entities.

Geometry without Objects / Literature without Words

> The view of axioms advocated by modern axiomatics, purges
> mathematics of all extraneous elements. . . . In axiomatic
> geometry the words "point," "straight line," etc., stand only for
> empty conceptual schemata.
> —Albert Einstein, "Geometrie und Erfahrung" (1921)

We are returning to basic geometry to look at one way in which mathematicians have made their subject increasingly abstract and increasingly distant from what could be thought of as the objective, material world. This increasing abstraction has accomplished many things for mathematics, including providing greater clarity about such things as Euclidean versus non-Euclidean geometry, the meaning of mathematical infinity, and the answer to the question, What is a number? Here, I want to examine some axioms for geometry the mathematician David Hilbert (1862–1943) offered in a series of lectures in 1898 and 1899. Hilbert was one of the leading mathematicians of his day, so of course he knew that the parallel postulate was independent of Euclid's other axioms. He was also aware of the work of other mathematicians on other shortcomings of Euclid's text.

The most important feature of Hilbert's geometry, for the purposes of the discussion here, is that he dispensed with Euclid's definitions of the objects of geometry, such as a point or line. Instead, Hilbert simply noted that he was going to "consider three distinct systems of things"—points, straight lines, and planes.[6] He does not tell us what these things are, in part because he does not wish us to have any intuitions or preconceived ideas about these objects. Any relationships between these entities would be either given by or derived from his axioms. This is precisely the point Einstein made in the quotation heading this section. Hilbert's axiomization of geometry "purges [it] of all extraneous elements," and (as Einstein noted) "this approach to geometry cannot predict anything about objects of our intuition or real objects."[7]

To correct Euclid's oversights, Hilbert's system requires many more axioms, which he separated into five types: axioms of connection, order, and congruence; a parallel postulate; and an axiom of continuity. In order to appreciate the relationship between Hilbert's and Euclid's axioms, and to obtain a glimpse at the care Hilbert took to ensure that he was allowing for no unstated assumptions, let's look at three of his axioms of connection and one of his axioms of order.

Hilbert's seven axioms of connection concern points and their relationship to the lines, planes, and space that contains, and so *connects*, them. The first two of these axioms are these:

1. **Two distinct points, *A* and *B*, always completely determine a straight line.**
2. **Any two distinct points of a line completely determine that line.**

The first axiom says that two points determine a line, as did Euclid's axiom, and the second axiom says that this line is unique, which Euclid assumes but does not make explicit. Hilbert's seventh axiom of connection clearly illustrates that something is going on here that was not present in the *Elements*; if one imagines that geometry necessarily has anything to do with the physical world, then this axiom would be absolutely unnecessary:

7. **Upon every straight line there exist at least two points, in every plane at least three points not lying in the same straight line, and in space there exist at least four points not lying in a plane.**[8]

For all that Hilbert has assumed so far, a line might consist of just the two points that define it and a plane of three points. Hilbert addresses this possible paucity of points in geometry with his five axioms of order, whose main purpose is to "define the idea expressed by the word 'between.'" To see but one example, consider Hilbert's second axiom of order:

2. **If *A* and *C* are two points of a straight line, then there exists at least one point, *B*, lying between *A* and *C* and at least one point, *D*, so situated that *C* lies between *A* and *D*.**

This axiom implies that a line has more points both between and beyond any two points on it. Indeed, it implies that any straight line will contain an unlimited number of points, since it will contain an unlimited number of points between any two points. (For example, according to this axiom the point *B* is between the points *A* and *C*, but applying the axiom again tells us that there is a point *B'* between *A* and *B*, and applying it again means that there is a point *B''* between *A* and *B'*. There is no end to this process.)

Hilbert's other axioms include six axioms of congruence (Hilbert's second axiom of congruence is similar to Euclid's first common notion), a theorem from Euclid's *Elements* that is mathematically equivalent to Euclid's parallel postulate, and one axiom of continuity.[9] After completing his presentation of these five types of axioms Hilbert, perhaps surprisingly, adds yet another axiom that "although not of a purely geometrical nature . . . merits particular attention from a theoretical point of view."[10] This *completeness* axiom maintains that if we have a system of points, straight lines, and planes satisfying the axioms of geometry, it is not possible to add more elements to the system and still have it obey the axioms of geometry. In other words, the original system is complete in the sense that if it contains points, then it contains all of the lines defined by these points and all of the points defined by these lines and so forth.[11]

The completeness axiom reveals that there is another notable difference between the conception of geometry as presented in Euclid's *Elements* and in Hilbert's *Foundations of Geometry*. Euclid did not assume that all of the lines through all of the points, or all of the circles with all possible centers and all possible radii, already existed. He postulated, in his definitions, that it was always possible to draw such a thing. So the geometer could, so to speak, bring a circle to life by realizing it on a piece of paper or in the sand. In Hilbert's conception of geometry all these things already exist. Indeed, his completeness axiom says that a geometer could not create any new circles or lines.

Hilbert's point in *The Foundations of Geometry* was not only to supply geometry with a proper set of axioms but also to completely sever any connections we might impose between geometric ideas and our intuitions. Indeed, when Poincaré, the other preeminent mathematician at the turn of the twentieth century, reviewed *Foundations*, he did not dwell on the originality of Hilbert's axioms.[12] Poincaré was most impressed with Hilbert's insights into the nature of the axiomatic approach to geometry. Rather than be limited to Euclid's parallel postulate as the only axiom one may or may not impose on geometry, as in the nineteenth century discovery of non-Euclidean geometries, a geometer is free to pick and choose among Hilbert's axioms those that are most convenient.[13]

Axioms for Literature

Hilbert's decision to not offer any explanation of what is meant by a "point," a "line," or a "plane," combined with the freedom he gave anyone studying geometry to choose among his axioms those that suit their purposes, reflects his conception of mathematics. It is this view of axiomatic geometry that, as Einstein wrote, "purges mathematics of all extraneous elements." But it means even more

than that: since the basic objects of geometry are left unspecified, it implies that the axioms are more fundamental than the objects and that these axioms may be applied to any particular interpretations of the words "point," "line," or "plane."

One twentieth-century author, Raymond Queneau (1903–76), exploited this freedom to explore how Hilbert's axioms could be interpreted in literature. Queneau was associated with the surrealists in Paris during the 1920s but, as he said in an interview in 1950, "fell out with Breton for strictly personal reasons, not ideological."[14] In his many later essays Queneau was often critical of surrealist ideas, especially automatism, yet he continued to admire one aspect of surrealist writing—the way in which it "inspired . . . an endlessly renewed variety of images."[15] After his break with Breton, Queneau looked beyond the images presented in literature and sought new literary forms that would, as he later wrote, offer "props for inspiration . . . [and] aids for creation."[16] And Queneau was not alone in his search for new forms; on November 26, 1960, Queneau and six other French intellectuals gathered in the basement of a cafe in Paris to discuss experimenting with novel literary forms.[17] A month later that same group, joined by others, met again and adopted the name Ouvroir de Littérature Potentielle (Workshop for Potential Literature), for which they immediately adopted the acronym OULIPO.[18] From the very beginning, there have been two central currents in Oulipian literature: the development of *potential* literature and the invention of new literary forms (and these new forms were determined by constraints—frequently based on mathematical ideas). We will turn to some of these both in this section and in later chapters. But first I want to look at Queneau's belief that mathematical ideas could be employed to deepen our understanding of literature.

Queneau discussed how Hilbert's axioms for geometry look when they are reinterpreted in literature in his *Foundations of Literature (after David Hilbert)* (1976).[19] Queneau's axioms for literature depend on specifying what he means by a "point," a "line," or a "plane." He made the following choices:

A word corresponds to a point.
A sentence corresponds to a line.
A paragraph corresponds to a plane.

Using these correspondences, Queneau provided versions of some of Hilbert's axioms to obtain axioms that could be used in the composition of a text, the entity in Queneau's system that corresponds to Hilbert's geometric space. Queneau offered three types of axioms that reflect the classification of axioms given by Hilbert. Queneau does not imagine that all of his axioms would hold for any particular piece; rather, his thinking is that by adopting particular axioms, an

author imparts a particular style (or, to use geometric language, certain properties) to a text.

Queneau's first axiom is a self-evident truth about the richness of language:

A sentence exists containing two given words.

This is a translation of Hilbert's axiom "Two distinct points, *A* and *B*, always completely determine a straight line." This first axiom does not say as much about the nature of literature as it does about the nature of language. But others, such as Queneau's second axiom, are intended to apply specifically to all sentences that appear in a particular text, not to all sentences within a given language:

No more than one sentence exists containing two given words.

This second axiom captures the content of Hilbert's axiom, "Any two distinct points of a line completely determine that line." Hilbert's axiom reinforces the idea that two points determine a unique line, but Queneau's axiom may be viewed either as a warning to a writer—that once two words are used in a sentence, if they are then both used in a subsequent sentence, that sentence may seem to be derivative from the first—or as a constraint on the text, a rule a writer must adhere to in order to further spark his or her creative imagination.

Even without knowing Queneau's third and fourth axioms, we can see why he wrote that his first four axioms are not consistent. Indeed, we can see an inconsistency even in his first two axioms. Each of these two axioms is a sentence containing the two words "two" and "words," so their reoccurrence in a single text violates the second axiom. Another way to think about this situation is that once the first axiom has been accepted, the second axiom prohibits its own formulation: each of these first two axioms, which are sentences, contains the words "two" and "words." But the second axiom posits that two words uniquely determine the sentence that contains them.

Queneau could have avoided this inconsistency between his first two axioms by replacing the first axiom with a stronger one, such as

Any two words are contained in one and only one sentence,

which has the same consequence as Queneau's first and second axiom. But this axiom is not a translation of any of Hilbert's, and it would preclude Queneau from formulating any other axiom containing two of the words "and," "any," "are," "contained," "in," "one," "only," "sentence," "two," or "words." For example, Queneau would have to reformulate each of his other axioms, which contain many of the words listed above.

But there is a more significant problem with Queneau's axioms owing to his decision to make the correspondences between point and word, line and sentence, and plane and paragraph. This choice means that Queneau's translations of Hilbert's axioms become sentences that say something about the nature of sentences. Queneau understood this difficulty with proposing any axioms of the sort he gave; indeed, he wrote that "axioms are not governed by axioms,"[20] which means that the list of axioms cannot be applied to the text of which they are a part.

Even though Queneau's axioms for literature fall short of actually providing a philosophical basis for all of literature, there are two important points to take away from this brief discussion of them. The first is that two axioms can contradict one another, or that a single axiom can even contradict itself. This is something that could well have been true of the axioms Bolyai and Lobachevsky adopted for their geometry. However, Beltrami's discovery that the Bolyai-Lobachevsky axioms hold for geometry done on the pseudo-sphere shows that the axioms are not contradictory. The second point, which will play an important role both below and in the discussion of poetic structures in chapter 7, is that a literary work can be viewed as a collection of words subject to certain constraints.

Experiments with Literary Constraints

We close this chapter by looking at an application of the second point above, which led to the creation of a very innovative and, as we will see, abstractly conceived text. This text is in the style of what is known as a *lipogram*, which is a text written without the use of one or more of the ordinarily available letters of the alphabet. There is a long literary tradition of writing lipograms, but I will only briefly mention two twentieth-century examples, both written under the axiomatic constraint "No word containing the letter 'e' may be used."

In the 1930s an American writer, Ernest Vincent Wright (1872–1939), published his novel *Gadsby: A Story of Over 50,000 Words without Using the Letter 'e'* (1939). Wright conveniently explains in the novel's subtitle something a reader might not notice—that the most commonly occurring letter in the English alphabet, *e*, never appears in *Gadsby*. Wright even restrained himself from using abbreviations for words that contain *e*; for example, he did not allow himself to use "Mr." for "Mister" or "Bob" for "Robert." In the author's introduction to *Gadsby*, he claimed that his greatest challenge was to get around using past tense verbs because almost all of them end in *-ed*. Then in 1969, the French writer Georges Perec (1936–82) published his *e*-less novel *La Disparition*; the most commonly used letter in French is also *e*. The direct translation into English of the book's

title would be *The Disappearance*, so when Gilbert Adair translated this novel into English without using the letter *e*, he gave it the *e*-less title *A Void* (1994).

In 1990 the French writer Paul Fournel published his novel *Suburbia* (*Banlieue*), which we will see can be viewed as an extreme version of a lipogram. The novel's table of contents is extensive:[21]

<div align="center">Table of Contents</div>

The first line of the Word from the Publisher builds up the reader's expectations by hinting that the original publication of the novel had been a fairly controversial event: "If we have decided to republish a work whose incendiary career was beset with obstacles we all remember far too well, it is because the quality of this little novel, now that passions have subsided, has emerged ever more forcefully."

Turning to the beginning of the novel the reader discovers a very curious text. Its first page has the heading "Suburbia" and no other text except the footnotes:

1. In French in the original.
2. Concerning the definition of *suburb*, see the epigraph *et seq.*
3. What intention on the author's part does this brutal opening suggest?
4. Local judge.

A perhaps slightly confused reader might turn to the second page and discover that it is also blank except for four footnotes:

1. Notice how Norbert comes crashing onto the scene.
2. This passage is a mixture of backslang and immigrant jargon. Transpose into normal English.
3. Motorcycle.
4. Obscene gesture.

Suburbia continues in a similar fashion for eight pages, not for the roughly 206 pages promised by the table of contents, although the index refers to page numbers as large as 137. The most striking feature of *Suburbia* is that, except for the footnotes, the pages are blank. In *Suburbia* Fournel was not attempting to give

some postmodernist exploration of the nature of literature.[22] *Suburbia*, instead, was written according to the lipogramatic constraint that it contain no letters or symbols. This constraint forced Fournel to write a *textless* narrative. Because of the footnotes on each page, it has content—it is not an empty text; it is simply a text-less text, a text that just happens not to contain any words.

LOOKING AHEAD

Hilbert's presentation of geometry might seem abstract, in that he does not define or describe its objects, but he leaves the words "point," "line," and "plane" undefined because he wants to allow a geometer to specify what type of points to admit. In his book Hilbert developed several versions of geometries by taking their *points* to be points with coordinates having some sort of restrictive properties. So Hilbert's geometry was not truly a geometry without objects; rather, it is a geometry where the axioms are more fundamental than the objects, which the geometer is free to specify.

Fournel's novel *Suburbia* is abstract in a different sense. It begins with the insight we gleaned from Queneau's axioms for literature, that a literary piece may be viewed as a collection of words subject to some additional constraints (axioms). This is, of course, close to the classical conception of poetry, as we will see in chapter 7, but applied to narrative fiction it is a modern notion. We will see in the next chapter that this modern view of the text parallels the modern conception of mathematics and mathematical objects.

Abstraction in Art, Literature, and Mathematics

The White Paintings

We call "abstract" all works of art which, though they may start
from the artist's awareness of an object in the external world,
proceed to make a self-consistent and independent aesthetic unity
in no sense relying on an objective equivalence.

—Herbert Read, *Art Now* (1933)

By the time the British art historian and poet Herbert Read (1893–1968) gave the above definition of abstract art, which began with unfaithful portrayals of real objects or images and soon led to nonobjective art, it had dominated Western art for thirty years. We saw in the first chapter that some artists sought to depict objects not from the "external world," as Read called it, but from the inner world of dreams and unconscious thought and, in time, turned to mathematical forms to realize part of their artistic ambitions. In the second chapter we saw one artist whose aesthetic ideals were not shaped by mathematical concepts, but those ideals led him to employ flat, uninterpreted geometric shapes in his paintings.

In this chapter we begin with two artists whose paintings are abstract in reflecting a "self-consistent and independent aesthetic unity" derived from their creators' aesthetic ideals "in no sense relying on an objective equivalence." These two artists had different, but not incompatible, conceptions of art; and for each of them their paintings seem secondary to these conceptions. What is of interest to us is how each of these artists produced paintings with attributes relevant to this chapter's examination of the sorts of abstraction that led to the spectacular advances in mathematics in the twentieth century.

Almost a half-century after Malevich displayed his paintings at the Zero-Ten exhibit, the artist Ad Reinhardt (1913–67) began to produce paintings in which

large square canvases were painted entirely black. In the 1930s Reinhardt's paintings and collages had been highly abstract and very colorful, but by the 1960s his paintings were seemingly monochrome squares. The best known of these paintings are his square 60-by-60-inch black canvases. Reinhardt was not the first artist to produce monochrome paintings, an honor that apparently belongs to the Russian painter Alexander Rodchenko (1891–1956), who displayed three monochrome canvases (*Pure Red Color, Pure Yellow Color,* and *Pure Blue Color*) in 1921 to declare the end of the art of painting.[1] However, as we will see, Reinhardt's paintings did not represent the end of art; rather, they reflected his aesthetic ideals as presented in his short essay "Art as Art" (1962). He began his essay with the statement of four, related assertions that may be taken to be his axioms: "The one thing to say about art is that art is one thing. Art is art-as-art and everything else is everything else. Art-as-art is nothing but art. Art is not what is not art."[2] These sentences are not only self-evident truths but also tautologies: they are sentences that are formally true, and they remain true if the word "art" is replaced by "food" or "weather" or "religion." Yet they make the point that a work of art need not represent anything; it need not be interpreted or even be interpretable.

Reinhardt also provided a prescription for how an artist might create "art": "The one work for a fine artist, the one painting, is the painting of the one-size canvas—the single scheme, one formal device, one color–monochrome, one linear division in each direction, one symmetry, one texture, one free-hand brushing, one rhythm, one working everything into one dissolution and one indivisibility, each painting into one overall uniformity and non-regularity."[3] It is as if Reinhardt wanted us to understand that his interpretations of these requirements led him to produce his square paintings. If this is the case, then at least in the way he presented his ideas in "Art as Art," the most basic principle for Reinhardt was not any object or canvas but the tautologies (axioms) about the nature of art—or in the case of his black canvases, the art object. Reinhardt does not ascribe any meaning to his art. His paintings have nothing to do with representation; they simply conform to his axioms, his self-evident truths, about art.

A decade before Reinhardt wrote "Art as Art," the artist Robert Rauschenberg (1925–2008) exhibited two striking paintings at the Sable Gallery in New York. Each of these paintings was made up of several panels: one of seven tall canvases and the other of two wider panels. The most striking feature of these two paintings was not their significant sizes (the one made up of seven panels was 6 feet tall and 10½ feet wide) but their execution. All of the panels that composed these paintings had been painted the same monochrome white. The only break to the whiteness came from the small gaps where the white panels abutted. In May

1951, before he had begun painting his *White Paintings*, Rauschenberg had had an exhibition at the Betty Parsons Gallery in New York. Then in October 1951 he wrote Parsons announcing his *White Paintings* and requesting that she give him another show. Of his paintings he wrote: "They are large white (1 white as 1 GOD) canvases organized and selected with the experience of time and presented with the innocence of a virgin. . . . They are a natural response to the current pressures of the faithless." Although Rauschenberg alluded to mystical or religious reasons for his *White Paintings*, he also claimed: "They bear the contradictions that deserve them a place with other outstanding paintings and yet they are not Art because they take you to a place in painting art has not been. (Therefore it is.)"[4]

These two excerpts from Rauschenberg's letters to Parsons show that he had grandiose religious and artistic arguments for the value of his *White Paintings*. But what is important here is how abstractly conceived these white paintings were. These paintings, like Reinhardt's, do not have a basis in objects in the external world. Instead, they reflect the artist's "aesthetic unity," his conception of what art is or what art is about. These monochrome canvases are not something outside of the world of art—they are art.

According to the art historian Branden Joseph, the *White Paintings* "occupy a terminal point" in the development of monochrome canvases,[5] which can be traced back to one of Malevich's paintings, *White on White* (1918), a large white tilted square painted on a slightly larger square white canvas. But if Rauschenberg's *White Paintings* were the terminal point in this development, then what are we to make of Reinhardt's black canvases? On closer inspection we see that Reinhardt's paintings are not, as he had prescribed, "one color–monochrome" and they do not have "one linear division in each direction." Rather, they are subdivided by a grid of orthogonal horizontal and vertical lines into nine smaller squares that are painted with every so slightly different tints. For example, his *Abstract Painting* (1963) consists of a black square subdivided into nine smaller, equal-sized squares, which are painted in one of three shades of black (the four corner squares have a reddish tint, the three squares crossing the middle of the painting have a greenish tint, and the remaining two squares, in the middle of the top row and bottom row of the painting, have a bluish tint). The subtlety of the tints Reinhardt chose allowed him both to satisfy all of his constraints and to explore his creative impulses. It also means that his paintings began with an almost imperceptible structure—a notion central to the abstraction of mathematics I discuss below.

Abstract Numbers

The square is an expression of binary thought. . . . Binary
thought distinguishes between impulse and no impulse, between
one and nothing.

—Kasimir Malevich, in Anderson, *Malevich*

We saw earlier that Malevich took the square as one of the most fundamental elements, if not the fundamental element, of his art. From this singular object Malevich executed several paintings that each presented a single idea. Hilbert, on the other hand, was willing to let the most fundamental objects of his geometry—for example, a point or a line—remain undefined. Hilbert's axioms delineated some of the properties these objects must necessarily possess, but the axioms gave no indication as to what these objects were. If the properties of these objects happened to agree with the properties of our previously developed intuitions about geometric points and lines, that would be as much a coincidence as anything else.

Even mathematicians who were willing to accept Hilbert's formalist point of view—a view that maintains that mathematics is more or less the formal manipulation of symbols according to certain rules—sought to provide clear definitions for the basic objects of mathematics. To accomplish this they developed a unified framework within which it might be possible to provide unambiguous definitions for the objects mathematicians study. Of course, any attempt to clearly describe mathematical objects must allow for some forever-undefined objects (for example, in general geometry the notion of a point), but the number of such *primitive* objects should be kept as small as possible. One approach to this goal, and the one whose connection to some twentieth-century creative endeavors we explore in this chapter, is to base many of the objects of mathematics on the notion of a mathematical *set*.

A naive, but sufficient for our study, definition of a set is the following: A set is a collection of objects. The objects in the collection are called the elements of the set. The first requirement for a collection to be a set is that the rule defining the set—that is, the property the elements of the set must satisfy in order to belong to the set—must be unambiguous. If someone hands you a set and an object, you must be able to determine whether the object belongs to, or is in, the set. Such a set is said to be well defined, or properly defined. Among such sets are the collection of all dogs named Zoe born on November 18, 2004, the collection

of all even counting numbers, and the collection of all isosceles triangles. Examples of collections that would not be considered to be sets are the collection of the one hundred greatest composers, the collection of all interesting numbers, or the collection of all visually attractive rectangles. The rules defining whether objects (or persons) belong in these latter three collections are subject to interpretation; whether or not John Cage is one of the one hundred greatest composers is open to debate.

Here, let me give one example to illustrate how the notion of a set, combined with the use of an axiom (or axioms) putting constraints on the elements of the set, can provide a definition for the basic objects of study for mathematics. The definition of a circle in Euclid's *Elements* only implicitly depends on the notion of distance, so it is necessarily opaque.[6] If we allow for the explicit use of distance, then we can give a simple, set-theoretic definition of a circle, reminiscent of Euclid's third postulate in chapter 1. To do this we begin with a set that consists of all points in the Cartesian plane. This is an admittedly huge set, but its definition is clear, so the set may be accepted as being well defined. To define a circle in the plane we simply need to define a new set by adding a constraint on the elements of the set of points in the plane: A circle is a set of points in the plane that are the same distance from a fixed point in the plane.

What is important to take away from this admittedly elementary example is that it is possible to describe many of the basic objects of mathematics as sets with constraints on their elements. The elements of the set might be undefined or primitive concepts, such as geometric points, but the more sophisticated objects of the discipline can then be defined using them. The basic objects of geometry are sets of points, the basic objects of arithmetic are sets of numbers, and the basic objects of other disciplines are sets of that discipline's most basic entities.

Sets are even more fundamental to the modern conception of mathematics than the above discussion might indicate. They have provided a framework for resolving ancient paradoxes of infinity, allowed mathematicians to introduce very abstractly conceived mathematical notions, and revealed underlying, unifying mathematical principles. And one view of modern mathematics, promoted by Bertrand Russell (1872–1970) early in the twentieth century, is that not only can the basic objects of mathematics be seen as sets of elements with some sort of conditions imposed on the elements, but all of mathematics can be reduced to the study of sets using formal logic. However, the simplicity of this vision was shattered when it was realized that having a set be defined by an unambiguous

statement was not sufficient. For example, consider a set *S* defined to be the collection of all whole numbers that are not in *S*. The condition "is not in *S*" seems to be unambiguous; if we have *S* and a particular number, say 3, before us, we should be able to look in *S* and see if it contains 3. The problem is that if we find that 3 is in *S*, then 3 must satisfy the requirement for a number to be in *S*, so 3 cannot be in *S*.

There are two lessons to be drawn from this example. The first is that *S* should not properly be called a set, and the second is that the very concept of a set would have to be subtler than the one we proposed. Russell, and others, found a way to avoid such contradiction-inducing sets, a subject that would take us too far from our topic. Keeping in mind that disclaimer, sets (even as we naively defined them above) can be employed to illustrate some of the types of mathematical abstraction that have accelerated the development of increasingly sophisticated mathematical concepts. We begin not with any sort of complicated mathematical ideas but with the most basic—that of a counting number.

We might think that the numbers 1 or 2 or 3 need no definition, but their meanings are not any more obvious than is the meaning of Euclid's "point." According to Russell, the first and still most satisfying answer to the question What is a number? was given in 1884 by Gotlieb Frege (1848–1925) in his *Grundlagen der Arithmetik*.[7] For example, let's see how Frege defined the number 3. Consider the four sets whose elements we list below:

A: a, b, c
G: Δ, Γ, K
S: Florida, Texas, Virginia
P: Mercury, Venus, Earth

Frege maintains that these four sets have a property in common, and as Frege explained it, that property is precisely the number 3. There appears to be a bit of circularity in this definition of 3, in that 3 is the property shared by all sets containing a trio of elements, but this circularity disappears if you adopt the point of view that sets are the primitive, or most fundamental, objects of mathematics and that other objects are defined using them. The four sets listed above are assumed to exist, and the concept of 3 can be defined using them.

To directly define 3 using these sets we introduce a mathematical idea other than counting. This is the idea of a *one-to-one correspondence* between the elements of two sets. Before I describe this concept, let's look at a one-to-one correspondence between *A* and *G*:

A		G
a	\leftrightarrow	Δ
b	\leftrightarrow	Γ
c	\leftrightarrow	K

The arrows *are* the one-to-one correspondence, and their existence shows that every element in A is associated with one, and only one, element in G, and every element in G is associated with one, and only one, element in A. In the parlance of set theory, A and G have the same *cardinality*, and we can *see* this without counting when we *see* the one-to-one correspondence.

The above approach clearly allows us to define any of the counting numbers 1, 2, 3, and so forth; they are simply the cardinality of some finite sets. As for the definition of zero, it begins when we postulate the existence of a set that has no elements, the so-called *null set* (or *empty set*), which is denoted by the symbol Ø. The null set is like Malevich's black square as he described it in the quotation introducing this section: it is the most fundamental mathematical object that distinguishes between existence and nonexistence. Postulating the existence of an empty set in order to understand zero does not place emptiness at the center of mathematics, but once the existence of the null set has been accepted, Frege's highly abstract definition of number can be given a concrete manifestation.

The natural numbers are the numbers 0, 1, 2, and so forth, and in this formalism mathematicians let zero correspond to Ø. The question is how we get the next number, 1, from zero, and here comes the formalism: mathematicians let 1 correspond to the set {Ø}. This notation has confused many undergraduates, who do not understand how the set {Ø} differs from the empty set Ø. The following explanation often fails to enlighten them: Ø is a set that does not contain anything, and {Ø} is a set that contains one thing, namely, the empty set. The confusion, I think, comes from identifying the empty set with nothing. It is not nothing. It is a set without any elements, but it is something. And we have already seen two analogues of this. In literature, *Suburbia*, discussed in the preceding chapter, is a novel without any text. In art, we have Rauschenberg's *White Paintings*. However, Rauschenberg wrote, "A canvas is never empty,"[8] which I would like to reinterpret as saying that a monochrome white painting is a painting. Although it has no content and its only form is that of the canvas, it is a work of art. Similarly, the empty set, the set containing nothing, is a mathematical object.

If we grant that {Ø} may be thought of as corresponding to 1, then 2 will correspond to the set {Ø, {Ø}}, which is a set containing two elements: the empty set and the set containing the empty set. Continuing in this way, 3 would corre-

spond to the set {∅, {∅}, {∅, {∅}}}, which is a set containing three elements: ∅, {∅}, and {∅, {∅}}. This correspondence between the counting numbers and sets built up from the empty set allows us to give a concrete meaning to each counting number, rather than relying on Frege's abstraction that each counting number is the property shared by different sets. It is not just that the set {∅, {∅}, {∅, {∅}}} *corresponds* to 3; this set *is* 3. And any other set whose elements can be put into a one-to-one correspondence with the elements of {∅, {∅}, {∅, {∅}}} has three elements, so that set's cardinality is 3.

To appreciate how mid-twentieth-century mathematicians used the abstract notion of a set to attempt to provide a unified framework within which to examine mathematical concepts, I need to introduce a new idea—one that had been central to the arts, especially poetry and music, for at least two millennia. Instead of looking at an earlier era, though, we'll look at what can only be called an avant-garde musical performance from the middle of the twentieth century.

Structure

> Structure becomes a sort of empty-silent-box, allowing for any
> kind of sounds to appear. But that very appearance is now
> conditioned by the presence of silence: sound emerges from
> silence and goes back to it.
> —Eric De Visscher, "There is no such thing as silence . . ." (1991)

On August 29, 1952, the pianist David Tutor performed a musical analogue to *Suburbia* or the *White Paintings*, a new composition by the American composer John Cage (1912–92). Accounts of the performance describe how Tutor entered the stage with Cage's handwritten score in hand, sat at the piano, placed the score in its proper place, and consulted a stopwatch. Tutor then lowered the keyboard cover of the piano. Thirty seconds later he raised the cover and lowered it again. Two minutes and twenty-three seconds later he again raised and lowered the keyboard cover. Finally, one minute and forty seconds later he again raised the cover. That was it—the world premier of Cage's three-movement, entirely silent composition *4'33"* (*Four Minutes and Thirty-Three Seconds*).

Before I discuss how Cage's piece can help us appreciate one of the more significant mathematical ideas put forth in the twentieth century, let's compare it with Fournel's *Suburbia*. Each of these pieces has an external form, which we will call its external structure. *Suburbia* obtains its external structure from being written on separate pages; *4'33"* gets its external structure from its three movements.

Neither the blank pages of *Suburbia* (ignoring the footnotes) nor the silent movements of *4′33″* seem to have any internal structure. There is nothing on any of the blank pages or in any of the three movements to differentiate one place from another. Yet in 1960 Cage described how each movement of *4′33″* was "built up . . . by means of short silences put together," which seems like a strange thing to say about three undifferentiated periods of silence. Indeed, Cage confessed that his description of how he composed the movements might seem "idiotic," but he maintained that that indeed was how he composed the piece.[9]

To see how Cage might have composed *4′33″* it is important to know that whereas traditional Western music is based on pitch and harmony, Cage based his theory of music on the more elemental notion of duration. So a representation of a piece emphasizing duration might look like the first three lines of Man Ray's 1924 poem "Untitled":

[10]

The length of each dash corresponds to the relative duration of the notes in the composition, and the notes are separated by silences of different lengths (so the spaces between the dashes would be of different lengths corresponding to the durations of the silences).

Cage could have composed each movement of *4′33″* by first deciding on the duration of the successive notes and the silences between them, putting an internal structure in place, and then allowing silence to occupy each of these durations. He could just as well have placed sounds in some of these durations, perhaps yielding a more traditional piece. But either way, the result would be a three-movement musical composition where each of the movements has an internal structure.[11]

Mathematical Structure

The quotation above from the contemporary composer and scholar Eric De Visscher concerns Cage's conception of his piece *4′33″*, but it is also close to the notion of *mathematical structure* that emerged in the middle of the twentieth century. This conception of mathematics is due to Nicolas Bourbaki—who was not a person but a pseudonym adopted by a group of mathematicians who, both individually and collectively, were among the most influential mathematicians of the century. Bourbaki sought to give all of mathematics a uniform formulation. Their goal was to explicate the essential ideas that underlie mathematics by discerning the common features among seemingly disparate objects. The unifying concept

that Bourbaki settled on was that of a mathematical *structure*. Each of these structures, one of which I describe below, is to be thought of as being intrinsic to the object. It is a "sort of empty . . . box" that lends the object certain properties.

In an expository article "The Architecture of Mathematics," Bourbaki admits there are many, many different sorts of mathematical structures. Indeed, it would be possible to provide "a *hierarchy of structure*, going from the simple to the complex, from the general to the particular." But at the "center" of this hierarchy there would be three types of "mother-structures."[12] For Bourbaki these three structures are dependent on three different notions—one that it is possible to compare two entities, one that it is possible to combine two entities to obtain a third of the same type, and one on the ideas of closeness and continuity. Bourbaki calls these, respectively, order structure, algebraic structure, and topological structure. Each of these structures plays a role in our examination of mathematical concepts in twentieth-century literature. In later chapters we will return to order and topological structures; here, I describe a single algebraic structure in order to see how it reflects the way De Visscher described Cage's structure for *4′33″* and to illustrate another sort of abstraction that has guided modern mathematics.

An Abstract Algebraic Structure

High school algebra is thought mostly to concern solving equations, but on a more basic level algebra deals with the basic operations of addition and multiplication. All we need in order to have an algebraic structure is to have a way of combining two entities to obtain a third. Any set of objects, together with a way to combine two elements of the set to obtain another element of the set, is an example of a set with an algebraic structure. For example, the set of all fractions, rational numbers, together with multiplication is a set with an *algebraic structure*.

But this example of an algebraic structure does not really reveal anything new to us. In order to give the flavor of what an algebraic structure is in Bourbaki's sense, we need to consider a more abstract example, known as a *group*. Suppose we have four symbols—we will use the letters a, b, c, and d—and a way to combine them, an operation we denote by \wedge. And suppose we know that when we combine the symbols a, b, c, and d using \wedge we have the following results:

$$
\begin{array}{llll}
a \wedge a = a & a \wedge b = b & a \wedge c = c & a \wedge d = d \\
b \wedge a = b & b \wedge b = c & b \wedge c = d & b \wedge d = a \\
c \wedge a = c & c \wedge b = d & c \wedge c = a & c \wedge d = b \\
d \wedge a = d & d \wedge b = a & d \wedge c = b & d \wedge d = c.
\end{array}
$$

This array of equations *is* the structure; it is our empty box. It does not matter what the symbols *a*, *b*, *c*, or *d* stand for; they are simply positions in the empty box. There are many ways to fill this box with more concrete mathematical objects so that the structure, our combining table above, is still valid, as we can see with two examples.

For our first example we introduce the symbol *i* to represent a mathematical entity having the property that $i \times i = -1$. (We will see why it is reasonable to consider *i* to be a number in chapter 8.) For this example we consider the four *numbers* 1, *i*, −1, and −*i* and use the usual multiplication, taking into account that $i \times i = -1$ and that for any numbers r and *s*, $r \times (-s) = -(r \times s)$. If we then fill our empty structure as follows;

$$1 \to a \qquad i \to b \qquad -1 \to c \qquad -i \to d,$$

and replace the operation ∧ with ×, then we will obtain the same array of equations as above with each of the symbols *a*, *b*, *c*, and *d* replaced, respectively, by 1, *i*, −1, and −*i*. So we have learned that our original algebraic structure is the same one given by multiplication of the numbers 1, *i*, −1, and −*i*.

For our second example we consider the numbers 0, 1, 2, and 3 with a new way to combine them, denoted by \oplus_4. The operation \oplus_4 is simple to explain. If you want to calculate something like $2 \oplus_4 3$ you apply the following procedure: you first add 2 and 3, $2 + 3 = 5$, then you divide 5 by 4 to determine its remainder, which equals 1. Then $2 \oplus_4 3 = 1$. Similarly, $3 \oplus_4 3 = 2$, because the remainder of $3 + 3 = 6$ when divided by 4 is 2; and $1 \oplus_4 2 = 3$, because the remainder of $1 + 2 = 3$ when divided by 4 is 3.

We now fill the empty box above by using the replacements

$$0 \to a \qquad 1 \to b \qquad 2 \to c \qquad 3 \to d,$$

and replacing the operation ∧ with \oplus_4. As in our example above, the array of equations for how to combine 0, 1, 2, and 3 using the operation \oplus_4 will look exactly like our original array, except that *a*, *b*, *c*, and *d* are replaced, respectively, by 0, 1, 2, and 3.

From this one example of an algebraic structure we can see that having an abstract structure that can be filled with different sorts of mathematical elements and operations (in this case 1, *i*, −1, and −*i* with the operation × and 0, 1, 2, and 3 with the operation \oplus_4) tells us that these two systems have some structural equivalencies. So, although they involve different symbols, these systems are manifestations of the same mathematical group. In more sophisticated situations, this ex-

ample is really too simple to reveal much; discovering that two mathematical systems have the same underlying structures can provide insights into one or both of the systems.

An Algebraic Structure and Narratives

A *semigroup* is a weaker algebraic structure than a group, meaning it is less restrictive in a sense that I will now explain. In the discussion of a group structure I did not give a formal definition of a group, but it is possible to check that in each of the examples above there was an *identity element* (an element that when combined with any [other] element leaves that [other] element unchanged), each element has an *inverse* (an element that when combined with the original element yields the identity element), and an operation with the property that it is *associative*. This last property allows us to combine three elements, even though the operation in a group only tells us how to combine two elements at a time. For example, suppose we want to calculate

$$a \wedge b \wedge c.$$

Since we only know how to combine two elements at a time, we can calculate it as

$$(a \wedge b) \wedge c,$$

meaning we first calculate $(a \wedge b)$, then combine this result with c. Or we can calculate $a \wedge b \wedge c$ as

$$a \wedge (b \wedge c),$$

meaning we calculate $(b \wedge c)$ and then combine it with a. The associativity of the operation in the groups tells us that we must get the same result whichever of these approaches we take. In other words,

$$(a \wedge b) \wedge c = a \wedge (b \wedge c).$$

A collection of objects together with an operation for combining any two elements in the set is a *semigroup* if the only thing we assume about the objects and operation is that the operation be associative.

In a short article, "The Relation X Takes Y for Z" (1972),[13] Queneau describes how the semigroup structure can provide a model of how characters in a narrative understand, or misunderstand, who the other characters in the narrative are. For example, suppose in a certain story there are three characters—David, Steve, and

Mike—and David mistakes Steve as Mike. Then Queneau proclaims the existence of a operation, which we denote by ∧, so that

$$David \wedge Steve = Mike.$$

So, for a straightforward story where three characters, *a*, *b*, and *c*, correctly understand who the others are, we would have the model

$$a \wedge a = a \qquad a \wedge b = b \qquad a \wedge c = c$$
$$b \wedge a = a \qquad b \wedge b = b \qquad b \wedge c = c$$
$$c \wedge a = a \qquad c \wedge b = b \qquad c \wedge c = c.$$

Notice that $a \wedge a = a$, $b \wedge b = b$, and $c \wedge c = c$ mean that each of the characters fully understand who they themselves are.

Queneau suggested that the "Vaudeville Situation" would be provided by the semigroup structure

$$a \wedge a = a \qquad a \wedge b = c \qquad a \wedge c = b$$
$$b \wedge a = c \qquad b \wedge b = b \qquad b \wedge c = a$$
$$c \wedge a = b \qquad c \wedge b = a \qquad c \wedge c = c.$$

This table tells us that in the story everyone understands who they are, but they are confusing the other two characters. For example, *a* believes *b* is *c* and believes *c* is *b*.

A diligent reader could check that in each of the above arrays the operation is associative, so the elements *a*, *b*, and *c*, together with the operation ∧, form a semigroup. There are 24 different semigroup structures that may be imposed on three elements, so there could be 24 narratives involving the three characters David, Steve, and Mike where there are unique misunderstandings. In his article Queneau suggested some author might want to "find concrete situations" corresponding to two of these. It does not seem that anyone has taken up his challenge.

Queneau's choice of the semigroup structure rather than the group structure to model these narratives indicates a degree of mathematical insight. Because each element in a group has an inverse element, if *a*, *b*, and *c* are different elements of a group, say with an operation ∗, it is not possible to have all of the possible combinations of misunderstandings Queneau proposed. We can see this by considering the possibility that both *a* and *b* understand that *c* is *c*; symbolically, $a * c = c$ and $b * c = c$. It follows that $a * c = b * c$. Since *c* has an inverse element, it can be cancelled from these two equations, allowing for the conclusion that $a = b$, so *a* and *b* are the same characters. Indeed, while there are 24 different semigroup structures containing three elements, there is only one such group structure.

LOOKING AHEAD

In a later chapter we will see that this last point—finding a common underlying structure, in this case among texts—was imagined to be an important type of literary analysis late in the twentieth century. We will not investigate whether identifying common narrative structures among different narrations is useful for comparing texts, but we will see that it is possible to find underlying geometric structures for some texts, and that these geometric models do lend interesting insights that it might be difficult to glean from a casual reading of the text. But before I discuss these ideas, we look at a single mathematical surface that inspired some twentieth-century artists and writers.

Literature, the Möbius Strip, and Infinite Numbers

Concrete Art

> It is by means of concrete painting and sculpture that . . . abstract ideas which previously existed only in the mind are made visible in a concrete form.
>
> —Max Bill (1936/1948), quoted in Huttinger, *Max Bill*

In December 1929 a group of artists held an exhibition in Amsterdam billed as the Select Exhibition of Contemporary Art and proclaimed themselves to be the initiators of a new art movement, which they called *Art Concret*. In April of the following year most of the artists from the exhibition published the first, and only, issue of the *Art Concret* journal, in which they offered a manifesto proclaiming their conception of art. I quote from this declaration at length because there are several things in it that are relevant to our themes:

We declare:

1. Art is universal.
2. The work of art must be entirely conceived and formed by the mind before its execution. It must receive nothing from nature's given forms, or from sensuality, or sentimentality. We wish to exclude lyricism, dramaticism, symbolism etc.
3. The picture must be entirely constructed from purely plastic elements, that is, planes and colors. A pictorial element has no other meaning than "itself" and thus the picture has no other meaning than "itself."
4. The construction of the picture, as well as its elements, must be simple and visually controllable.
5. The technique must be mechanical, that is, exact, anti-impressionistic.
6. Effort for absolute clarity.[1]

To see how some of these concepts can be realized in a painting, let's look at a painting by one of the driving forces behind both the exhibition and the journal, the Dutch artist Theo van Doesburg (1883–1931), best known for having been one of the founding members of the *De Stijl* movement in 1917. The month following the exhibition, van Doesburg wrote to one of his former *De Stijl* colleagues, Anthony Kok: "My latest canvas, on which I have worked for a long time, is in black, white, and grey: a structure that can be controlled, a *definite* surface without chance elements or individual caprice." After admitting that such a painting might be lacking in feeling, van Doesburg continued by saying that this painting was not "lacking in spirit, not lacking the universal and not . . . empty as there is *everything* which fits the internal rhythm."[2]

The painting van Doesburg was writing about was his *Arithmetic Composition* (1929–30), shown in plate 4.1. It is quite easy to see how this painting adheres to some of what I will call the *axioms* of the Art Concret manifesto. In particular, it does not contain any of "nature's given forms" (axiom 2), it is constructed "from purely plastic elements . . . planes and colors" (axiom 3), the painting's elements are "simple and visually controllable" (axiom 4), and the technique used was "mechanical, that is, exact, anti-impressionistic" (axiom 5). But it is not so easy to see how each of this painting's pictorial elements "has no other meaning than 'itself'" (as required by axiom 3). Note that, at least for this painting, van Doesburg's interpretation of these axioms led him to use only the colors white, grey, and black.

The contemporary art theorist Gladys Fabre wrote that there is more to this painting than "the progression and diminution of four diagonally aligned black squares." She notes that there are two progressions at work in this canvas: the striking black squares but also the alternating white and grey backgrounds, which also diminish in size. According to Fabre, the effect of these two progressions is that the eye is first drawn from the large black square, in the lower right corner, up to the small black square, in the upper left corner. Then "the eye is turned back by the small grey square" and drawn back to the lower right corner.[3] Although I have just described these two progressions in sequence, they are happening simultaneously— reflecting van Doesburg's interest in both simultaneity and space-time, two ideas from physics that had influenced his artistic thinking in the mid- to late 1920s.

By September 1930 van Doesburg seems to have changed his mind about the role a progression of geometric forms should play in a painting. As Fabre explained it, when van Doesburg painted *Arithmetic Composition*, he viewed such a progression as representing movement or even simultaneity, but he turned to the idea that a painting should be static. In his diary he wrote, "If painting has a

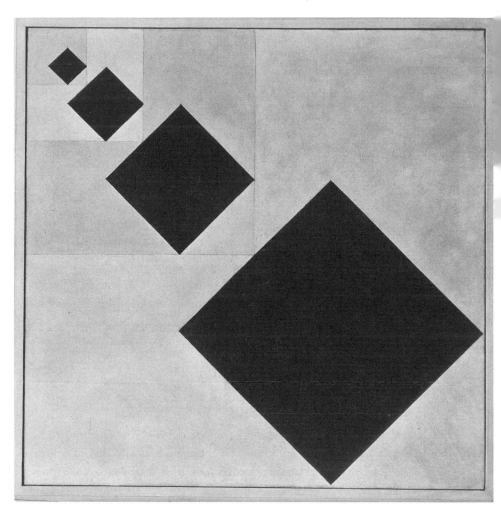

Plate 4.1. Theo van Doesburg, *Arithmetic Composition*, 1929–30. Felix Witzinger, Switzerland / The Bridgeman Art Library.

raison d'être, it is thanks to its stability"; to this he later added: "The dynamism of the past is replaced by a constant—a fixed set of relationships, a perfect equilibrium between action and rest."[4] According to Fabre, when van Doesburg wrote this, he was rejecting progressions of mathematical forms and the exclusive use of black, white, and grey. His new thinking manifested itself in his painting *Simultaneous Counter-Composition* (October 1930), which contained four large tilted squares (painted monochrome yellow, red, blue, and black) over which two diagonal, perpendicular black lines were painted. This change in van Doesburg's

thinking, and this painting, signaled the end of the short-lived Art Concret movement. However, several ideas from the manifesto and the movement survived.

Evidence for this last claim can be found in 1936, just a few years later, when the sculptor Max Bill (1908–94) wrote in the quotation that heads this chapter that the goal of concrete art was to make *visible* abstract ideas. This, of course, differs from the artistic goals of André Breton that we examined in chapter 1, as can easily be seen by comparing the nature of the objects that concrete art and Breton's brand of surrealism sought to represent. An artist adhering to the principles of concrete art seeks to represent abstract ideas—the sort of ideas one might consciously consider. On the other hand, a surrealist seeks to represent dream objects—objects from unconscious thought.

Throughout his productive and multifaceted artistic career Bill returned again and again to a special geometric shape to provide concrete manifestations of abstract ideas. In his book *Surfaces* (1972) Bill explains that in 1935 an architect had asked him to design a sculptural piece to hang over a proposed electric fireplace—the idea being that the sculpture would distract anyone from noticing the artificiality of the flameless device. Bill came up with the idea for a twisted strip of metal that would hang over the fireplace and slowly turn in the rising heat. With any luck, or in the right light, the twisted piece of metal would "through its form and movement act as a substitute for the [missing] flames."[5]

Bill was quite pleased with the shape he had discovered and its proposed usage (which was rejected by the architect), but he soon learned that he had rediscovered a shape that was widely known to mathematicians as the Möbius strip. The Möbius strip is named for the nineteenth-century mathematician August Ferdinand Möbius (1790–1868), who discussed it in a research paper. This mathematical surface is not given by an algebraic equation, like many of the surfaces Man Ray photographed in Paris in the 1930s. Rather, it is given by an easily explained geometric construction.

This construction begins with a long rectangle. It is easiest to demonstrate with a flexible material such as paper. Suppose you take a rectangular piece of paper and bend it without twisting it, so that the two shorter edges are touching. If you then glue the two shorter edges together, you will obtain a surface that looks like a bracelet. Or if you gently bend the long rectangular strip, again without twisting it, so that the two long edges are touching, you will have obtained a long tube or cylinder.

Neither of these two constructions is novel; their outcomes can easily be visualized without actually cutting a rectangle out of paper and gluing its edges together. But the construction of the Möbius strip from this same paper rectangle,

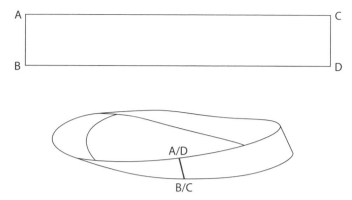

Figure 4.1. Construction of the Möbius strip.

though easily carried out, is less easily visualized. Once again we begin with the long rectangle, this time with its corners labeled as in figure 4.1. We begin by picking up the rectangle and carefully twisting it so that corners A and B remain in their same positions but the positions of corners C and D are reversed. Next, being careful to not twist the paper again, we bend it so that the two shorter edges meet, with the corners A and D touching and the corners B and C touching. Gluing the paper into this position yields the Möbius strip that Max Bill had rediscovered.

The sculpture that emerged from Bill's proposed mathematical flames, which he called an *endless ribbon* for reasons we will explore below, went through a series of modifications before finally being cast in bronze in 1953.[6] Bill used the adjective "endless" in the titles of several of his Möbius strip–based sculptures and not just because the Möbius strip has the property of a loop or circle—if you start to move along it, you will eventually return to the same place. The Möbius strip has a subtler sort of circularity that can be understood through a simple thought experiment.

Imagine moving along the edge of the Möbius strip beginning at point A and moving toward point C, so along what was the top edge of the unglued rectangle. Since C and B have been attached, as you pass through C you will also pass through point B, and you will then be moving along what had been the bottom edge of the unglued rectangle, from B towards D; when you arrive at D, which has been attached to A, you will have arrived back at your starting point. This means that the Möbius strip has only one edge! If you start at any point on the edge, and then move along the edge, you will traverse both of what had been the top and bottom edges of the unglued rectangle before returning to your starting

point. A similar thought experiment reveals that the Möbius strip has only one
side.

The Möbius Strip and Literature

> The track I'm running on
> Won't be the same when I turn back
> It's useless to follow it straight
> I'll return to another place
> —Robert Desnos, "Möbius Strip" (1928)

It is reasonable that sculptors might incorporate such an elegant geometric object
as the Möbius strip in their work; what might be surprising to learn is that both
writers and literary analysts have appealed to the Möbius strip, and related forms,
to either create or understand narratives. Probably the best-known application of
the Möbius strip to the content of fiction is the short story "Frame-Tale" (1963)
by American writer John Barth.[7] The text of this story consists of only two pages,
the front and back of a single sheet of paper, and very few words. The first page
contains the story's title; directions to the reader, "Cut on dotted line / Twist end
once and fasten / AB to ab, CD to cd"; a single parenthetical word, "(continued),"
printed near the bottom of the page; and a familiar phrase, "ONCE UPON A TIME
THERE," printed vertically, top to bottom, on the page's right margin (which is
separated from the rest of the page by the dotted line that is to be cut). On the
second page the left margin has the phrase "WAS A STORY THAT BEGAN" printed
vertically, top to bottom, again separated from the rest of the page by a dotted
line, and the word "(continued)" is again printed near the bottom of the page.

If the reader follows Barth's instructions, the resulting twisted piece of paper
is a Möbius strip. The story that is printed on the strip now reads, "ONCE UPON
A TIME THERE WAS A STORY THAT BEGAN ONCE UPON A TIME THERE WAS A
STORY THAT BEGAN. . . ." Barth's "Frame-Tale" is an endlessly repeating, self-
referential story. Part of the genius of this two-page-long story owes to its title. A
frame-tale is a story told within a story; this story offers an unending number of
stories within stories.

Arguably, Barth's "Frame-Tale" is simply an endlessly repeating story, so it is
circular and could have been modeled on a circle rather than on the Möbius strip.
However, "Frame-Tale" is the first story in Barth's collection *Lost in the Funhouse*,
and in an interview in 1984 Barth explained that this collection was not simply a
"miscellany" of short stories. Rather, the entire collection is a series; and in each

story, "as the apparent narrator . . . goes through his biographical development, the time of the stories tends to move back from the present into the mythic past." So, within each story there is a circling back, as Barth puts it, "with a twist to it." Barth's description can be reworded to make his appeal to the Möbius strip not only explicit in "Frame-Tale" but implicit in the other stories: in each story as the narrative moves forward, it returns back but is changed—twisted.[8]

In order to appreciate Barth's use of the word "twisted," we must look more closely at the Möbius strip, both in its mathematical conception and its three-dimensional physical model. The mathematical description of the Möbius strip begins with a two-dimensional rectangle, which has no thickness and so no "front" or "back," and identifies the ends in such a way as to obtain a two-dimensional object that can be realized only in three-dimensional space. The mathematically significant property of the Möbius strip is that it is a *non-orientable* surface. For an understanding of this concept, it is best to cheat a bit and assume that the original rectangle has an infinitesimal thickness—say, one formed by two parallel, transparent planes. Then, we can imagine a thin object moving *along* the surface, wedged between these two transparent surfaces. The non-orientability property of the Möbius strip is that when an object sliding along the surface returns to its original position between the two sheets of glass, it will have been reversed (it will look like the mirror image of itself). This reversal is Barth's "twisted."

We need to compare this mathematically ideal Möbius strip with a material three-dimensional one, such as would be produced by a reader following Barth's instructions in "Frame-Tale." As we have seen, to make such a model you begin with a rectangular piece of some sort of highly flexible material. This rectangle is itself three-dimensional because it has a length, width, and slight thickness, so it has a front and back. Before you construct the Möbius strip, imagine painting a blue dot on the front of the rectangle and a red dot on the back of the rectangle, directly behind the blue dot. Next, you twist the rectangular shape and fasten the ends together to make the Möbius strip. This object is one-sided in the sense that it is possible to move from the blue dot to the red dot simply by moving along the surface of the object. Although it is one-sided, at each point on the surface there is a corresponding point on the other "side" of the surface (for example the blue and red dots are opposite each other). The reason I introduced the idea of adding the blue and red dots is that it will help us understand both the mathematical Möbius strip and how writers have used it.

In the mathematical model, if an object moves along the surface from the blue dot to the red dot, it will have returned to its original position (albeit with a

reversed image, as we learned in our earlier discussion) because the rectangle has no thickness and so no front or back. In the physical model, if an object moves along the surface from the blue dot to the red dot, it will be behind the blue dot because the object is one-sided. At the risk of repeating what I have already said, this is because the physical model of the Möbius strip has a thickness, while the mathematical model does not. So, when an object is moving along this physical model of the strip, there is always the other side; no matter where you paint a blue dot, you can paint a corresponding red dot opposite the blue one.

Two writers who have more clearly exploited the ideal, mathematically correct version of the Möbius strip than Barth were Robert Desnos, the member of Breton's surrealist group who was so admired for his use of automatism, and the contemporary writer Albert Wachtel. The first four lines of Desnos's poem "Möbius Strip," which introduced this section, illustrate this point. Desnos's description of going straight and returning implies only some sort of circular path, but the "return to another place" tells the reader that something will be different. Judging from the title of the poem, we can infer that what will have changed is not the place but the poem's narrator's perception of the place. The narrator will have changed, like the orientation of the object sliding along the surface of the Möbius strip.

This same idea plays a central role in Wachtel's story "Ham" (1996).[9] In order for you to appreciate Wachtel's multiple uses of the Möbius strip in "Ham," it is helpful to know the plot of the story and also how it unfolds, or rather folds, in the text. The plot is straightforward: A Jewish mathematician (Neil) travels to Munich, Germany, to give a lecture, and a German mathematician (Klara) picks him up at the airport. On the drive into town Neil asks Klara if he can visit a synagogue, as he will be busy for the next few days and this will be his only opportunity to worship. He attends a brief service while Klara waits for him in the car. The next morning Neil gives a provocative lecture about a well-known result concerning mathematical infinity, which I discuss later in this chapter. After the lecture Neil and Klara go for a short walk, and then Klara drives Neil to visit the concentration camp at Dachau. On the way to the camp they stop for lunch. Then, while they are at the camp, there is some sort of incident involving protestors. The above description seems to be the chronology of the events that underlie the story, but let's see how they unfold in the narration.

The text opens with Neil being driven to visit the concentration camp after his talk. On the way to Dachau, Neil and Klara stop at a cafe for lunch. When they arrive at the camp, they have a brief conversation that includes several phrases

that recur later with slight but meaningful differences. The text then flashes back to Neil's lecture, earlier in the day. And then the narrative flashes back to Klara's meeting Neil at the airport, his visit to the synagogue, his lecture (followed by a discussion), and their walk, lunch, and visit to Dachau.

Wachtel's brief description of the walk Neil and Klara take after his lecture provides the key to understanding many of the shifts that occur in the text: "Past a fountain that at once bubbled up and sprayed . . . up and down corridors and stairs, they followed a Möbius band of indirection on a course that ended opposite itself." Their conversation during this walk changes Neil's perception of some of the things Klara says when they are visiting Dachau. Earlier in the text (though later in the story's actual chronology) she had said that during the war, her mother had said of the neighbors taken to the camp, "Too bad they are Jews." Klara continued: "And she was consoled. It is difficult to accept now, but can Mother be wrong? *Gypsy, Jew, polio.* They were all incurable." Then she said:

> "The mind is malleable, Neil. To us it seems monstrous, but it was reasonable then."
> "You've got your *seems* and *was* reversed."
> "This is the terrible point. Our truths were damaged, not our reasoning. Murder was virtue, Jesus Aryan, and we reasoned from there."

In the second version of their conversation, while they are at the camp, Klara says: "Sister remembers Mama saying, as they led her Jewish friends away, 'Too bad they are Jews.' Pneumonia, polio, Jews. . . . To us it seems monstrous, but we reasoned from there." It is not possible to reconcile these two reports of the same conversation. They take place at the same place, at the same time, but their orientations are slightly different. It is as if Neil and Klara had arrived at the same point on a Möbius strip, first along one path, then along another: one at the beginning of the text and the other after they had taken their walk outside Klara's office.

Wachtel also uses the physical model of the Möbius strip. For example, it helps us understand how Neil has transferred his hatred of what the Nazis did to the Jews to a distrust of all Germans, and it explains some of Klara's words and her curious style of driving, using the brake and accelerator simultaneously. But some writers have appealed solely to the physical model, where every point on the Möbius strip has an associated point behind it. One contemporary writer who did this is Gabriel Josipovici. Each page of his short story "Mobius the Stripper" (1974) is divided into an upper and lower half by a horizontal line.[10] The horizontal lines are there to separate the story written on the successive top halves of the

pages from the story written on the successive bottom halves of the pages. The top story, told in the third person, is about a large man, Mobius, who works as a stripper; the bottom story, told in the first person, is about a writer struggling to overcome writer's block.

In the top story we learn that Mobius lives alone in a London flat and rarely leaves except to go to work. For Mobius, stripping is not sexual ("seshual" in his unspecified accent) but "metaphysical." Indeed, while the other, exclusively female, strippers at the club disrobe to music, Mobius uses no music in his act: he talks to the audience while stripping, explaining that by disrobing he is seeking to find the truth. When Mobius is alone in his apartment, he sleeps, eats bananas (and only bananas), and listens to voices. What he hears in these voices are snippets of conversations about him—someone describing when they first saw or heard about Mobius, or someone telling someone else how interesting Mobius's act is.

The bottom story opens with a line Mobius had heard from one of the voices—the narrator tells us, "I first heard of Mobius the stripper from a girl." In this story the narrator's girlfriend is trying to convince him to go with her to one of Mobius's performances. The narrator, the writer who is struggling to write, tells her to go alone; he wants to stay and write (or try to write). Throughout their argument the girlfriend both criticizes the writer for secluding himself from life and extols the effect Mobius has on the large audiences at his shows. In the end, the writer goes for a brief walk in the park; when he returns to the apartment, the woman has left, and he sits down and begins to write.

The reader is led to believe, mostly from the title of Josipovici's story, that the writer in the bottom story is about to write the top story. Another hint that the writer is about to write Mobius's story comes from what the writer had seen in the park. In the top story we read that Mobius would occasionally "stroll down to the park . . . protected by his big coat and Russian fur hat." While in the park, waiting for his girlfriend to leave the apartment, the writer had seen a "fat man with one of those Russian fur hats." Since the writer begins to write the top story at the end of the bottom story, the text has an overall cyclic nature—following the bottom story we are naturally led to read the top story. Yet Josipovici exploits the property of the physical model of the Möbius strip that opposite any point on the strip there is a point on the reverse side; if you think of the top and bottom stories as both occurring on a physical model of a Möbius strip, the dialogue spoken in the bottom story bleeds through to Mobius in the top story. This also offers us another way to think of the appearance of the man wearing the Russian fur hat in the park in the bottom story; it is not that this image inspired the writer to use it in the top story but that the two stories are interacting.

Concrete Mathematics and Infinite Numbers

> Most numbers are infinite, and if a number is infinite you may
> add ones to it as long as you like without disturbing it in the least.
> —Bertrand Russell, "Recent Work on the
> Principles of Mathematics" (1901)

In the next chapter we look at how a surface related to a higher-dimensional ana-
logue of the Möbius strip has been used to model a challenging narrative. Before I
take up that topic, I would like to explore another mathematical topic which plays
an important role in Wachtel's "Ham" and which led Bertrand Russell (1872–
1970) to assert, in the quotation above, that there are infinite numbers and that
"you may add ones" to an infinite number "as long as you like without disturbing
it in the least." To explore this topic, I must digress and discuss the work of the
mathematician Georg Cantor (1845–1916) on mathematical infinity.

Cantor is credited with introducing the idea into mathematics of comparing
the sizes of two infinite collections by inquiring whether there can be a one-to-one
correspondence between their elements—the very idea Frege employed to define
the counting numbers 1, 2, 3, and so forth, each of which is simply the cardinality
of some finite set. What is less clear—and this is one of Cantor's greatest mathe-
matical achievements—is that the notion of a one-to-one correspondence can be
used both to give a sensible answer to the question of what it means for a set to be
infinite and to compare the relative sizes of infinite sets. Equally as significant,
this idea also permits us to define *infinite numbers*.

We would like to simply assert that a set is infinite if its elements cannot be
put into a one-to-one correspondence with any set whose cardinality equals
one of the counting numbers. But in using this idea to show that a set is infinite, one
could be forced to show that the elements of the set cannot be put into a one-to-
one correspondence with any of the unlimited number of sets, $\{\emptyset\}$, $\{\emptyset, \{\emptyset\}\}$, $\{\emptyset, \{\emptyset\}, \{\emptyset, \{\emptyset\}\}\}$, and so forth. Instead, it would be easier to discuss infinite sets if
we had a positive formulation for the definition of an infinite set. Cantor gave
such a definition, and that definition seems to depend on a paradox.

We first look at two sets:

W:	1	2	3	4	5	and so forth
S:	1	4	9	16	25	and so forth.

The set W consists of all of the counting numbers, and S consists of all of the
counting numbers squared. Since every number in S is also contained in W, it is

easy to understand that S is contained in W but not equal to W (S is a *proper subset* of W). So we have two sets, one of which is contained in the other. However, you can see from the way I have lined them up that there is a one-to-one correspondence between the elements in W and the elements in S (each element in the top row corresponds to the element below it in the bottom row, and each element in the bottom row corresponds to the element above it in the top row). Symbolically, if n is a counting number, then $n \leftrightarrow n^2$. If we try to describe this situation in ordinary language, it seems that one of these sets must be larger than the other. Cantor took the existence of this one-to-one correspondence to mean that W is infinite: a set is infinite if there is a one-to-one correspondence between the elements of the set and the elements of a proper subset. But (and this is where Cantor used the notion of a one-to-one correspondence most fruitfully) since this one-to-one correspondence exists, neither set can be larger than the other, so they have the same cardinality.

Cantor also showed that there is a one-to-one correspondence between each of W and S and the seemingly much larger set

Q: **the collection of all positive fractions (i.e., all positive rational numbers).**

This last result is much more striking than the conclusion that the set of all counting numbers and the elements of the set of all squares of counting numbers can be put into a one-to-one correspondence. Each of W and S is a collection of discrete counting numbers, so it seems plausible that there might be some way to pair up the elements, as I did explicitly above. However, the set of all positive fractions is much less easily visualized. For example, this set contains each of the counting numbers because each may be expressed as a fraction. Indeed, each may be expressed as a fraction in an unlimited number of ways:

$$1 = 1/1 = 2/2 = 3/3 = \ldots$$
$$2 = 2/1 = 4/2 = 6/3 = \ldots$$

Our visualization of the set of all positive fractions, Q, is further challenged by the observation that between any two fractions there are an endless number of other fractions (like the points on a line in Hilbert's axioms for geometry). To see why this is true, consider the two fractions 1/2 and 3/4.

1/2 3/4.

One systematic way to find a fraction between these two fractions is to calculate their average (which is found by adding 1/2 and 3/4 and then dividing by 2).

This average is the fraction 5/8, so we have the inequalities $1/2 < 5/8 < 3/4$. We list these numbers in increasing order:

| 1/2 | 5/8 | 3/4. |

This averaging process can be continued—the average of 1/2 and 5/8 is 9/16, and the average of 5/8 and 3/4 is 11/16—so we have, in increasing order, the five fractions

| 1/2 | 9/16 | 5/8 | 11/16 | 3/4 |

and we have found three fractions between the original two fractions, 1/2 and 3/4. Taking averages of adjacent fractions in the above list, we obtain another four fractions between 1/2 and 3/4:

| 1/2 | 17/32 | 9/16 | 19/32 | 5/8 | 21/32 | 11/16 | 23/32 | 3/4. |

This process can be continued indefinitely, leading us to this startling conclusion:

Between any two rational numbers there are an unlimited number of rational numbers.

This means that the set Q is so complicated that we cannot list the elements of this set in increasing order because there are no two adjacent rational numbers.

Given this last observation, it is rather surprising that Cantor found a way to provided a one-to-one correspondence between the counting numbers (1, 2, 3, and so forth) and the positive rational numbers. The genius of Cantor's idea is not to try to list the rational numbers in increasing order, but rather, to list them systematically, without regard to how large they are. To accomplish this he imagined writing the rational numbers in unending rows. The top row contains all fractions with a 1 in their denominator, the second row all fractions with a 2 in their denominator, the third row all fractions with a 3 in their denominators, and so forth. This listing, which can never be physically completed, begins

1/1	2/1	3/1	4/1	5/1	6/1 . . .
1/2	2/2	3/2	4/2	5/2	6/2 . . .
1/3	2/3	3/3	4/3	5/3	6/3 . . .
1/4	2/4	3/4	4/4	5/4	6/4 . . .
1/5	2/5	3/5	4/5	5/5	6/5 . . .

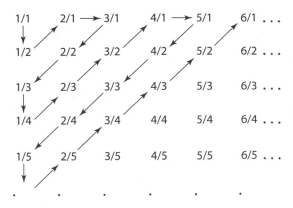

Figure 4.2. A path that provides a one-to-one correspondence between the counting numbers and the positive rational numbers.

Of course, there are many rational numbers that are represented many times in the above array. In fact, every number is represented an infinite number of times. (For example, a number equal to 3/2 appears in the second, fourth, sixth, and every even-numbered row, since $3/2 = 6/4 = 9/6 = 12/8 = \ldots$) But this did not concern Cantor because when he starts to develop his one-to-one correspondence, he will just need to be careful not to include a number he has already included. The key to Cantor's one-to-one correspondence between the numbers 1, 2, 3, . . . and all of the positive rational numbers is the zigzag path through the array shown in figure 4.2. The idea is to start at 1/1 and then follow the path and count a number when you reach it, unless you have already counted it.

This path leads to a listing of the rational numbers that begins:

1.	1/1
2.	1/2
3.	2/1
4.	3/1
5.	1/3
6.	1/4
7.	2/3
8.	3/2
9.	4/1
10.	5/1
11.	1/5

Notice that when we reached 2/2 on the zigzag path, we skipped it and left it off the list because its numerical equivalent, 1/1, was already on the list. Similarly, we skipped the numbers 4/2, 3/3, and 2/4 because they were already on the list as 2/1, 1/1, and 1/2. The above listing may be interpreted as a one-to-one correspondence between the W, all the counting numbers, and Q, the positive fractions. Explicitly, each positive fraction corresponds to the element of W that is its line number.

There are several points that we should take away from the above discussion of the one-to-one correspondences between the sets W, S, and Q. For one, it is interesting to look at Cantor's argument—or more specifically, the visual presentation of Cantor's argument in figure 4.2, where I have illustrated the path through the array of positive rational numbers—through the lens of the idea Max Bill expressed in the quotation that opened this chapter. The abstract idea of a one-to-one correspondence between the discrete set of positive counting numbers, W, and the highly nondiscrete set of all positive rational numbers, Q, is made concrete: we can see it. The other two observations to take away from the above discussion are more mathematical.

First, the process I used to show that there is a another rational number between any two rational numbers may be used to see why there is no smallest positive rational number: if you take any positive rational number and divide it by 2, you obtain a smaller positive rational number, which is, after all, the average of the number and zero. This means that it is not possible to list the positive rational numbers in increasing order. However, they can be listed; one such list is the one we discovered above by following Cantor's lacing path. The fact that they can be listed means that we can put an *order structure*, in Bourbaki's sense, on the positive rational numbers that does not agree with the "order" that we might think of as being associated with their magnitudes. For Bourbaki an order structure on a set is given by some relationship that has the following properties:

Every element x is related to itself (symbolically, $x\mathrm{R}x$).

For elements x and y, if $x\mathrm{R}y$ and $y\mathrm{R}x$ then it must follow that $x=y$.

For elements x, y, and z, if $x\mathrm{R}y$ and $y\mathrm{R}z$ then it must follow that $x\mathrm{R}z$.

The easiest example of an order structure on a set is the relationship "less than or equal to" on the collection of all decimals. (It is easy to work through the details establishing that "less than or equal to" satisfies the three conditions above.) This is also an order structure on the set of all positive rational numbers. But we

want to see how Cantor's listing of the rational numbers puts a very unorthodox order structure on the positive rational numbers that in no way agrees with the one depending on their magnitude. For positive rational numbers x and y we say that xRy if "x is not after y on the list." In this order 1/2 comes before 2/1, but it also comes before 1/3.

The other observation I want to make brings us back to the mathematical lecture in "Ham." Following Frege's idea of abstracting the meaning of "number" from one-to-one correspondences between sets, the discovery that the sets W, S, and Q can pairwise be put into one-to-one correspondences means that they have something in common. And that something is one of the *infinite numbers* Russell referred to in the quotation introducing this section. The infinite number that represents the cardinality of these sets even has a special symbol, \aleph_0, pronounced *aleph null*. This number has the property Russell claimed: "You may add ones to it as long as you like without disturbing it in the least." To understand this counter-intuitive claim let's think about how the number $\aleph_0 + 1$ should be interpreted: it is the cardinality of a set having one more element than the set whose cardinality is \aleph_0. (For this set we will use the collection W above, $\{1, 2, 3, 4, \ldots\}$.) If we put one more element into this set, say 0, then we have a new set $\{0, 1, 2, 3, \ldots\}$ that we denote by N. However, these two sets have the same cardinality, as the following list illustrates:

W		N
1	\leftrightarrow	0
2	\leftrightarrow	1
3	\leftrightarrow	2
4	\leftrightarrow	3

so symbolically, $n \leftrightarrow n-1$. In this interpretation of $\aleph_0 + 1$ we have established Russell's claim that $\aleph_0 + 1 = \aleph_0$.

This introduction of the infinite number \aleph_0 would not be very interesting if there were only one such number. But there are others. To see what just one of them looks like, consider the surprising, even a bit shocking, discovery of Cantor's that if we take

I: the collection of all positive irrational numbers (i.e., numbers that are not rational),

there cannot possibly be a one-to-one correspondence between I and any of our earlier sets. It is easy to see why this is so, but making the argument formally correct is a bit subtle, so we will just see how it *could* work. The outline of Cantor's

demonstration is simple: if you assume there is a one-to-one correspondence between the set W and the set I, you will be led to a contradiction because it will be possible to produce a positive irrational number that the one-to-one correspondence must have missed. This means that no such one-to-one correspondence can exist.

To see this, suppose we have such a one-to-one correspondence between the elements of W and I, which we view as a listing of the positive irrational numbers. This listing might begin with the four numbers as follows:

1. .31289765 . . .
2. .18976898 . . .
3. .901463290 . . .
4. 10.44432197 . . .

Because each of the numbers in I is irrational, its decimal digits do not terminate and do not repeat. I will describe how to produce a decimal not on this list, without concerning ourselves with the technical detail that the decimal we produce does not repeat (it will clearly not terminate).

To produce a nonterminating decimal, we use the following notation for its as yet undetermined decimal expansion:

$$X = d_1 d_2 d_3 d_4 d_5 \ldots$$

We have to explain how to find the digits d_1, d_2, d_3, d_4, d_5, and so forth, to guarantee that X is not on our purported listing of all of the irrational numbers. Here is how we do it: Choose d_1 so that it does not equal the first decimal digit of the first number on the above list, so $d_1 \neq 3$. This means that X cannot equal the first number of the list. Next, we choose d_2 so that it does not equal the second decimal digit of the second number on the list, so $d_2 \neq 8$. This tells us that X cannot equal the second number on the list. In general, we choose the nth decimal digit of X so that it does not equal the nth decimal digit of the nth number on the above list. If we create X in this way, then X cannot be on the above list because it cannot equal the first number, or the second number, or the third number, and so forth. We can create X precisely because we are assuming there is a one-to-one correspondence between the sets of counting numbers and positive irrationals.

Although I will not describe how to choose the decimal digits of X, d_1, d_2, d_3, d_4, d_5, . . . to ensure that X is irrational—so that we have produced an irrational number that our one-to-one correspondence missed—assuming we were to do this, we would have shown that no such one-to-one correspondence can exist. So

the *size* of the collection of all irrational numbers is larger than the *size* of the collection of all counting numbers. The infinite number corresponding to this cardinality is denoted by *c*. There are indeed, in ordinary language, different sizes of infinity.

We are finally in a position to discuss a point made by the mathematician Neil in Wachtel's story "Ham." In his lecture Neil claims to have demonstrated that "the infinite set of rational numbers exceeds the irrational," contrary to Cantor's demonstration that the infinitude of the irrational numbers exceeds the infinitude of the rational numbers. One of the mathematicians in attendance, Rathauer, thanks Neil for his talk and comments that following his demonstration of the "insufficiency of an irrefutable proof" the audience must want to consume him alive. He continues, "Since Cantor proved that there are more irrational, and you that there are more rational, the result is, in the common sense, irrational. One cannot irrefutably prove two opposites without challenging proof itself." This, of course, refers to the law of the excluded middle from symbolic logic; it says that any properly formulated statement is either true or false. There is no other possibility. But as we already saw in Queneau's axioms for literature, in an axiomatic system it is possible for axioms to be inconsistent—which means it is possible to deduce from them two contradictory conclusions. This last statement may be reframed as saying it is possible for some properly formulated statement to be both true and false—and so for the law of the excluded middle not to hold.

Rathauer alludes to this in "Ham": "Whether irrefutable contradictory proofs deny the excluded middle is a matter to be pursued." But Neil complains: "There is no mathematical deconstruction intended here. . . . Cantor remains irrefutable." We never learn what Neil meant by this last claim, but perhaps he believes there is some sort of non-orientability in mathematics itself—that the truth or falsity of a proposition can depend on the path taken to it. Alas, Wachtel saves Neil from falling into this Möbius-strip model for mathematical truth when, towards the end of the story at the camp, another mathematician who had attended the lecture tells Neil, "You are mistaken." So this mathematician had seen a flaw in Neil's argument.

LOOKING AHEAD

Each of the writers considered in this chapter—Barth, Wachtel, Desnos, and Josipovici—consciously and explicitly based their narratives on a very special mathematical surface. Yet some mathematical surfaces can help us understand the

narrative structure of works by authors who have no particular affinity with mathematical thinking. In the next chapter we see how the narrative structure of one particularly challenging novel can be better understood after being modeled first as a simple mathematical bar graph and then as a highly complex mathematical surface that is a multidimensional generalization of the Möbius strip.

Klein Forms and the Fourth Dimension

In the Labyrinth

I am alone here now, safe and sheltered. Outside it is raining,
outside in the rain one has to walk with head bent, hand shielding
eyes that peer ahead nevertheless, a few yards ahead, a few yards
of wet asphalt; outside it is cold, the wind blows between the bare
black branches.

—Alain Robbe-Grillet, *In the Labyrinth* (1959)

The novel *In the Labyrinth* (*Dans le labyrinthe*, 1959) by French novelist and film-maker Alain Robbe-Grillet (1922–2008) is a disconnected, almost shattered narrative. Elements of these apparent discontinuities can be seen in the book's opening paragraph, which begins with the words introducing this chapter. The very next sentence begins, "Outside the sun is shining," and then on the next page, a paragraph opens with "Outside it is snowing." A reader might expect that these references to different types of weather indicate the passage of time in the narration, but between the references to rain, then to the sun shining, then to snow, the narrator simply observes the effect of the rain and wind on the trees outside. In the few paragraphs between the references to sun and then to snow, the narrator describes the room he is in. For a couple of paragraphs following "Outside it is snowing," the narrator describes a snowy street scene before returning to his discussion of the room.[1]

The first twenty pages of the novel continue to juxtapose two descriptions: one of the furnishings of the room and another of the actions of a soldier in the snowy street. What further confuses any casual reader's attempt to keep all these shifts straight is the description of an engraving on one wall of the room. The

image in the engraving is of a crowded cafe. In the center of the cafe three soldiers sit at a table, isolated from the other patrons. Towards the end of the narrator's description of this engraving, one of the soldiers is suddenly said to be sitting alone in the darkened cafe, "the proprietor having turned off most of the lamps before himself leaving the room." This soldier from the cafe then becomes the soldier in the snowy street outside the narrator's room. To even further confuse matters, the text shifts to the thoughts of the soldier and how a child he had earlier met on the street had led him into the cafe.

These opening pages of the novel reveal the three narrative spaces that appear throughout the entire text: the present in the interior of the room, the present in the streets outside the room, and a past time in the streets. In 1965 the literature scholar Ronald James Lethcoe offered a clearer explanation of these three narrative spaces.[2] The first of these narratives encompasses the descriptions of the room offered by a man who is lying in a bed in the room. Second, the man is also telling himself a story about a soldier he sees in the engraving in the room. Finally, during the telling of the story of the soldier, the reader is occasionally offered glimpses into the soldier's thoughts about past events. This explains the apparent confusion in the opening paragraphs of the novel about whether it is rainy, sunny, or snowy outside. These are descriptions of the weather in the story the man in the bed is constructing about the soldier in the painting.

At the very beginning of the text, when the story shifts from "Outside it is raining" to "Outside the sun is shining" then to "Outside it is snowing," the man has not yet decided upon which weather conditions will hold in the story he is telling; he settles on "it is snowing." There are other places in the text where a "No" strangely interrupts the story. To cite but one example, in one passage the soldier is in front of an apartment house. The door is ajar, and the soldier can see a dark passageway. Then, in the text, we read, "No. No. No." The next paragraph tells us that the door is not ajar but is closed. The soldier opens the door and sees a lighted passageway. Thus, we can see the man in the bed composing the story of the soldier, rejecting some ideas and settling upon others.

After explaining the three narrative spaces in the text, Lethcoe appealed to the simple idea of a mathematical graph in the Cartesian plane to provide a visual representation of the shifts from space to space and of how long the narration remains in each space, as measured by numbers of pages of text. Lethcoe labeled the vertical axis with three "Levels of Reality" (I, II, III) and labeled the horizontal axis with page numbers (1 through 221): Level I represents the room, Level II represents the soldier in the street, and Level III represents the thoughts of the soldier. The resulting graph looks like an urban skyline consisting exclu-

sively of one-, two-, and three-story buildings. This graph does provide some insights into what *In the Labyrinth* is about—if that is even a fair expectation. In the first fifteen pages the narrative shifts between Level I (the room) and Level II (the soldier in the street) fourteen times. But the rate of these shifts decreases once the main part of the narrative remains with the soldier.

However, anyone reading Robbe-Grillet's novel does not sense that the soldier's story is its main theme. The narrative continues to be interrupted by shifts back to Level I and Level III. Lethcoe points out that a reader who simply skips the text on Level I will encounter a fairly straightforward story about a soldier and his thoughts.[3] This explains why certain portions of the novel have a large number of shifts between Levels II and III. These occur when the soldier is daydreaming throughout the story and then, at the story's end, when he is dying, having been shot.

Lethcoe's graphical representation is useful for determining how long the narration dwells in events on each level, but it does not tell us anything about how these spaces are related. A way to perhaps more accurately represent these three narrative spaces would be to think of them as being nested: there is the man in the room, the story of the soldier within the man's cognitive space, and inside the soldier the past that the soldier thinks about. The relationship between these spaces could be represented by three concentric circles. The innermost circle represents the soldier's thoughts about his past; the annular region around this circle represents the story of the soldier in the streets that is being told or thought by the man lying in the bed; and the outside annular region represents the story of the man in the room.

The annular-region representation of the narrative would be a fairly static one—it would not reveal anything about how the narration unfolds as the reader reads the text. The twentieth-century literary scholar Bruce Morrissette (1912–2000) attempted to model the narrative structure of several of Robbe-Grillet's novels through an object related to a higher-dimensional analogue of the Möbius strip that is known as the Klein bottle, after the mathematician Felix Klein (1849–1925).[4]

In the previous chapter I explained how to make the Möbius strip out of a rectangle. In order to understand the construction of a Klein bottle, and the difficulty of visualizing one, let's look back at the construction of the Möbius strip. Instead of lifting the rectangle from the page and twisting it to line up corners *A* and *D* and corners *B* and *C*, imagine that we are required to keep the very flexible rectangle on the page and still glue the two ends together as desired. This can be accomplished only if we allow one end of the rectangle to curve around and

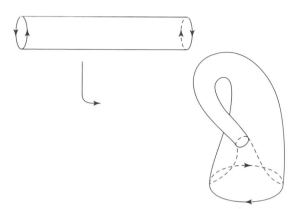

Figure 5.1. Construction of a Klein bottle.

slide into the interior of the rectangle to be attached to the other end. As we saw, this self-intersection can be avoided if we allow for the use of an additional, third dimension—that is, if we treat the rectangle as if it were living in three-dimensional space and simply pick it up and use this additional degree of freedom to twist it.

To form a Klein bottle we begin not with a rectangle but with a cylinder with arrows drawn in opposite directions around its two open ends (see fig. 5.1, top). If we were to begin with a cylinder with arrows drawn around its open ends pointing in the same direction, it would be simple to bend the cylinder so that the two arrows line up (and if we then glued the ends together, the result would be a donut-shaped object). A Klein bottle, in contrast, is produced when the two ends of the cylinder are glued together so that the arrows, originally pointing in opposite directions, now point in the same direction. In order to align the arrows on the opposite ends of the cylinder, we would be forced to allow one end of the cylinder to pass through its body to line up the arrows (fig. 5.1, bottom).

To achieve the desired arrow alignment without having the end of the cylinder pass through its side, it is necessary to posit the existence of an additional fourth dimension for space. Then, arguing by analogy, just as the two-dimensional strip can be twisted in three-dimensional space to produce the Möbius strip, the three-dimensional cylinder can be twisted in four-dimensional space to obtain a Klein bottle. And just as the Möbius strip has only one side, a Klein bottle has only one surface (meaning that it does not have an inside or an outside).

If we attempt to represent the Klein bottle in three-dimensional space we have to allow the cylinder to intersect itself, as is implied in figure 5.1. This drawing of a Klein bottle is what inspired the concept of a Klein worm—a long, flex-

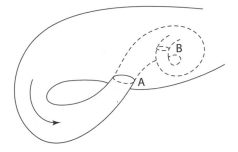

Figure 5.2. A Klein worm.

ible tube with several, possibly even many, self-intersections (fig. 5.2). With a Klein worm it is possible to represent the containment relationship between different spaces and, if we ignore what looks like the self-intersections of the worm with itself, to illustrate the continuous movement from one space to another. As with the Klein bottle, what appear to be self-intersections are meant only to represent our inability to properly visualize the form. Mathematically, the apparent self-intersections could be avoided if we posited an additional physical dimension for each of them.

The key to connecting the drawing in figure 5.2 with the narrative structure of *In the Labyrinth* is to imagine the worm (cylinder) as having a direction to it (which I have indicated by an arrow). The space of the room, where the man is lying in bed, is the ambient space the worm occupies. When the worm passes into itself (for example, at point *A*), the narration moves to an inner space—in *In the Labyrinth* to the story the man is telling about the soldier in the street. Then, when the contained part of the worm twists and turns inside itself, at point *B*, the story moves into yet another narrative space—this time into the soldier's reflection on past events.

Morrissette gave two reasons for the value of such a mathematical analysis of a text. The first was loosely based on then-current structuralist ideas: that finding similar formal structures in various, even disparate, disciplines reveals something about "inherent intellectual categories, à la Kant, or deep mental structures, à la Lévi-Strauss."[5] This idea is one manifestation of Bourbaki's search for common mathematical structures, as in the mathematical groups with four elements we examined back in chapter 3. His second reason—that the use of mathematical models to analyze a text can yield insight into the text itself—is, perhaps, more convincing and more to our point. Using Klein worms to discuss the narrative spaces of *In the Labyrinth* is fairly straightforward, but because the narration shifts so often, it would be nearly impossible to model the entire narrative. However,

this exotic surface does inform our understanding of the narrative structure of Robbe-Grillet's text. For example, when the narrative becomes that of the story of the soldier, the worm enters into the body of the worm; and when the story of the soldier shifts to the story of past events in his life, the worm twists around and moves into itself. In this way the shifts in space and time that the reader may have perceived as being jumps can be seen as continuous movements.

Thus, this model seems to imply that the transition from one narrative space to another, rather than being abrupt, as is implied by Lethcoe's graph model, is smooth. A reasonable question is whether this continuous model is faithful to the seemingly discontinuous text. Lethcoe discussed in his article how a more careful reading of *In the Labyrinth* reveals that the shift from one narrative space to another is frequently mediated by some event or observation. For example, shifts from the room to the soldier in the street often occur when the narrator associates an object in the room with an object in the story he is telling. At other times, in the narrator's story of the soldier, the soldier will close his eyes, and that movement shifts the narration to the soldier's thoughts (the third narrative space). These subtle signs signal the text's transition through one of the Klein holes in the model for the narrative structure.

This insight that the text is not disconnected but made continuous through narrative cues, flowing seamlessly from episode to episode, allows us to briefly explain what Bourbaki called a *topological structure*. Loosely speaking, the topological properties of a surface are the ones that are preserved if the surface is twisted or stretched but not torn; and two surfaces are said to be *topologically equivalent* if one can be transformed into the other only through twisting and stretching. For example, in the previous chapter we saw how the ends of a rectangle might be glued together in two different ways; one of these results in a bracelet-type surface, and the other results in the Möbius strip. It is possible to discern why these two surfaces are not topologically equivalent by seeing that they have different properties that remain unchanged when they are twisted or stretched. The simplest difference between these two surfaces can be seen in something we discovered in chapter 4: the Möbius strip is non-orientable. This means that if an object—say, a circle with an arrow pointing clockwise—moves along the surface of the Möbius strip and finally returns to its original position, the arrow will be pointing in the counterclockwise direction. This is not the case with an object that moves around the bracelet; when the object returns to its original position, it will have its original orientation.

How much insight into the narrative structure of *In the Labyrinth* can be gleaned from a study of the Klein worm is unclear; however, it is an interesting

appeal to a mathematical surface by a literary scholar. Indeed, the surface manifests one of the central tenets of Art Concret, noted in the preceding chapter, in that it makes an abstract idea visible. In the next section we will see that some artists appealed to the use of mathematical forms not because of their abstract nature, as had Max Bill, nor their utility, as had Morrissette, but because of their supposed connections with mystical insights and hidden dimensions.

Surfaces, Mysticism, and the Fourth Dimension

> Geometrical forms being so profound an abstraction of form may
> be regarded as neutral; and on account of their tension and the
> purity of their outlines they may even be preferred to other
> neutral forms.
> —Piet Mondrian, "Plastic Art and Pure Plastic Art" (1937)

In the quotation above, Piet Mondrian (1872–1944), a *De Stijl* colleague of van Doesburg's, called geometrical forms "neutral" because the artist could use them in abstract art without sparking a viewer's imagination to glean from a painting any objectivity or anything not intended by the artist.[6] But this conception of art, and the role a geometric object could play in a painting, is a modern one. At least since the Renaissance, artists have employed a special three-dimensional form to hint at mystical insights that could be gleaned from a study of their work. To understand this form we return briefly to Man Ray's use of mathematical surfaces.

As we saw in chapter 1, some of Man Ray's *Shakespearean Equations* were based on fairly familiar mathematical surfaces; for example, in the painting *As You Like It* he reinterpreted the sphere. One basic mathematical image that appeared in at least two of Man Ray's other works is the three-dimensional object known as a dodecahedron. At first glance, a dodecahedron looks a bit like a classic soccer ball, which is made up of twelve black pentagons and twenty white hexagons. But the dodecahedron only has twelve sides, each of which is a regular pentagon. As was his inclination, Man Ray took great liberties in representing the dodecahedron. In one of Man Ray's photographs from the 1930s, one he proposed to use on the cover of a selection of his photographs, a woman is sitting behind a table that contains several objects. One of these is a dodecahedron with a mannequin's hand poking through one of the pentagonal sides. Another dodecahedron-type object appears in his 1943 watercolor and ink *Pythagore.*[7] In this piece a modified dodecahedron appears to be impaled on a pentagonal- or

hexagonal-based cone. The title of the piece harkens back to the mystical specu-
lations about the role of mathematics in the working of the cosmos of the sixth-
century BCE philosopher Pythagoras.[8]

The dodecahedron is one of the five mathematical objects whose faces are
all the same regular polygon (i.e., an equilateral triangle, a square, a pentagon, a
hexagon, etc.) and where the same number of polygons meet at each corner, the
sides all meet each other at the same angle, and the object is convex (which im-
plies that each of its corners points away from the interior). The two most famil-
iar of these are the cube, whose six sides are all squares, and the tetrahedron,
which is a pyramid whose base and three sides are all equilateral triangles. There
are two other such solids all of whose sides are equilateral triangles (one with
eight sides, the octahedron, and one with twenty sides, the icosahedron), and
there is only the dodecahedron with pentagonal edges. (There cannot be any such
solid whose faces have more than five sides.)

These five objects are called Platonic solids, not because Plato discovered them
(they were known earlier) but because in the *Timaeus* (fourth century BCE) he
used four of them to provide geometric models for the four fundamental
elements—earth, air, fire, and water—and took the twelve-sided dodecahedron
to represent the heavens. This early association of the dodecahedron with the extra-
terrestrial cosmos endowed it with mystical attributes not normally ascribed to
a mathematical figure. So when Man Ray used the image of a dodecahedron on
the cover for a book of his photography, he was not just reinterpreting a mathe-
matical form, as he was to do in his *Shakespearean Equations* a dozen years later.
Rather, he was lending an air of mystery to his photographs, perhaps even hint-
ing at some mystical insights they might offer.

Another surrealist artist—indeed, the one who is most widely known today—
employed the dodecahedron exactly as Plato had proposed. That artist is the
Catalan painter Salvador Dalí, whose association, or perhaps we should say loose
affiliation, with Breton's group began in late 1929 and lasted through the 1930s.
Dalí and Breton met when Dalí traveled to France for his first Parisian exhibi-
tion. Breton, who was by then already familiar with Dalí's work, wrote a preface
to the exhibition's catalog. However, Dalí came to Breton's group with a different
conception of art, and understanding a bit about it might help us appreciate his
use of the dodecahedron.[9]

Dalí's conception of art, as expressed in his "paranoiac-critical" theory, was at
odds with Breton's call for artists to simply display dream images. Rather, Dalí
maintained that an artist should represent the external world as experienced while
in a state of paranoia, allowing him or her to actively interpret the world through

an obsessive or compulsive lens. This means that central to Dalí's paranoiac-critical theory is the artist's active interpretation of the external world, not of the artist's subconscious. Although Dalí's artistic vision is almost the antithesis of Breton's, his paintings often offer dreamlike images—images that today are frequently called *surreal*.

Dalí's use of the dodecahedron occurred in his 1955 painting *The Sacrament of the Last Supper*. This painting shows Christ and the twelve disciples seated around a square table. Christ is seated in the center of the far side of the square, facing out of the canvas, with three disciples on each side of him. There are two disciples on each of the other sides of the table, so two with their backs to the viewers. Christ is centered in what looks like the top half of a pentagon. And this pentagon is flanked on its three visible sides by other pentagons. The four visible pentagons seem to be enclosing the space containing Christ and the disciples, as if the entire scene is inside a dodecahedron, thus associating Christ with the cosmos. Of this painting, Dalí said that it was an "arithmetic and philosophical cosmogony based on the paranoiac sublimity of the number twelve."[10] Although the word "dodecahedron" does not appear in Dalí's discussion of his painting, his use of pentagons and his appeal to the number twelve as playing a role in the origin or reasons for the universe does seem to hark back not just to the twelve disciples of Christ but also to Plato's use of the twelve-sided dodecahedron.

The Hypercube

The short answer as to why Plato thought the five regular solids should have anything to do with the fundamental workings of material space is that Plato was an *idealist*. As such, he held the view that ideas are as real as, and certainly more significant than, what we sense or perceive in the material world. This idealism allowed Plato to posit that these mathematically perfect forms gave shape to the fundamental elements of the cosmos—earth, air, fire, and water—and to the heavens themselves.[11] And idealism has remained an important thread throughout the history of Western philosophy. Rather than trace this history here, which could allow us to expand our discussions of many twentieth-century artistic and literary developments but would take us too far afield, we move on to a somewhat forgotten, but nonetheless influential, late nineteenth-century idealist—the Englishman Charles Howard Hinton (1853–1907).

Hinton had studied mathematics and physics at Oxford, receiving both a BA and an MA, but between his work on these two degrees he studied physics in Berlin, where higher-dimensional spaces were being widely discussed.[12] Perhaps drawing on these discussions, Hinton conjured up a *hyperspace* philosophy,

which he developed in two books, the first in 1888 and the second in 1904.[13] The central idea of Hinton's hyperspace philosophy is the assumption that the physical space we inhabit has an additional fourth dimension and that all so-called three-dimensional material objects, including humans, have a slight extension into the fourth dimension. It follows, at least in Hinton's thinking, that to fully understand any object, we need to see its full four-dimensionality; seeing this would allow us to comprehend the object in its totality.[14]

In his books Hinton both outlined this philosophy and attempted to teach his readers how to perceive the fourth dimension. One of the objects Hinton sought to help the reader visualize is the four-dimensional analogue of the standard three-dimensional cube. Hinton does this through first explaining how information about the shape of a three-dimensional object may be obtained by looking at two-dimensional slices of the object. For example, any two-dimensional slice of a sphere will be a circle. However, a two-dimensional slice of a three-dimensional cube can be a fairly complicated polygon, depending, for example, on whether the slice is or is not parallel to a face of the cube.

Hinton attempted to argue by analogy and describe the possible shapes of three-dimensional "slices" of a four-dimensional cube; I have not attempted to reproduce his descriptions here. Instead, I want to examine two different ways to learn to imagine the four-dimensional cube. These are easier to follow than Hinton's three-dimensional slice idea, and one of them leads directly to a mathematical surface that has been used to bring mystical ideas to a painting.

Forming a Cube and a Hypercube through Motion

We begin by visualizing how the motion of a square may dynamically produce a cube. Imagine that you have a one-by-one square lying flat on your desktop. We want to move this square in a direction perpendicular to each of its edges, so up from the desk, a distance of one unit. As the square moves upward, it sweeps out a cube in space. But in order to understand how the three-dimensional cube may be used to sweep out a four-dimensional cube, we need to look a bit more precisely at how the parts of the moving two-dimensional square produce the parts of the three-dimensional cube (as in the top two images of fig. 5.3).

In the drawing we imagine that the square in the background on the left moves forward, out of the plane of the paper. It is this motion that forms the cube. But let's be certain we understand where the cube formed by this motion gets its six square faces. The back face of the cube is the position of the original square; the front face of the cube is the position of the original square after it has moved one unit. This accounts for two of the cube's six faces. Each of the other

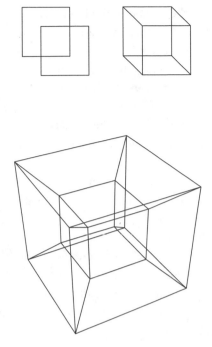

Figure 5.3. Top: Movement of a square to form a cube; *bottom*: movement of a cube to form a hypercube.

four, square faces of the cube is produced by the movement of a line segment; for example, the left face of the cube is produced by the movement of the left edge of the square and the top of the cube, by the top edge of the square.

We now want to try to understand what sort of object is produced if we start with a three-dimensional cube and move it in a direction perpendicular to each of its faces, so along a fourth dimension. It is not easy to visualize either such a motion or the object it sweeps out in four-dimensional space, but it is possible to understand a few of the object's characteristics. For example, we claim that just as the ordinary cube is bounded by six squares, eight cubes bound this new object. To see this we first identify two of these cubes: one is the position of the original cube before it moved, and the other is determined by the position of the original cube after it has moved. But where do the other six cubes come from? We saw above that if a square moves in a direction perpendicular to its face, it will produce a cube. Since the cube we are moving has six square faces, and it is being moved in a direction perpendicular to each of these faces, each of these moving squares forms a cube—each of the six faces of the original cube sweeps out a cube. This means that the four-dimensional object we obtain will be bounded by a total of eight cubes.

One way to visualize the motion of the three-dimensional cube, which leads to a distorted three-dimensional representation of the four-dimensional cube, is to imagine beginning with a cube, and represent having it move in a direction perpendicular to each of its faces by having it expand. As it does each of its faces will sweep out a cube, resulting in the distorted view of the four-dimensional hypercube shown in the bottom image of figure 5.3. (Hinton dubbed this object a *tesseract*.) The eight three-dimensional cubes that make up the four-dimensional cube can be seen in the drawing, but they are distorted. There is the central cube that was then expanded to form the second, large cube. And during this expansion, each face of the original cube swept out a cube, each of which in the drawing has the required six sides (a smaller square face opposite a larger square face and four trapezoid-looking sides).

Forming a Cube and a Hypercube through Folding

Although the tesseract helps us imagine what a four-dimensional cube might look like, it is not a particularly aesthetically appealing mathematical surface. However such a surface does emerge if we try to understand how the four-dimensional cube can be obtained from a three-dimensional object by folding and gluing. We first look at how a two-dimensional figure can be seen to provide a way of visualizing the surface of the three-dimensional cube. The surface of a cube, which is, of course, a three-dimensional object, consists of six squares. We begin with six squares laid flat, as in figure 5.4. It is fairly easy to see how this figure could be folded up to form a cube (and to make it even easier to use this figure to form a cube, imagine simply gluing together the edges that are joined by arrows; the square at the bottom of the cross becomes the cube's top). What is important for us to acknowledge is that this folding and gluing cannot be done in the flat plane of the piece of paper; a third dimension needs to be employed in order to form the cube—specifically, you need to pick up the paper and fold it in our three-dimensional space.

To see the three-dimensional figure that can be folded to form a four-dimensional cube, we turn to the use of another mathematical surface in one of Dalí's paintings, *Crucifixion* (*Corpus Hypercubus*) (1954). This painting (plate 5.1) depicts a crucified Christ. Instead of a traditional cross, however, the structure on which Dalí's Christ has been crucified looks like it has been assembled from eight cubes. Four cubes are stacked vertically; these four cubes might be thought of as providing the structural core of the mathematical object. Then another cube is attached to each of the exposed faces of the third cube from the bottom. This configuration looks like a cross when viewed from any of its sides. This object is

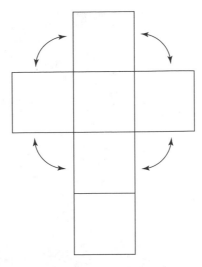

Figure 5.4. An unfolded cube.

an *unfolded hypercube*, as I will explain below, and Dalí's use of it again leads the viewer to make associations between Christ and the mystical insights that the paranoiac-critical lens provides the artist.

It is much more difficult to visualize how to fold the eight-cube configuration in Dalí's painting to obtain the four-dimensional cube than how to fold the cross-looking object of figure 5.4 to obtain the cube. This is, of course, because we have to perform the folding and gluing in four-dimensional space. To appreciate how this gluing cannot take place in three-dimensional space, just look at how the five exposed faces of the bottom cube are attached to faces of other cubes to form the four-dimensional cube. The bottom of the bottom cube is attached to the top of the top cube; that seems straightforward enough. However, each of the other four square faces of the bottom cube is attached to one of the outward-looking faces of one of the four cubes that jut out from the column. For example, the front face of the bottom cube is attached to the front face of the cube behind Christ's torso, and the right face of the bottom cube is attached to the outward-looking face of the cube behind Christ's left hand. And all of this bending and gluing has to take place while the bottom cube is stretched and greatly distorted but not torn apart.

There is a bit more to Dalí's use of the hypercube in this painting than in his use of the dodecahedron in *The Last Sacrament*, but it is not easy to pin down what that "more" is. In 1951 Dalí had published his "Mystical Manifesto," in which, according to one art historian, Dalí moved "toward a coalescence of geometry,

Plate 5.1. Salvador Dalí, *Crucifixion* (*Corpus Hypercubus*), 1954. Oil on canvas. Gift of the Chester Dale Collection, 1955 (55.5). Image © The Metropolitan Museum of Art. Image source: Art Resource, NY. © Salvador Dalí, Fundació Gala–Salvador Dalí, Artists Rights Society (ARS), New York 2013.

nuclear physics, and Catholic mysticism."[15] These two paintings, in ways never explicated by Dalí, were, in the words of another art historian, "his quest for a rather oddball synthesis of science and spirituality."[16] Exactly which mystical insights Dalí intended a viewer to take away from these two paintings will probably never be known—and that is probably as Dalí intended.

LOOKING AHEAD

The next chapter discusses much simpler mathematical structures known as graphs (which look a bit like networks). First, I show how a mathematical graph can be used to visualize the relationship between two novels that are contained within a single text, where the author has dictated which of the text's chapters constitute the different novels. I then use a graph to model a text in which the author allows, indeed forces, the reader to make many choices between pairs of possibilities in order for the narrative to move ahead. Finally, we look at how two writers used a simple graph to structure a play in which the audience is asked to make a choice at the end of each scene. The graph allowed the writers to reduce the number of scenes the actors need to learn while providing the audience the impression they are being offered a very large number of choices.

Paths, Graphs, and Texts

Literature and Choice

In its own way, this book consists of many books, but two books above all.

—Julio Cortázar, *Hopscotch* (1963)

The Argentinean writer Julio Cortázar's novel *Hopscotch* (originally published in Spanish as *Rayuela* in 1963) begins with a curious "Table of Instructions" that opens with the above sentence: "In its own way, this book consists of many books, but two books above all." Impatient readers who skip the instructions there and turn to the text will discover that the book's 155 chapters are separated into three sections: "From the Other Side," "From This Side," and "From Diverse Sides: Expendable Chapters." Because this seems to be an ordinary text, the reader might turn back to Cortázar's instructions to see what he meant by "many books, but two books above all." There, Cortázar explains that to read the first of the two primary books, which constitute what I will call book 1, the reader should read the first two sections of the text—so the chapters in "From the Other Side" and "From This Side"—in the order in which they are presented. Book 1 does not include any chapters from the third section of the book, "From Diverse Sides: Expendable Chapters."

To read book 2 the reader is instructed to intersperse the chapters from the third section of the text between the chapters from the first two sections of the text. Cortázar did not intend for the reader to shuffle these chapters together in a random manner; he offers a particular ordering for the chapters of book 2. The key to this ordering of the chapters is the number at the end of each chapter. Cortázar explains that the reader is to follow each chapter by the one named at its end. Book 2 begins with chapter 73, at the end of which the reader is directed to next read chapter 1. The sequence of the first few chapters for book 2 is

$73 \rightarrow 1 \rightarrow 2 \rightarrow 116 \rightarrow 3 \rightarrow 84 \rightarrow 4 \rightarrow 71 \rightarrow \ldots$ Book 2 ends with the sequence of chapters $72 \rightarrow 77 \rightarrow 131 \rightarrow 58 \rightarrow 131 \rightarrow \ldots$ Note that, in a sense, this reading of *Hopscotch* never ends: at what should be the end of book 2, a diligent reader will endlessly alternate between the last two chapters, 131 and 58.[1] Before I discuss a simple mathematical model of the relationship between the chapters of *Hopscotch* required for books 1 and 2, it is worthwhile to appreciate its narrative.

The literary scholar James Irby offered an analysis of the plot of each of the two principal books that Cortázar claims are in his text. Although the plot of book 1 is "unfolded in chronological order," it is, Irby acknowledges, "difficult to summarize because of various gaps and evasions of emphasis."[2] Events or discussions that seem to be important to the narrative "often occur marginally, almost imperceptibly, amid horseplay, wandering discussions or seemingly casual encounters." Yet book 1 does have a central character—a bohemian Argentinean, Horatio Oliveira, who lives in Paris around 1950. He is interested in and prone to have long discussions about literature, art, philosophy, and music. These discussions take place among his eclectic group of friends, which includes his girlfriend. What is perhaps the climax of book 1 occurs during one of these gatherings: Oliveira touches his girlfriend's sleeping child and realizes the child has died. Instead of alerting the others, he remains engaged in the ongoing discussion. Once Oliveira's nonchalant attitude towards the child's death becomes known, he is ostracized from his group of friends. Eventually, he is deported to Argentina. The novel ends with Oliveira "perched on the windowsill" contemplating suicide.[3]

If the reader follows Cortázar's instructions for book 2, some of the gaps in the narrative of book 1 are filled in, but some others are not and new ambiguities are introduced.[4] There is even a major character in book 2 who makes only a very brief appearance in book 1. (He is an author who seems to be writing the book *Hopscotch*, reminiscent of how the writer in the bottom story of Josipovici's "Mobius the Stripper" appears to be writing the top story.) And some of these newly introduced chapters simply add to the narrative flow. For example, in book 2, chapter 59 is inserted between chapters 40 and 41. At the end of chapter 40 Oliveira has returned to Argentina and has been considering how there is a sadness underlying his and his friends' lives "as they think about possibilities come to naught and the Argentinean character and time's inexorable passage."[5] This is followed by chapter 59, whose entire text is a quotation from the anthropologist Claude Lévi-Strauss's memoir, *Tristes Tropiques* (1954): "Then, to pass the time, they catch fish they cannot eat; to avoid the rotting of fishes in the air, notices have been posted all along the beach telling the fishermen to bury them in the sand just as soon as they have been caught." Then, in the opening of chapter 41, Oliveira is

in the hot afternoon sun, trying to "straighten out nails by hammering them on a tiled floor," as fruitless an undertaking as the fishermen catching fish they will not eat and then burying them in the sand.[6]

Cortázar's instructions tell the reader which ordering of the text's chapters to use for book 1 or book 2. By the time *Hopscotch* was published, however, another author, Marc Saporta (1923–2009), had published a novel allowing, even requiring, the reader to choose an order in which the pages of the text be read. Saporta's text, *Composition No. 1* (1962), was packaged inside a box that contained a title page plus 149 unnumbered loose-leaf pages of the text, which the reader is instructed to read in any order. On each of these 149 pages Saporta offered an episode in the life of the book's main character, "X." These episodes include such disparate events as X entering a village in Germany as part of the occupation forces, an automobile accident, a woman (Marianne) threatening suicide, another woman (Dagmar) working on a painting she calls *Composition Number One*, X raping a girl (Helga), and X stealing money from someone.[7] Not every page contains a full description of these events; for example, different aspects of the rape scene appear on several pages of text, and many of the scenes involve Marianne, to whom X appears to be married. As you read the shuffled pages of text, glimpses of events are fleshed out, in a fashion not dissimilar to the way in which the interspersing of the chapters from the third section of *Hopscotch* between the chapters of book 1 fills in missing details. But because the pages of *Composition No. 1* are unnumbered and meant to be shuffled before reading, it is not possible to determine the chronological order of these events in X's life.

This last observation points to an important difference between how the reader is expected to approach *Hopscotch* and *Composition No. 1*. Cortázar wrote *Hopscotch* with the expectation that a reader would follow the narrative according to either the scheme offered for book 1 or the one offered for book 2. Although Cortázar did admit that the reader could pursue other choices of chapters to read—remember that he did write that *Hopscotch* "consists of many books"—the two books that he claimed were "above all," books 1 and 2, had fairly easily discerned chronologies.

Yet a reader of *Hopscotch* could respect Cortázar's ordering of chapters and still be allowed a great deal of leeway as to which chapters to select. In order to understand how this is so, it is helpful to *see* the relationship between the chapters used for book 1 and the chapters used for book 2. This relationship is more clearly revealed through the use of a simple yet powerful mathematical model for the text. Since there is a sequence to the chapters (not necessarily the one given

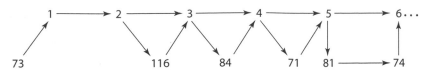

Figure 6.1. Graph representing the beginnings of book 1 and book 2 in Cortázar's novel *Hopscotch*.

by their chapter numbers), it is possible to model these two books by a mathematical graph. This graph in its entirety is large, involving 155 chapters, so figure 6.1 provides only its beginning.

The entire graph reveals that book 2 is an elaboration of book 1. Between consecutive chapters of book 1 the reader is requested to insert as few as zero and as many as twenty-two chapters from the third section of *Hopscotch*. It seems that a reader would still obtain roughly the same narrative, just without as many details, by inserting some but not all of the later chapters. That the reader is allowed only this type of choice—that is, the choice of which of chapters 57 through 155 to use—implies that Cortázar's 564-page text contains many, many books. If we just count the books where, after each of the book 1 chapters, the reader is allowed to choose between reading the next book 1 chapter and reading the chapter or chapters Cortázar suggests for the book 2 reading, we discover that the reader is given forty-five choices between following one of two paths—for a total of 2^{45} possible books.

A reader of either Cortázar's *Hopscotch* or Saporta's *Composition No. 1* is not required to make any choices. Cortázar gives instructions to the reader, and the pages of Saporta's book can be read in the order they are in when the reader opens the box. Some writers, however, have prepared texts that do not simply allow the reader to make choices but force him or her to do so in order for any sort of narrative to emerge from the text. Such a text does not represent a story but implicitly contains many different narratives. Each of these narratives is a *potential* story that cannot be actualized until the reader engages with the text and begins to make choices.

In 1967 Queneau composed such a text, "A Story as You Like It" ("Un Contre à votre façon"), which is one of his best well-known pieces.[8] Queneau's text begins with a question:

1. Do you wish to hear the story of the three alert peas?

 if yes, go to 4
 if no, go to 2.

If the reader answers "yes" to the first question, the story begins with the text from 4:

> 4. Once upon a time there were three peas dressed in green who were fast
> asleep in their pod. Their round faces breathed through the holes in their
> nostrils, and one could hear their soft and harmonious snoring.

This text is followed by the choices

> if you prefer another description, go to 9
> if this description suits you, go to 5

If this description suits the reader, then the story continues:

> 5. They were not dreaming. In fact, these little creatures never dream.

The reader can then choose one of the following:

> if you prefer that they dream, go to 6
> if not, go to 7

If you would prefer that the three peas be dreaming, and then affirm that you like
the color of their gloves, the story so far would read:

> Once upon a time there were three peas dressed in green who were fast asleep in
> their pod. Their round faces breathed through the holes in their nostrils, and
> one could hear their soft and harmonious snoring. They were dreaming. In fact,
> these little creatures always dream and their nights secrete charming dreams.
> Their cute little feet were covered in warm stockings and in bed they wore black
> velvet gloves. All three were dreaming the same dream; indeed, they loved each
> other tenderly and, like proud mirrors, always dreamed similarly.[9]

Of course, a different reader, or the same reader a few minutes later, might make
different choices. For example, even if the reader wants "to hear the story of the
three alert peas," the reader may or may not like the color of their velvet gloves and
may or may not want to know what they are dreaming about.

The beginning of the story given above corresponds to the sections of Que-
neau's text numbered 4, 6, 7, and 10, so this beginning of a story would be ob-
tained by the reader going through the sequence of sections numbered 1, 4, 5, 6,
7, 10, followed by yet another choice to be made. It is not possible to determine,
just by reading Queneau's text, if or how the different narrative flows are re-
lated; it is not even easy to judge how many different narratives the text contains.
A dedicated reader could try to enumerate them, but that would not be a very
enlightening experience; it might yield a correct count of the number of possible

stories, but it would not help us understand the connections between the different stories. Queneau had a better idea: he gave a graphical representation of his text. His graph is laid out differently from the one shown in figure 6.2 but conveys the same information as the one here. A story from Queneau's text corresponds to any path in this graph that starts at 1 and follows the arrow-directed paths until the path reaches a number from which no arrow leaves (so at either 20 or 21).

By using this correspondence between stories and paths through this graph that start at 1 and end at either 20 or 21, we can draw several evident conclusions about Queneau's text. One of these is that it contains some very short stories, such as $1 \rightarrow 4 \rightarrow 9 \rightarrow 21$, although since 21 is simply the announcement that the story is done, this is really only the story $1 \rightarrow 4 \rightarrow 9$. Another conclusion is that there are some fairly long stories, such as

$$1 \rightarrow 4 \rightarrow 9 \rightarrow 5 \rightarrow 6 \rightarrow 7 \rightarrow 8 \rightarrow 10 \rightarrow 11 \rightarrow 12 \rightarrow 13 \rightarrow 14 \rightarrow 15 \rightarrow 16$$
$$\rightarrow 18 \rightarrow 19 \rightarrow 20.$$

This story would be even longer if at step 11 the reader were to follow the looped path that starts and ends at 11 (which corresponds to the reader consulting a dictionary for the meaning of "ers").

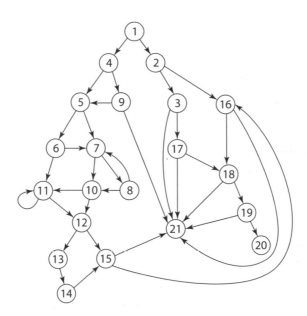

Figure 6.2. Graph of the different narratives contained in Queneau's "A Story as You Like It."

These two conclusions could have been reached by just reading Queneau's text, but the graph also reveals some features of the text that might take awhile to uncover by simply reading it. (For example, that there are eight different endings to Queneau's stories: the pairs $3 \rightarrow 21$, $9 \rightarrow 21$, $15 \rightarrow 21$, $16 \rightarrow 21$, $17 \rightarrow 21$, $18 \rightarrow 21$, $19 \rightarrow 21$, and $19 \rightarrow 20$.) Beyond these special observations, the complexity of the graph reveals the large number of potential stories within Queneau's text. A patient person could track through the different possible paths in the graph and determine that it contains at least 105 potential stories, something a very careful study of the text could also accomplish, but less easily.

Mathematical Graph Theory

> The branch of geometry that deals with magnitudes has been
> zealously studied throughout the past, but there is another branch
> that has been almost unknown up to now. . . . This branch of
> geometry deals with relations dependent on position alone, and
> investigates the properties of position; it does not take magnitudes
> into consideration.
>
> —Leonhard Euler, "The Seven Bridges of Königsberg" (1735)

While the graph for *Hopscotch* reveals some insights into how Cortázar's additional chapters were interlaced among the chapters of book 1 to produce book 2, a careful reading of the list of chapters for book 2, which Cortázar gave in his "Table of Instructions," could provide a dutiful reader the same insights. By contrast, a listing of the many stories implicit in Queneau's text would be too long to reveal the text's secrets. The graph, like the Klein-worm model for Robbe-Grillet's *In the Labyrinth*, allows us to see the intrinsic structure of the text. Later in this chapter we will see how two writers, both affiliated with Queneau, used a graph to provide a structure for a play that allowed the audience to make choices between scenes. Like Bourbaki or someone writing a sonnet (see chapter 7), these writers put structure before the object. But before we discuss the innovative play by Paul Fournel and Jean-Pierre Énard, let's examine how simple graphs were used to solve one well-known mathematical problem.

In 1735 the mathematician Leonhard Euler (1707–83) presented a paper from which this section's epigraph was taken. In his paper Euler set out to answer a question that had long occupied the residents of Königsberg, Prussia (now Kaliningrad, Russia). Apparently there was a tradition among Königsberg's residents to stroll around town, and such walks often involved crossing bridges that con-

nected the main portions of the town with each other and with an island in the middle of the Pregel River. Residents, and now also Euler, wondered whether it was possible to walk across the particular configuration of the town's bridges (seen in the top image of fig. 6.3) in such a way as to cross each of these seven bridges once and only once. It seemed that if one tried to cross each bridge once and only once, at some point one would either have to leave some bridge or bridges uncrossed or else would be forced to re-cross a bridge or bridges that had previously been crossed.

To study this problem Euler replaced the rough map shown at the top of the figure with a simple graph, the bottom image in figure 6.3. To construct this graph Euler represented each of the four landmasses with a simple dot (called a *node* of the graph) and indicated each bridge by a path connecting the appropriate nodes. Notice how this representation of the map, with its bridges and landmasses, reflects the ideas expressed in Euler's quotation heading this section. The sizes of the landmasses and the lengths of the bridges are irrelevant. The graph does not take into consideration any magnitudes—it is a pure representation of relative positions—so the graph preserves the topological properties of the physical map. The question of whether one can walk through Königsberg and cross each of the seven bridges exactly once is now replaced with the equivalent question about the graph: is it possible to begin at some node in this graph and traverse each and every path once and only once?

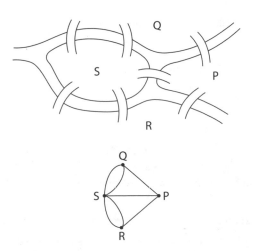

Figure 6.3. Configuration of the seven bridges of Königsberg (*top*) and graph representing possible paths between the locations, or nodes (*bottom*).

Euler's insight into answering the question was to focus on the nodes and how the paths connect the nodes, not on the paths. This is a subtle shift in point of view, but in Euler's hands it was all that was needed to solve the problem. To understand Euler's solution let's focus on the node labeled *P* in the graph. In the discussion below we will discover that if you hope to traverse each path in this graph, your walk will have to either start at *P* and end elsewhere, or start elsewhere and end at *P*. To see this, first imagine that you start at *P* and suppose, for concreteness, that you leave *P* along the path leading to *Q*. Then, if you are going to cross all of the paths, at some point you will have to return to *P* (say along the path from *S*). Then, if you are going to cover all paths, you will have to leave *P* along the path to *R*. As you continue to move around this graph, you can never return to *P* because you have already crossed all of the paths that connect to it. This thought experiment leads us to the following modest conclusion:

> **If you begin at node *P*, and if it is possible for you to cross each path in the graph, then your walk must end at another node.**

This conclusion follows because *P* is connected to the graph by three paths, so the same conclusion holds for the nodes *Q* and *R*.

Next consider the same graph but assume that you start at a node other than *P*. We maintain that were it possible to cross all of the bridges, then your walk would have to end at *P*. This is because, while traversing the graph, you will cross some path to *P*, then leave *P* along another path, and finally return to *P* on the third unwalked path. This leads us to another, modest conclusion:

> **If you begin at a node other than node *P*, and if it is possible for you to cross each path in the graph, then your walk must end at node *P*.**

As with our first modest conclusion, all we used was the fact that *P* is connected to the rest of the graph by three paths, as are the nodes *Q* and *R*, so this conclusion also holds for them.

It follows from our two conclusions about the nodes *P*, *Q*, and *R* that if it is possible to cross each path in the graph exactly once, then your trip must start or end at each of the three nodes *P*, *Q*, or *R*. Since it is neither possible to start at more than one node nor to stop at more than one node, it follows that no such stroll is possible.

This simple example shows part of the power of very simple graphs. Graphs played a significant role in the proof of the four-color theorem in the 1970s. Directed graphs—graphs where the paths between the nodes have a direction to them, like one-way streets—have aided in the design of networks, both com-

puter networks and networks that model traffic flow. Elsewhere, in *What Is a Number?*, I discussed how an important property of these simple graphs can be used to demonstrate that there are only five Platonic solids.

A Play Based on a Graph

SCENE 1: The king is unhappy; misfortune reigns in the palace.
The queen, returning from a journey, cannot comfort him. He is
unhappy for one of the following reasons, between which the
audience will choose:
 His daughter the princess has lost her smile.
 The princess has been kidnapped.
—Paul Fournel and Jean-Pierre Énard,
The Theater Tree (1986)

A later colleague of Queneau's in OULIPO was the writer Paul Fournel, whose textless novel, *Suburbia*, I discussed in chapter 2. Fournel and the writer Jean-Pierre Énard (1943–87) wanted to write a play that required the audience (like the reader in Queneau's story) to make choices. They did not want this to be a play that would simply be read; rather, they wanted it to be performed before an audience, with the audience making choices. This presented Fournel and Énard with the problem of how to stage such a production. For there to be a sufficient number of optional scenes for the play (and the choices) to be interesting, the cast would have to learn many scenes, and assuming there were any sort of sets, the crew would have to be ready to change them quickly and on short notice.

To appreciate the brilliance of the Fournel-Énard play, imagine that the audience must choose between two alternatives at the end of each of three scenes, so at the end of scene 1, scene 2, and scene 3. Scene 4 will be the play's conclusion. This means that the actors would have to learn fifteen scenes. They would have to know scene 1 and two scene 2s, since the audience is to choose between two possible second scenes, scene 2a and scene 2b. At the conclusion of either of these scenes, the audience is then to be given a choice between two versions of scene 3—so two possible scenes to follow scene 2a and two possible scenes to follow scene 2b. This means there are four different scenes the actors would have to be prepared to perform for scene 3. Similarly, each of these four scenes can be followed by one of two scenes for scene 4, so the actors would need to learn eight different fourth scenes. Given this plan, in which the audience has three chances to participate in the play's development by choosing between two possibilities,

the actors would need to memorize $1 + 2 + 4 + 8 = 15$ scenes, allowing for eight different plays. Arguing as we did above, if the playwright wants the play to have five scenes and wants to give the audience two choices at the end of each of the eight possible scene 4s, the actors would need to learn an additional sixteen scenes. This means that the actors would have to learn a total of thirty-one scenes and there would be sixteen possible plays. A graph for such a play would be a simple tree diagram.

Fournel and Énard came up with an ingenious way to reduce the number of scenes the actors would need to learn in order to still offer the audience a choice at four different points in the play: they forced a structure on the choices available to the audience in a way that would give the audience the impression that they had a great deal of leeway in making their decisions. In the play, *The Theatre Tree: A Combinatory Play* (1986), each potential play consists of five scenes.[10] The first scene is fixed. The audience then chooses the scenes for scene 2, 3, 4, and 5, so as in the above example, each play will have five scenes and the audience will make four choices. To perform all of the possible five-scene plays— there are sixteen possible plays in all—the actors are required to learn fifteen different scenes, rather than the thirty-one calculated above. (They would need to learn even fewer plays if the last act of the play did not consist of two scenes.) This economy is a tribute to the text's structure, which Fournel and Énard based on the simple graph shown in figure 6.4.

The first scene, and choice, is given in the quotation introducing this section. Whether the audience chooses to go to scene 2a or scene 2b, at the end of that scene they are offered another choice: the audience must decide whether a masked hero, who has either made the princess smile or rescued her from her

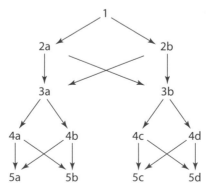

Figure 6.4. Graph of the possible sequences of scenes in Fournel and Énard's *Theatre Tree: A Combinatory Play.*

kidnappers, is the king's son or the queen's lover. So, although the audience cannot know this, they are presented with the same choices for the third act regardless of which scene they had chosen for the second act. As we can see from the graph in figure 6.4, the third choice is a bit more complicated, depending on the second choice: in the case that the masked man was chosen to be the king's son, the audience must decide if the princess, who has fainted, will awaken or remain unconscious; in the case that the masked man in the queen's lover, the audience must decide if the king will kill the queen or challenge her lover to a duel. As a final, fourth choice, the audience must decide if they want a happy or unhappy ending. The happy ending is used for scenes 5a and 5c, the unhappy ending for the scenes 5b and 5d.

LOOKING AHEAD

All of the writers discussed in this chapter allowed, or required, the reader or audience to make choices. This means that these writers put choice at the center of their pieces: they gave up some authorial control. Chapter 9 examines writers and artists who gave up all, or close to all, control in the realization of their work by allowing chance, randomness, or just the disorder of our daily lives to play an important role in the production of their work.

In the next chapter, however, I discuss a traditional but demanding poetic structure that can be modeled, and so better understood, using special one-to-one correspondences known as permutations. We then turn to an innovative twentieth-century collection of poems that are interrelated through a special property of the sequence of counting numbers known as the Fibonacci numbers. Finally, we look at some poets who employed mathematical ideas either to give their poems form or to provide them with content.

Poetry, Permutations, and Zeckendorf's Theorem

Structured and Programmed Poems

All we need is fourteen lines, well, thirteen now,
and after this one just a dozen
to launch a little ship on love's storm-tossed seas . . .
—Billy Collins, "Sonnet" (2001)

At least until the twentieth century, the authors who most heavily relied on a predetermined structure for their compositions were poets. Poetic structures were almost always determined by such an elementary mathematical idea—simple counting—that it is not really fair to maintain that they were developed using mathematical concepts. These counts of syllables or lines almost certainly followed the invention of these forms based on their aesthetic qualities, yet the counts became intrinsic to what makes a poem a haiku or a sonnet or a sestina. In this chapter we examine a couple of more elaborate twentieth-century poetic structures based on mathematical ideas, but first let's look a bit more closely at the classical sonnet and sestina forms.

The sonnet, a form that was invented in Italy in the 1230s, has three different structures: a metrical structure based on a counting of the syllables in each line, a rhyme scheme based on a numbering of the lines, and a count of the total number of lines.[1] Additionally, a sonnet has a rhetorical structure that derives from its rhyme scheme. For example, the traditional Italian sonnet consists of fourteen lines, of ten or eleven syllables each, that should be thought of as two groups of lines—the first eight lines and the last six lines. The first eight lines have a rhyme pattern indicated by the sequence of letters a b b a a b b a. The rhyme scheme for the remaining lines is less rigidly prescribed, but a typical rhyme scheme for the

last six lines of an Italian sonnet is c d c d c d. This separation of the Italian sonnet into stanzas with distinct rhyme schemes gives it a rhetorical structure. Typically, in the first line of the sonnet, some statement is made or question posed; at the end of the eight-line section this opening position is modified; and then in the last six lines some sort of resolution is offered or conclusion is reached.

In the sixteenth century Sir Thomas Wyatt (c. 1503–42) became the first English writer to employ a modified version of the Italian sonnet form. The sonnet blossomed when Shakespeare (1564–1616) took it up. He kept the sonnet's fourteen lines, but adopted one of Western poetry's most familiar metrical schemes, which is based not on a direct count of syllables but on a count of *iambs*. An iamb is a combination of two sounds—an unstressed one followed by a stressed one. For example, the sentence "I saw the dog" consists of two sequential iambs: "I saw" and "the dog." The most common metrical pattern in English poetry is iambic pentameter, wherein each line of the poem contains five iambs (and so sounds like "da-Dum, da-Dum, da-Dum, da-Dum, da-Dum"): "I saw the dog—she had the ball in sight." Iambic pentameter provides the meter for almost all of Shakespeare's sonnets.

Shakespeare also adopted the rhyme scheme a b a b, c d c d, e f e f, g g, a grouping of three quatrains followed by a couplet, which naturally imposes a rhetorical structure on the sonnet different from the one in the classical Italian sonnet. Each of the groupings of four lines usually introduces an idea, and the couplet at the end of the sonnet offers some sort of summary or insight.

We will see in this chapter that some twentieth-century poets experimented with ideas from advanced mathematics to provide their poems with both form and content. Poets do, however, continue to employ classical forms, or variations on them. For example, the contemporary American poet Billy Collins' poem "Sonnet," the first three lines of which introduce this chapter, is not a classical sonnet; the number of iambs varies from line to line, and there is no prescribed rhyme scheme. Yet, as the first line of Collins' sonnet proclaims, he feels compelled to at least retain the sonnet's fourteen lines; otherwise, it is just a poem and has no connection with sonneteers past.

The Sestina

In the preceding paragraphs I focused on the sonnet because it is a classical form based on the simplest mathematical principles—a simple count of syllables (or of iambs) in each line and a rhyme scheme based on the numbering of the fourteen lines. A much more demanding traditional poetic form, known as the *sestina*, requires not only that separate stanzas have the same rhyming sounds at the ends

TABLE 7.1
Line-Ending Words in Elizabeth Bishop's "Sestina"

Stanza 1	Stanza 2	Stanza 3	Stanza 4	Stanza 5	Stanza 6
house	tears	child	almanac	stove	grandmother
grandmother	house	tears	child	almanac	stove
child	almanac	stove	grandmother	house	tears
stove	grandmother	house	tears	child	almanac
almanac	stove	grandmother	house	tears	child
tears	child	almanac	stove	grandmother	house

of their lines, but also that the lines of each stanza end in the same words, which have been shuffled in a particular way. While this shuffling can be explained in words, we can also model it with mathematics to better understand it.

A sestina has six, six-line stanzas followed by a three-line *envoy*. What is truly special about a sestina is that the same six words that end the lines in the first stanza are used to end the lines in each of the other stanzas, but in a different order in each stanza. And the way in which the six end-words in one stanza are rearranged to become the six end-words in the next stanza follows a fixed pattern. To see this pattern of end-word shifts, we begin with the first stanza of the poem "Sestina" (1956) by Elizabeth Bishop (1911–75):

> September rain falls on the house.
> In the failing light, the old grandmother
> sits in the kitchen with the child
> beside the Little Marvel Stove,
> reading the jokes from the almanac,
> laughing and talking to hide her tears.[2]

In table 7.1, I illustrate how these end-words shift from stanza to stanza.

At first glance this pattern of words might seem to be a random or arbitrary shifting of the last words of the lines from one stanza to the next. But a closer look reveals regularities. For example, we see that the end-word for the first line of any stanza shifts to become the end-word for the second line in the next stanza. Similarly, the end-word for the second line of any stanza becomes the end-word for the fourth line in the next stanza. There are similar patterns to the shifts for the words ending the third through the sixth lines of each stanza. The total pattern of shifts from one stanza to the next is as follows:

> The end-word of line 1 becomes the end-word of line 2.
> The end-word of line 2 becomes the end-word of line 4.

The end-word of line 3 becomes the end-word of line 6.
The end-word of line 4 becomes the end-word of line 5.
The end-word of line 5 becomes the end-word of line 3.
The end-word of line 6 becomes the end-word of line 1.

Symbolically, we can just view these shifts as changes in line numbers:

$$
\begin{aligned}
1 &\rightarrow 2 \\
2 &\rightarrow 4 \\
3 &\rightarrow 6 \\
4 &\rightarrow 5 \\
5 &\rightarrow 3 \\
6 &\rightarrow 1
\end{aligned}
$$

Such a rearrangement of the numbers 1, 2, 3, 4, 5, 6 is called a *permutation* of those numbers; a permutation of any set is simply a one-to-one correspondence between the set and itself. It will help us understand the sestina if we see how any two permutations of the numbers 1 through 6 can be combined to form a possibly different permutation of 1 through 6. For example, if we want to combine the permutation above with the permutation

$$
\begin{aligned}
1 &\rightarrow 3 \\
2 &\rightarrow 6 \\
3 &\rightarrow 5 \\
4 &\rightarrow 1 \\
5 &\rightarrow 2 \\
6 &\rightarrow 4
\end{aligned}
$$

we could apply the second permutation and then the first, and obtain

$$
\begin{aligned}
1 &\rightarrow 3 \rightarrow 6 \\
2 &\rightarrow 6 \rightarrow 1 \\
3 &\rightarrow 5 \rightarrow 3 \\
4 &\rightarrow 1 \rightarrow 2 \\
5 &\rightarrow 2 \rightarrow 4 \\
6 &\rightarrow 4 \rightarrow 5
\end{aligned}
$$

which is the permutation

$$
\begin{aligned}
1 &\rightarrow 6 \\
2 &\rightarrow 1 \\
3 &\rightarrow 3
\end{aligned}
$$

$$4 \rightarrow 2$$
$$5 \rightarrow 4$$
$$6 \rightarrow 5$$

(Note that the above two permutations could have been combined in the opposite order, meaning that we could have applied the first permutation and then the second. This would lead to a different permutation.)

The collection of all permutations of 1, 2, 3, 4, 5, 6, together with the operation of combining them by iteration, forms a mathematical group (one example of which we saw in chapter 3 in the discussion of Bourbaki's mathematical structures). Since there are 720 permutations of 1 through 6, this group has 720 elements (compared with the four elements in the group we saw before). The important point about the permutation that we uncovered behind the structure of the sestina is that if you repeatedly apply it—and so combine it with itself—after six iterations all of the numbers will be back in their original place.

We could verify this mathematically by showing that combining this permutation with itself six times would yield the identity permutation, the one that leaves every number in its original position. But to see that this is the case, let's just follow the position of the end-word of the first line of the first stanza in each of the subsequent stanzas. In the second stanza it will end the second line, in the third stanza it will end the fourth line, in the fourth stanza it will end the fifth line, in the fifth stanza it will end the third line, and in the sixth stanza it will end the sixth line. Since the pattern from stanza to stanza is that the end-word for the sixth sentence becomes, in the next stanza, the end-word for the first sentence, it follows that if there were a seventh stanza in the sestina it would have the same end-word for its first line as did the first stanza. We could similarly trace the path of the end-word for each line of the first stanza and see that, after the sixth stanza, they would all return to their original position. So the six-stanza sestina perfectly exhausts all of the end-word rearrangements generated by the permutation.

It is a mathematical property of any permutation of 1, 2, 3, 4, 5, 6 that when it is repeatedly combined with itself, all of the numbers will return to their original positions after six or fewer iterations. The question is, are there other permutations of 1, 2, 3, 4, 5, 6 that have the property that after six iterations, and not before, all of the numbers will be back in their original positions? The answer is that there are many—there are 120 such permutations. We will probably never know the aesthetic reason poets settled on the above permutation to structure the classical sestina.

Zeckendorf's Theorem and Twenty-One Minus One Poems

We saw that in the sestina there are structural interconnections between the separate stanzas that could be modeled with what is known as a permutation. In this section instead of examining a single poem with several stanzas, we will look at a collection of twenty poems where there are subtle relationships between the separate poems. These hidden structures are not given by some formal iterative process, as with the sestina, but are based on one property of a special sequence of numbers introduced by the Italian mathematician Leonardo de Pisa, more commonly known as Fibonacci (c. 1170–1250).

At the beginning of the thirteenth century Fibonacci wrote a tract entitled *Book of Computation* (*Liber Abacci*, 1202). This book is remembered mostly for two things: for its advocacy for the adoption of the Hindu-Arabic number system (our present base-ten placeholder system which requires the use of only the ten digits 0, 1, 2, 3, 4, 5, 6, 7, 8, and 9 to represent any whole number) and for the introduction of a special sequence of numbers which is today known as the Fibonacci sequence.

Fibonacci discovered his well-known sequence of numbers while solving the following problem concerning the reproduction rate of rabbits:

> A certain man had one pair of rabbits together in a certain enclosed place, and one wishes to know how many are created from the pair in one year when it is the nature of them in a single month to bear another pair, and in the second month those born to bear also.[3]

Fibonacci offered the following solution for the number of pairs of rabbits at the end of each month:

After 1 month	2 pairs
After 2 months	3 pairs
After 3 months	5 pairs
After 4 months	8 pairs

In this sequence each term, beginning with the third, is the sum of the previous two terms, so the sequence of pairs of rabbits is 1, 2, 3, 5, 8, 13, . . .[4] In his solution to the problem above, Fibonacci does not point out how this sequence replicates but simply continues to keep track of how many pairs of rabbits there are at the end of each month to conclude that at the end of the year there will be 377 pairs of rabbits.

The contemporary poet Paul Braffort exploited an interesting property of the Fibonacci numbers to provide a structure for his collection of poems *My Hypertropes: Twenty-One Minus One Programmed Poems* (*Mes Hypertropes*, 1979).[5]

A mathematically aware reader might suspect from this title that the Fibonacci numbers play some role in the programming of the poems: rather than saying that the collection contains twenty poems, Braffort expressed this fact by representing 20 as the difference of the Fibonacci numbers 21 and 1. But this collection's title does not even hint at the twentieth-century mathematical result Braffort relied upon in writing his poems.

In 1972 the Belgian mathematician Eduard Zeckendorf (1901–83) established the following theorem:

Every positive integer can be represented as a sum of *non-consecutive* Fibonacci numbers in one and only one way.[6]

Zeckendorf's theorem says more than that "every number may be written as a sum of Fibonacci numbers": it says that there is a unique way to express every positive integer as a sum of Fibonacci numbers no two of which are adjacent in the listing of the Fibonacci numbers. For example, there are several ways to write 14 as a sum of Fibonacci numbers:

$$14 = 13 + 1 = 8 + 5 + 1 = 8 + 3 + 2 + 1 = 5 + 3 + 3 + 2 + 1, \ldots$$

Just one of these, the first one, contains only nonconsecutive Fibonacci numbers. Such a representation of a number is now called its *Zeckendorf representation*, and these representations play a role in the structures of Braffort's poems.

Braffort dedicates each poem in *My Hypertropes* to another writer, but that is not the "programmed" aspect of the collection; this comes from the Zeckendorf representation of the number of any particular poem. For example, the Zeckendorf representation of 12 is $12 = 8 + 3 + 1$. This means that the poem numbered 12 shares some of the characters or images with the poems numbered 1, 3, and 8. Two contemporary poets, Amaranth Borsuk and Gabriela Jaurequi, who have provided a magnificent translation of *My Hypertropes* into English, explain that this approach allows characters to suddenly appear in unexpected locations or for certain turns of phrase to recur, forcing Braffort to construct scenarios to account for their reappearance.[7]

In order to incorporate poems numbered with Fibonacci numbers into this scheme—because each of the numbers 1, 2, 3, 5, 8, and 13 is its own Zeckendorf representation—Braffort used the Zeckendorf representation only for any non-Fibonacci number; for a Fibonacci number he used its representation as a sum of the two previous Fibonacci numbers. With this scheme, only Braffort's first poem, "The Preallable Explanation (or The Rhyme's Reason)," is not influenced by any of the others.[8] Possibly because of this, and possibly because the number

1 appears in the Zeckendorf representation of so many of the numbers 1 through 20, the first poem introduces many of the characters and concepts that suddenly appear in later poems. Both to illustrate the complexity of Braffort's wordplay and to show how connected the first poem is with later ones, I give Borsuk and Jaurequi's entertaining translation of that poem:

> This is my work, this is my study,
> like Jarry, Cyrano puffy,
>
> to split hairs on Rimbaud
> and on willies find booboos.
>
> If it was fair or if it snowed
> in Lhassa Emma Sophie Bo-
>
> vary widow of slow carnac
> gave herself to the god of wack.
>
> Leibnitz, saying: "Vers . . ." What an ac-
> tor for this superb "Vers . . .". Oh "nach"!
>
> He aims, Emma, the apoplexy
> of those drunk on galaxy.
>
> At the club of "spinach" kings (nay,
> Bach never went there, Banach yea!)
>
> Leibnitz—his graph ibo: not six
> mus, three nus, one phi, bona xi—
>
> haunts without profit Bonn: "Ach! Gee
> if I were great Fibonacci!!! . . ."[9]

Braffort's playfulness is apparent even in this first poem; the name Fibonacci is given by the ending sounds of the lines:

> line 2 fi
> line 4 bo
> line 6 fi-bo,

continuing until line 16 ends in "phi, bona, xi," and then the last line of the poem ends with "Fibonacci."

Next let's see how portions of this poem play out in later poems whose numbers have 1 in their Zeckendorf representation. As an example, let's look at the

twelfth poem "MODELS (or Petrovich's Band)." (Recall that $12 = 8 + 3 + 1$.) Poem 12 is written following a classical metrical scheme, called an alexandrine, and has two six-line stanzas. In each stanza the first line is influenced by Poem 1, the third line by Poem 3, and the sixth line by Poem 8.[10] These influences are not from the entire Poems 1, 3, or 8, but from specific lines. For example, the first line of the sixth couplet in Poem 1,

> He aims, Emma, the apoplexy,

informs the first line of Poem 12,

> For a sweet word from Emma: a word for model,

and the second line of the sixth couplet from Poem 1,

> of those drunk on galaxy,

informs the first line of the second stanza of Poem 12,

> Our galaxies have already packed their valise.

From Poem 3 the phrase

> . . . when I saw you
> weave a letter to Elise . . .

becomes, in Poem 12,

> they say from this time forth five letters to Elise.

And from Poem 8, the couplet

> And Muses who compose
> They're a troop they're tropes

becomes

> Tragic tropes: Leonardo is Fibonacci.

("Tragic tropes" is a play on the title of Lévi-Strauss's memoir *Tristes Tropiques*, an excerpt of which formed an entire chapter in Cortázar's *Hopscotch*.)

Thus, Braffort's collection of poems, *My Hypertropes*, has an internal structure provided by a mathematical theorem. The structure does not entirely determine these poems, but it does provide connections between the poems that might not be there otherwise.

Concrete Poetry and Mathematical Images

All definitions of concrete poetry can be reduced to the same formula:

form = content / content = form.

—Mary Ann Solt, *Concrete Poetry* (1968)

Now I want to discuss a few poems that include mathematical elements. In the first poem, that element is a curve from calculus that provides a structure for the narrative of the poem; in a later poem these elements are mathematical symbols that have no obvious interpretation.

The first poem we take up, "Murderous Logic" ("La Logique Assassine"), has a visible geometric structure that informs its narrative; the poem and the structure are shown in plate 7.1. This poem was a collaboration between Man Ray and his wife, the Belgian poet Adon Lacroix (1887–1986). Man Ray and Lacroix were married in 1914 and immediately began to collaborate on projects, including a book of woodcuts and poems in 1914 and a book of pen-and-ink drawings and poems in 1915. The lithograph I want to discuss is one of their 1919 collaborations; Lacroix wrote the poem and Man Ray provided it with its dramatic presentation.[11]

One contemporary scholar, William Bohn, has given an interpretation of this poem. The poem begins in the upper left corner of the frame with the poem's title, which is followed by a few lines that are, in Bohn's words, "nearly impenetrable." In English translation they read:

it is backward
and an X-ray of
anyone wrongly or
rightly convinced yes but
irreparably terminated forever.

Bohn speculates that Lacroix is saying something like "murderous logic is the reverse of ordinary logic . . . just as an X-ray is the opposite of a photograph."[12]

The remainder of the poem is not quite as oblique, but in the end, it leaves the reader with a central, unresolved ambiguity. To get to that ambiguity the narration follows the inside curve, spiraling towards the center; after it reaches the center, the narration spirals outward along the other curve. At the beginning of the descent, a couple is beginning to make love; as they spiral inward, they become increasingly aroused. At the center of the spiral, the narration starts to

Plate 7.1. The concrete poem "La Logique Assassine," 1919, by Man Ray and Adon Lacroix. © 2013 Man Ray Trust / Artists Rights Society (ARS), New York / ADAGP, Paris.

move away from the center along the other curve. When the lovers exit the spiral, we learn that the man had been satisfied with the sexual encounter but the female narrator had not been. She complains to the man and blames the failure on another woman.

Bohn looks to the text that is printed outside the spirals to decipher what has happened. From these first words it is not clear whether the couple had just been involved in a ménage à trois, or if the female lover had become distracted because

she had remembered the other woman, or if the other woman had been making love with the man all along. Then one of two things seems to happen: either the narrator kills the other woman, or she commits suicide. Bohn settles on the latter: the poem most likely reveals that the narrator comes across the man and the other woman in the woods. They are making love. The narrator interrupts them, they exchange words, and then the other woman kills herself.[13]

Man Ray's use of the two spirals to present Lacroix's poem works on two levels: on the level of the lovers and the possibly disorienting effect of their rising passion, and on the level of the irrational logic of a murderer or a suicide. This poem is but one example of a type of poetry that has more or less always existed but was embraced by poets throughout the twentieth century. This is so-called *visual*, or *concrete*, poetry.

In chapter 1 we examined several responses to what Breton called the crisis of the object. These included presenting ordinary objects as art objects, such as readymades and readymades aided; producing objects one had encountered in dreams or imagined when in a dreamlike state; and displaying mathematical objects without comment. Bohn, whose explication of Lacroix and Man Ray's poem we considered above, has described how many twentieth-century attempts to remake or reimagine poetry can be understood if we consider what he has called *crises of the sign*. To understand fully Bohn's argument would require knowledge of the basic ideas of the branch of linguistics known as semiotics. However, if we allow ourselves to be fairly imprecise, we can understand why Bohn would have reached his conclusions.

Semiotics studies the relationship between symbols and what they represent: there is the symbol (for example, the word *c-a-t*), called the signifier; there is the concept of "cat," called the signified; and then there might be a particular cat, called the referent. So when you read "Babu is a cat," the physical cat, named Babu, is the referent, the concept of a cat is the signified, and the word "cat" is the signifier. And we have already seen this distinction in chapter 3, in the discussion of Frege's definition of the concept "three." This concept is the number that we usually represent by the numeral 3—so "three" is the signified and 3 is the signifier.

In his book *Modern Visual Poetry* Bohn described the three "crises of the sign" in twentieth-century poetry. These are not crises in the sense that they were difficulties to be overcome by poets; rather, they were challenges to the standard conception of poetry both in form and content. The first crisis occurred when "poetry was suddenly expected to perform the function of painting."[14] This is perhaps the most easily understood of Bohn's three crises. We have already seen

an example of this with Man Ray and Lacroix's poem "Murderous Logic." The poem is pictorial and not easy to read.

Bohn's second crisis of the sign is more subtly described, so it accommodates a wide range of poetic styles. As Bohn described it, the second crisis "was not really precipitated by separating the signifier from the signified but by privileging the former at the expense of the latter."[15] Such forms have both visual and verbal elements—they include poems with creative typography—but not necessarily any mathematical elements. To understand but one example, consider the poem "Like Attracts Like" by the poet Emmett Williams (1925–2007).[16] This poem, which has no mathematical elements or structure, consists of thirteen lines, each containing only three words: "like attracts like." In the first line the words are separated by something like seven spaces. On each successive line "attracts" remains in the center of the line, but the first "like" has shifted slightly to the right, closer to "attracts," and the second "like" has shifted slightly to the left, also closer to "attracts." By the ninth line the *e* in the first "like" is slightly overlapping the *a* in "attracts," and the *l* in the second "like" is slightly overlapping the *s* in "attracts." In line 13, the last line of the poem, the two "like's" appear as "likelike" typed over the word "attracts." So the poem is shaped like a V that is flat on the bottom; the wide top is given by the eighteen spaces of the poem's first line, and the narrower bottom is given by the eight spaces of the poem's last line.

Many of the poets who wrote these shaped poems, as well as those manifesting the first crisis of the sign, frequently identified themselves as concrete poets. The literary scholar Mary Ellen Solt examined the different concrete poetry movements and distilled from them the common element that introduced this section:

form = content / content = form.

This formula itself is a concrete expression—it is not to be analyzed mathematically. Rather, it manifests Solt's conclusion that the form and content of a concrete poem are inextricably linked, as in Williams' poem "Like Attracts Like."

Bohn then describes how the third crisis of the sign is "related to the first two but involved a different transgression." This transgression was to violate the "traditional prohibition against semiotic incest, the linguistic sign was transformed into a visual sign."[17] To give an example of this, we can move to the middle of the second half of the twentieth century, when the contemporary poet Charles Bernstein, along with Bruce Andrews, founded the literary journal *L=A=N=G=U=A=G=E* in 1971. Bernstein and Andrews were critical of "aesthetic rigidity—the narrow fo-

cusing of putting forward one stylistic or procedural choice above all others."[18] Bernstein further explained his view of poetry in one of his essays: "Every phrase I write, every juxtaposition I make, is a manifestation of using a full-blown language: full of possibilities of meaning & impossibilities of meaning. It can't be avoided."[19]

I think it is fair to say that Bernstein's understanding of how a poet should use language is analogous to how a mathematician allows for the use of novel concepts in his or her work. For example, as Breton alluded to in "Crisis of the Object," mathematicians' acceptance of non-Euclidean geometries opened up new and active areas of research and discovery. Perhaps similarly, Bernstein did not want to restrict how he used language, broadly interpreted, to express his poetic ideals. I want to end this chapter with a poem Bernstein wrote that even goes beyond using "a full-blown language." This poem, "Erosion Control Area 2" (1995),[20] begins with these three lines:

Clothe \leq ma·

oμ β wolμ iε

Whicɸ t∩ ou \geq

The entire four-page-long poem is creatively typeset and includes letters from both the Latin and Greek alphabets and symbols from mathematics. Many of the mathematical symbols have no referent. For example, the symbol \cap is like the plus sign, +. It is a binary operation that acts on sets: given two sets A and B, the notation $A \cap B$ represents the set containing the elements that are contained in both A and B; it is called the intersection of A and B. The symbol \leq is not an operation but something used to compare the relative sizes of two elements of a set which has an order structure—for example $3 \leq 4$, $4 \leq 4$, and $\aleph_0 \leq c$.

LOOKING AHEAD

What Bohn called the three crises of the sign were simply the results of poets' seeking new forms or structures or content to express their artistic visions. Sometimes, as with Man Ray and Lacroix's poem "Murderous Logic," these structures were purely mathematical. Sometimes, poets simply used mathematical symbols for visual impact. Of course, any mathematical symbol is entirely arbitrary; we could just as easily use the symbol $*$ to indicate addition as the symbol +. There is also an arbitrariness in language between the signifier and the signified, or the signifier and the referent if you prefer. In chapter 9 we will see how other writers

have exploited this arbitrariness in order to introduce chance elements into their art. But before we look at these examples, we will look at how some artists and writers employed mathematical symbols that have fully understood meanings—the numerals 1, 2, 3, . . . , and the symbols π and $\sqrt{-1}$—in their paintings, poetry, and theoretical speculations.

Numbers and Meaning

Targets, Numbers, and Equations

I'm interested in things which suggest the world rather than
suggest the personality. I'm interested in things which suggest
things which are, rather than in judgments. The most
conventional thing, the most ordinary thing.

—Jasper Johns, *Drawings* (1974)

Numbers and their real or imagined attributes have long inspired visual artists
and writers. While the Pythagorean, mystical meaning of certain numbers aided
seers and fortunetellers from the sixth century BCE through the Renaissance,
nonmystical, even mundane representations of numbers began to appear in
twentieth-century literature and art. We have already seen that some poets em-
ployed exotic, or at least unfamiliar, mathematical symbols in their poetry. In
this chapter we look at how some artists and writers used numbers and numerals
in their works.

One of the most highly respected of these artists was Jasper Johns. In his first
solo show, in 1958, Johns exhibited two of his best-known paintings, one of the
American flag and the other of a target. He continued painting flags and targets
after that first exhibition, but the works of greatest interest to us are his numbers
paintings and lithographs. These pieces can be separated into three types: (1) a
series of ten canvases each painted or printed with one of the ten numerals from
0 to 9, with the numeral filling the entire canvas; (2) a single canvas with the nu-
merals 0 through 9 superimposed over each other; and finally, (3) a series of single
canvases, each divided into an array with one of the numerals 0 through 9 inside
each cell of the array. The first of these eleven-by-eleven grid paintings, *Grey Num-
bers* (1958), is one of several where the numbers fill the entire frame:

First row	0 1 2 3 4 5 6 7 8 9
Second row	0 1 2 3 4 5 6 7 8 9 0
Third row	1 2 3 4 5 6 7 8 9 0 1
Fourth row	2 3 4 5 6 7 8 9 0 1 2
.	
Eleventh row	9 0 1 2 3 4 5 6 7 8 9

Grey Numbers is painted in various shades of grey; some of the other paintings offering the same grid pattern are painted varying shades of red or of white.

Beyond the observation that like Johns' paintings of flags and targets, these pieces proclaim their modernity by not offering portrayals of landscapes, persons, or scenes (real or imagined), the question I want to address is, What should we make of these paintings, drawings, and lithographs? An interview Johns gave in 1965 indicates something about his reasons for producing pieces consisting entirely of the numerals 0 through 9, either individually or together. The interviewer asked, "What was it first made you use such things as flags, targets, maps, numbers and letters and so on as starting-points?" Johns began his answer with, "They seemed to me pre-formed, conventional, depersonalized, factual, exterior elements." He went on to say: "I'm interested in things which suggest . . . things which are, rather than in judgments. The most conventional thing, the most ordinary thing." So Johns' appeal to numerals has no mystical or otherworldly connotation. For him a numeral is a perfectly ordinary object, just like some of the other objects he represented in his art, such as a flashlight or a Coke bottle.

Johns, of course, is correct in saying that numerals are ordinary objects, the sort of thing we attach to our houses or emboss on our license plates. They do not need to be thought of as representing numbers; they can be seen merely as symbols or even abstract forms—signifiers without referents—like the mathematical symbols in Bernstein's poem "Erosion Control." The dichotomy of viewing numerals as mere symbols or as representations of abstract numbers is at the heart of trying to understand the paintings of another twentieth-century artist, Alfred Jensen (1903–81).

We begin our look at a few of Jensen's paintings with a modest example, *The Apex Is Nothing* (1960), which at first glance might not seem to have anything to do with numbers. The first thing you might notice about this canvas (shown in plate 8.1) is how it has been partitioned into four rectangles with a small rectangle covering where they meet. Next, you probably notice the symbols, both in the center of the canvas and arranged in four large X-shapes in each of the four large rectangles.

Plate 8.1. Alfred Jensen, *The Apex Is Nothing*, 1960. Photograph by Ellen Page Wilson, courtesy Pace Gallery. © 2013 Estate of Alfred Jensen / Artists Rights Society (ARS), New York.

It is helpful to the interpretation of the symbol in the center of the painting and the ones that appear in the Xs to know that Jensen spent the first six years of his life in Guatemala and that, earlier in 1960, Jensen had read a book that rekindled his interest in the culture that had surrounded him in his early childhood.[1]

Two aspects of the Mayan culture seem to have inspired Jensen—the Mayan number system and their calendar systems. Their number system has two striking features. The first is that the Mayans had a symbol for zero at least 500 years before Fibonacci introduced a symbol for zero to Europe. The second is that the Mayan system was in base twenty (in contrast to our base ten system), which means that the Mayans needed symbols for the digits 1 through 19, as well as for zero. For the numbers 1 through 4 the Mayans used one, two, three, or four dots. Then, rather than using five dots for 5, they used a short horizontal line segment. This allowed them to represent 6 through 9 with a horizontal line under one, two, three, or four dots; 10 was represented by two horizontal line segments, one above the other. By always writing five dots as a horizontal line segment, the Mayans could represent any of the numbers 1 through 19 with line segments and up to four dots. For example, 19 was three horizontal lines and four dots.

The symbol in the center of Jensen's painting is the Mayan symbol for 18, which consists of three horizontal line segments and three dots, except that Jensen rotated it so that the lines are vertical, with the three dots to the left of them. Indeed, all of the symbols that make up the X-shapes are Mayan numerals (albeit all rotated 90 degrees). Let's first try to make sense of why Jensen placed 18 in the center of this painting; to do this it helps to understand the Mayan calendars. The Maya used two calendars, one based on a 365-day year, the *Haab*, and another based on a 260-day sacred year, the *Tzolkin*. The Haab is divided into eighteen months, each of which is twenty days long (there is also a five-day month). The Tzolkin is divided into twenty periods of thirteen days. So the Mayan symbol for 18 in Jensen's painting probably refers to the eighteen standard months of the Haab.

The Mayan numerals arranged in the forms of the four Xs can also be decoded, not by using the Mayan culture but another one. Each of the crossing lines in the two upper Xs are formed by even numbers (the X on the upper left by the numbers 18, 16, 14, 12, 10; and the X on the upper right by the numbers 0, 2, 4, 6, 8). Similarly, each of the crossing lines in the two lower Xs are formed by the odd numbers 9, 7, 5, 3, 1, and 11, 13, 15, 17, 19. Jensen wrote that his interest in contrasting even and odd numbers owed to his understanding of ancient Chinese cosmology, wherein the odd numbers, 1, 3, 5, 7, 9, were thought to be "Heavenly" and the even numbers, 2, 4, 6, 8, 10, were thought to be "Earthly." Why he represented them in the Mayan numeration system is not self-evident, but we can speculate on the reasons after knowing what he wrote seventeen years later about two of his later paintings: "I express the . . . six spectral color hues as the placement for areas 0–1–3–5–7–9, brought to a completion of twenty. . . . Thus, I demonstrate a uni-

fying method characteristic of the vigesimal system first created by the ancient people of China and Maya."[2]

Although the role of numbers in ancient Chinese cosmology, especially the role of odd-even duality, is clearly based on mystical properties, Jensen wrote that the "mystical associations of number" did not mean much to him. Instead, it was their use in ancient calendars and in keeping track of the motions of celestial bodies and "the edge of the sun reappearing" that were a source of Jensen's "concrete and symbolic number structures."[3] So it seems reasonable to speculate that Jensen's use of Mayan symbols to represent numbers central to ancient Chinese cosmology in this earlier painting was an attempt to unify the two systems.

Another painting, *The Light Color Notes* (1962), reveals Jensen's emerging affinity for using numbers as elements in his paintings while exploring their meanings in calendar systems. For this painting Jensen partitioned a canvas into seven horizontal strips. He painted the top and bottom strips black, and then each of the five central ones a brighter color, over which he painted the mathematical equations:

$$72 \times 260 = 18720$$
$$144 \times 208 = 29952$$
$$216 \times 156 = 33696$$
$$288 \times 104 = 29952$$
$$360 \times 52 = 18720$$

We do not know precisely what all of these numbers meant to Jensen, but we can guess what he might have been indicating with the top and bottom equations. Although the two Mayan calendars are of different lengths, they occasionally agree. Suppose the first day of each of these two calendars coincides on some particular day; then they will eventually share their first day when some multiple of 365 equals some multiple of 260. The smallest number that is a multiple of both 365 and 260, called the least common multiple of the two numbers, is 18,980. So 18,980 days after the two calendars have their first day on the same day they will have their first days on the same day again. We also have the factorizations $18,980 = 365 \times 52$ and $18,980 = 73 \times 260$. These two equations are close to Jensen's, but they are off a bit. This is because in this painting, and in others, Jensen does not use the 365-day year but what is sometimes knows as the 360-day solar year, which equals eighteen of the twenty-day Mayan months.[4] This painting shows that seventy-two 260-day years contains the same number of days as fifty-two 360-day years.

One of Jensen's most ambitious projects is his large 78- by 144-inch painting *The Ionic Order* (1979). This painting contains a dizzying display of equations

and captions. For example, the upper left corner of the canvas starts with a numbered list of seven equations:

$$3 \times 11 = 33, \ 5 \times 11 = 55, \ 7 \times 11 = 77, \ 9 \times 11 = 99,$$
$$11 \times 11 = 121, \ 13 \times 11 = 143, \ 15 \times 11 = 165,$$

which are seven consecutive odd multiples of 11. Then to the right of these equations Jensen painted the six lines:

IONIC DOUBLE YEAR

$= 522$ DAYS.

TEMPLE

DEDICATED

IN

344

It is not clear whether these words apply to the above equations or to the ones listed in a column to the right of the words:

$$4 \times 6 = 24, \ 6 \times 6 = 36, \ 8 \times 6 = 48, \ 10 \times 6 = 60,$$
$$12 \times 6 = 72, \ 14 \times 6 = 84, \ 16 \times 6 = 96,$$

which are seven consecutive even multiples of 6.

All we can conclude about this remarkable painting is that Jensen was presenting us with something he had uncovered. The numbers and equations have something to do with cosmology or calendars—we just do not know exactly what. Our understanding of why Jensen displayed these equations is further undermined by something he wrote that somewhat contradicts his claim that he was not interested in numbers' mystical properties: "My use of numbers is governed by the duality and opposition of odd and even number structures."[5]

Two significant artists of the second half of the twentieth century wrote articles on Jensen's work, and they offered conflicting views of how we should think about these paintings. The first of these artists was Donald Judd (1928–94), who is best known for producing three-dimensional pieces that have strong geometric lines. Judd admired Jensen's work. In 1963 he wrote of Jensen's use of numbers and equations in his paintings, "The theories are important to him and completely irrelevant to the viewer."[6]

The other twentieth-century artist who wrote about Jensen's paintings and drawings was Allan Kaprow (1927–2006). Kaprow is known for inventing the concept of a *happening* in the late 1950s, perhaps motivated by something he later wrote (in the mid-1960s), "The line between art and life should be kept as fluid,

and perhaps indistinct, as possible."[7] To confront this line, people would come together and participate in an event—the happening—which an artist might have choreographed or which might consist of some entirely ordinary act such as flying on a "jetliner going from New York to Luxembourg with stopovers at Gander, Newfoundland, and Reykjavik, Iceland" or moving "up and down the elevators of five tall buildings in midtown Chicago."[8]

In 1963, Kaprow wrote that Jensen's "theory of the universe" will need to be understood before we will be able to "truly grasp the importance" of his work.[9] I like to think of Kaprow's conception of Jensen's art, and of a person viewing it, as analogous to a happening and an audience. Jensen's act of painting was his participation in his own happening; no one needs to view his work for him to have produced it. But if an accidental audience witnesses a happening, the members of that audience will have no idea what is going on unless they have some insight into what the participants think they are doing.

Judd and Kaprow's contrasting views of modern art—that it can be appreciated and/or understood on its own or that it can be appreciated and/or understood only if you know something about the artist's theories—are examples of two themes that have dominated discussions of art and art theory for almost a century. I take up this matter in this book's last chapter. But I would like to note that on viewing these paintings, regardless of whether you know anything about Jenson's thinking, you can be overwhelmed by the purity with which they reveal the subtlety and breadth of the human imagination. Even more to the point of this book, anyone observing these paintings will intuit that, for some reasons we may never know, Jensen turned to numerals and numerical equations, mathematical symbols, and relationships to release his creative energies.

Numbers: Imagined and Imaginary

> Right now I am preoccupied with numbers. I do calculations
> from morning to night. . . . I've made a few small discoveries.
> —Velimir Khlebnikov to Mikhail Matyushin (1913)

In 1913 the Russian artist and writer Aleksei Kruchenykh (1886–1968) published a short collection of poetry, prose, and artistic manifestos, *Let's Grumble* (*Voropshchen*). This pamphlet also contained three lithographs, two of them by Kazimir Malevich. At the center of one of Malevich's lithographs, *Arithmetic*, are six symbols:

$$(:7 \ Й =)$$

The art critic John Milner wrote that these symbols appear to be "meaningless unless [they are] simply a general reference to arithmetic."[10] I would like to offer another possibility: Malevich was paying homage to his sometime collaborator, the poet, playwright, and mystic Velimir Khlebnikov (1885–1922).

The same year Malevich's lithograph was published, he, Khlebnikov, Kruchenykh, and the composer Mikhail Matyushin (1861–1934) staged an opera, *Victory over the Sun*.[11] Khlebnikov wrote a prologue for this opera, and Malevich did the costume and set designs. But Khlebnikov had two other obsessions during this same time: one was studying numbers and their roles in our understanding of both history and our place in the universe, and the other was writing a type of poetry that uses invented words that are phonetically close to one another. (We will see one example of this poetry in the next chapter.) Indeed, in 1913 he wrote to Matyushin that, as indicated in the quotation heading this section, he was doing "calculations from morning to night."[12]

These calculations led Khlebnikov to many conclusions, several about the role of the number 365. Here, we will look at just two of these, which I describe in order to offer some insight into how Khlebnikov combined both rational and mystical reasoning. His first discovery, if you will, is temporal and concerns historical events. In "Two Individuals: A Conversation" (1913), he observes that "in A.D. 131 a temple to Jupiter was built on the site of Solomon's temple"; then 365 years later, in 496, the Franks converted to Christianity; and then another 365 years later, in 861, the Bulgarians converted to Christianity. He also notes another important span of roughly 365 years, between Muhammad's migration from Mecca to Medina, in 622, and Russia's conversion to Christianity, in 988.[13]

Khlebnikov also became convinced that 365 is a key to understanding "man's right to first place on Earth," and not just because of its connection with calendars. "The Head of the Universe: Time and Space" (1919) begins with two claims: that "The surface of the earth is 510,051,300 square kilometers," and that "the surface of a red corpuscle—that citizen and star of man's Milky Way—[is] 0.000128 square millimeters." Khlebnikov determines that the ratio of these two numbers is $365 \times 10^{10} = 3{,}650{,}000{,}000{,}000$, which is off a bit: the ratio is closer to $398.5 \times 10^{10} = 3{,}985{,}000{,}000{,}000$. (We have no way to check another claim Khlebnikov made in that short essay, that the ratio of the largest shaded area to the smallest shaded area in some of Malevich's sketches equals 365.)[14]

Another of Khlebnikov's conclusions about how numbers guide our destinies was his "basic law of time," which involves only the addition and subtraction of powers of 2 and 3. He wrote: "A negative shift in time occurs every 3^n days and a positive shift every 2^n days." He then incorporated this observation into formulas

that would give the dates of certain significant events. For example, his *Law of English Sea Power* is given by the equation

$$x = k + 3^9 + 3^9 n + (n-1)(n-2)2^{16} - 3^{9(n-2)},$$

where k equals "the day in 1066 when the island was conquered by the Danes at the Battle of Hastings." Khlebnikov claims that if $n=1$ then "x falls on the year 1174, the year of the struggle with France; if $n=2$ then x comes out as 1227, the year of the struggle with Denmark; if $n=3$, then x comes out as 1588, the year of the Spanish Armada."[15] It is not easy to verify Khlebnikov's claims, as he does not describe how these calculations are to be performed. Recall that the Battle of Hastings occurred on October 4, 1066. If we take $k=1066$ and assume that each year contains 365 days, then the formula yields the years 1173, 1227, and 1586. On the other hand, since October 4 is the 277th day of the year, we might assume $k=1066+277/365=1066.76$. With this value of k the formula yields the years 1174, 1228, and 1587.

Khlebnikov did not restrict his attention only to whole numbers. The opening sentence of his short piece "We Climbed Aboard" (1916), which is just over half a printed page in length, is, "We climbed aboard our $\sqrt{-1}$ and took our places at the control panel." The unnamed passengers then fly over the surface of the earth making observations as "centuries of warfare passed before me." And in another short piece, "Dream" (1916), Khlebnikov writes, "We were at the $\sqrt{-2}$ exhibit." In a much longer piece, "The Scythian Headdress: A Mysterium" (1916), he speaks to the "Numbergod" and learns that "-1 is no less real than 1; that whenever you find 1, 2, 3, 4, you also find -1, -2, -3, as well as $\sqrt{-1}$, $\sqrt{-2}$, and $\sqrt{-3}$. . . . It is time to teach people to find the square roots of themselves and of minus-individuals."[16]

So Khlebnikov thought of numbers as tools for uncovering mysterious yet concrete patterns in history (perhaps even laws guiding human destiny), as symbolic keys to understanding the mysteries of the universe and our place in it, and possibly as metaphors for hidden dimensions we all possess. What separates him from Jensen is that Khlebnikov shared his discoveries and insights through his writings; even if he was mistaken in some of his calculations, he explained why he believed certain things about numbers. Jensen did not.

To understand what Malevich's lithograph has to do with Khlebnikov's writings about numbers, we need to look more closely at the very nature of number. To the ancient Greeks, especially the Pythagoreans in the sixth century BCE, a number was a counting number, one of the numbers 1, 2, 3, and so forth. You could study a ratio of such quantities, but that ratio was not itself a number. By

the third century BCE Archimedes seems to have accepted that such a ratio is itself a number and that even quantities that cannot be expressed as the ratio of whole numbers, such as $\sqrt{2}$, can be thought to be numbers. A much more modern notion of a number, and the one taught to children in school, is that a (positive) number is the measurement of a geometric length. This point of view allows us to think of a number as being a point on the number line (a positive number represents the distance from the origin to itself; a negative number simply represents a distance in the opposite direction from the origin). And some of these numbers that we all accept are defined in very nonintuitive ways.

The most familiar of these is the symbol π, whose mathematical meaning deserves comment. It is a theorem from Euclid's *Elements* that given any two circles, the ratios of their circumferences to their diameters are equal. Specifically, if one circle has circumference C_1 and diameter D_1 and another circle has circumference C_2 and diameter D_2, then the ratios C_1/D_1 and C_2/D_2 will be equal to one another. This means, at least to anyone using the modern notion of a number, that there is a number X so that $X = C_1/D_1 = C_2/D_2$. It is this number that we represent by the Greek letter π.

According to the geometric conception of a number, π is a number, being the circumference of a circle whose diameter equals one unit. However, there is another conception of number that has its basis not in geometry and measuring geometric lengths but in algebra and solving algebraic equations. An *algebraic number* is a solution to a polynomial equation with coefficients that are counting numbers. Examples of such polynomials are

$$3X^3 - 2X^2 + 7 = 0 \qquad X^{12} - 76X^4 + 2X - 98 = 0 \qquad X^2 - 2 = 0.$$

Sometimes an algebraic number can be seen to be a geometric length. For example, the two solutions to the polynomial equation $X^2 - 2 = 0$ are both algebraic numbers and represent geometric lengths. (One solution is $\sqrt{2}$, and the other solution is the negative of $\sqrt{2}$. Each of these solutions can be thought of as a geometric length: $\sqrt{2}$ is the length of the diagonal of a one-by-one square.) The number π is not the solution to any such polynomial equation, so it is a geometric number that is not an algebraic number.

A simple change to the equation $X^2 - 2 = 0$, say to $X^2 + 2 = 0$, leads to an algebraic number that does not have any sort of geometric meaning (symbolically, we would represent it as $\sqrt{-2}$). Although this quantity does not have a geometric meaning, it does have an algebraic meaning, so it has a mathematical meaning. And there is no end to the quantities that have an algebraic meaning but not a geometric meaning. For example, the solutions to any of the equations

$$X^2 + 1 = 0; \qquad X^2 + 3 = 0; \qquad X^2 + 5 = 0; \qquad X^2 + 49 = 0,$$

which may be represented, respectively, as $\sqrt{-1}$, $\sqrt{-3}$, $\sqrt{-5}$, and $\sqrt{-49}$ do not have any geometric meanings.

To summarize the above discussion: there are numbers that represent geometric lengths, such as $\sqrt{2}$ and π, and there are numbers that represent solutions to polynomial equations, such as $\sqrt{2}$ and $\sqrt{-2}$. Moreover, some numbers are numbers in both senses (e.g., $\sqrt{2}$), some numbers are geometric but not algebraic (e.g., π), and some numbers are algebraic but not geometric (e.g., $\sqrt{-2}$). And, although it is not obvious from their definitions, there are many more geometric numbers than algebraic numbers. The cardinality of the set of all algebraic numbers is \aleph_0, and the cardinality of the collection of all numbers that are geometric lengths is the same as the collection of all irrational numbers, c (see chapter 4).

We can now offer an explanation for the parenthetical grouping of symbols in Malevich's lithograph. In standard mathematical practice the symbol i denotes the square root of negative 1, so $i = \sqrt{-1}$, just as the special symbol π denotes the circumference of a circle whose diameter equals 1 unit. Then, just as the area and circumference of any circle can be represented as multiples of π^2 or π, each of the algebraic numbers we saw earlier may be expressed as a geometrically defined number multiplied by i:

$$\sqrt{-3} = i\sqrt{3} \qquad \sqrt{-5} = i\sqrt{5} \qquad \sqrt{-49} = i\sqrt{49} = 7i.$$

Because these numbers have no geometric meaning they seem unreal and so are called *imaginary numbers*.

The Cyrillic letter Й corresponds to the English vowel *i*. By placing (:7 Й =) centrally in his lithograph, Malevich was probably honoring the mystical calculations and use of numbers and number symbols of his friend Khlebnikov. We have seen that Khlebnikov believed that his calculations, and use of imaginary numbers, offered insights into understanding both the universe and our place in it. Malevich's unanswered equals sign seems to be more of a question than a claim about the mystical meaning of numbers and their symbols.

LOOKING AHEAD

In this chapter we saw how the artists Jasper Johns and Alfred Jensen used numerals in their paintings, Johns because he thought of them as being perfectly ordinary objects and Jensen, seemingly, both because they are concrete symbols and because of their roles in ancient cosmologies. We then saw that several early

twentieth-century Russian creative artists appealed to mystical associations of numbers and number symbols.

In the next chapter we head in a different direction, away from artists and writers who sought to reveal their aesthetic or mystical ideas through appeals to mathematical ideas and towards writers who sought to express their aesthetic visions by appealing to chance, random processes, arbitrariness, or algorithms. We will see that while these results are not uniformly aesthetically appealing, owing to the methods employed by the writers, all of them are nonetheless intriguing.

Randomness, Arbitrariness, and Perfect Numbers

Dada Poetry

Take a newspaper.
Take a pair of scissors.
Choose in the newspaper an article which is the same length as
you wish to make your poem
Cut out the article
—Tristan Tzara, *Sept Manifestos Dada* (1920), trans. Scobie

Chance, in several of its different conceptions, played openly acknowledged roles in the arts in the twentieth century. Throughout the century two contrary yet intertwined views of chance drove artistic innovations: continuing attempts to reduce chance elements in artistic creations and continuing attempts to embrace chance elements in artistic creations. Neither of these themes necessarily involved mathematical ideas, but as we have already seen, artists frequently called upon mathematics either to eliminate or enhance the chance, or random, elements of their work.

The contemporary literary theorist Alison James, in her study of the role of chance in the writings of Georges Perec, whose *e*-less novel, *A Void*, I mentioned in chapter 2, offers descriptions of four ways in which chance "may intervene in the construction of a work of art."[1] James's categories will help us frame our look at how artists and writers have utilized chance, or at least ideas closely related to those of chance or randomness, in their work. We begin with a quick look at James's different, but not necessarily unrelated, notions of chance.

We have already seen two of these: the use of "psychic automatism," as employed by surrealists in their automatic writings, and the use of some sort of

chance or random elements in the performance or reading of the piece, such as allowing the reader or audience to make choices. The first of James's two other notions of chance is the application of what we would commonly call *randomness* in the construction of the piece, the simplest examples being rolling a dice or flipping a coin. The second is the use of some sort of mechanical automatism, such as an algorithm, either disclosed or undisclosed. Artists have sometimes employed more than one of these types of chance in a single work—for example, both randomness and a formal procedure.

This last point can be supported by looking at some of the activities of Tristan Tzara (1896–1963), one of the founders of the Dada movement, a precursor to the surrealist movement. The guiding principles of the Dada movement are essentially impossible to explicate because, to quote from Tzara's "Dada Manifesto" (1918), "DADA MEANS NOTHING."[2] A few pages later he wrote this description of Dada: "abolition of memory: DADA; abolition of archeology: DADA; . . . an absolute indisputable belief in each god [that is the] immediate product of spontaneity: DADA."[3] The word "spontaneity" is the key to understanding why some Dadaists turned to chance operations in the production of some of their art. For example, consider Tzara's procedure, indeed algorithm, for making a Dadaist poem, whose first four lines introduced this section. The remainder of the poem instructs the poet to cut each of the words out of the article and place them into a bag. The poet should then shake the bag before removing the words one at a time. As each word is pulled from the bag, the poet should, as Tzara's poem directs,

Copy them out conscientiously . . .
The poem will resemble you.[4]

One example of Tzara's newspaper clipping poems is "Maison Flake" (1919), which begins with the two lines

unlatch bugles the announcement vast and hyaline animals of the maritime
 service
aerostatic ranger all that is strides galloping clarity life[5]

One twentieth-century Dada scholar, Manuel L. Grossman, admits that on first reading, Tzara's poem "seems to be little more than a jumble of discordant words and images." But, he continues, if the reader "is willing to make the necessary connections, a new conception of life . . . gradually begins to emerge." In this "Dadaist paradise . . . the imagination is as free as it should be." The supreme law of the land is the imagination. "There are no rules here where any word can give birth to any other."[6]

A Dada artist and poet who took a bit more control over the production of his poetry, while still allowing chance to play a significant role in its creation, was Hans Arp (1886–1966). Arp also wrote poems by using words taken from a newspaper, especially from advertisements, but he did not cut them up and randomly pull them from a bag. Instead, Arp underlined words and sentences in the newspaper and then used these words and sentences to write his poems. The chance element here is Arp's choice of a newspaper; he tried to not control his choice of the words and sentences to underline. (He said that often he would shut his eyes and then choose the words and sentences.)[7]

Both Tzara and Arp used the slight arbitrariness of which words and sentences happened to appear in the newspaper, together with a well-defined process, to produce some of their poems. So, ultimately, these poems were derived from the chaos of the everyday world and the arbitrary choices made by reporters and editors. One twentieth-century artist, Daniel Spoerri, also derived his work from this chaos, or more specifically, from the disorder of our daily lives. This artist was part of a larger art movement that further challenged any traditional answer to the question, What is art? An examination of one of Spoerri's projects allows me to digress and discuss a few of the most interesting mathematical questions of antiquity that persist to the present day.

Disorder and Art

I like the contrast provoked by fixating objects, to extract objects from the flow of constant changes.
—Daniel Spoerri, "Trap Pictures" (1961), in Piene and Mack, *Zero*

In 1960 the art critic Pierre Restany (1930–2003) published "The Nouveau Réalistes Declaration of Intention," in which he wrote, "We are witnessing today the depletion and sclerosis of all established vocabularies . . . of all styles." He proposed that artists move beyond traditional forms of expression and pursue "the thrilling adventure of the real perceived in itself and not through the prism of conceptual or imaginative transcription."[8] The most important phrase here is "the real": Restany was proposing that artists turn to the external world of objects, to the world where sociological ideas mediate the viewer's perception of the art piece, to see art.

One of the co-signers of Restany's declaration was the Romanian-born artist Daniel Spoerri, whose attempt (paraphrasing from Restany's declaration) to "exteriorize" his creative instinct led him to explore the disorder of the objects in our

daily lives. In 1962 he published his book *An Anecdoted Topography of Chance* (in French), in which he described the objects on a table in his Parisian hotel room. He wrote that the location and type of each object was "based on chance and disorder" and that he captured them exactly as they were on October 17, 1961, at 3:47 p.m.[9] The book included a foldout tracing of the outlines of the objects on the table numbered 1 through 79 (an 80th numbered object in the drawing was a cigarette burn on the drawing itself). Spoerri's descriptions of the objects are simple, as these samples illustrate:

1. Piece of white bread with a bite out of it, sliced from a loaf bought yesterday.

1A. Crumbs from the slice of white bread with a bite out of it.

26. Small aluminum spoon, a real bargain, bought at the drugstore on Rue LACÉPÈDE.[10]

Spoerri's work on his descriptions of the objects on the small blue table did not stop with the February 1962 publication of his book. Soon thereafter, he began to work on an expanded French edition in which he added more notes about the objects seen in the original topography. He also added a description of the objects on the table on February 21, 1962, at 8:07 p.m. There were only nine objects on the table at that time, further reinforcing the roles that flux and chance play in our lives. There have been five editions of *An Anecdoted Topography of Chance*, and Spoerri and his new collaborators have further commented on the descriptions of the objects from the original *Topography*. These additional comments are sometimes elaborations and sometimes almost stream-of-consciousness connections between ideas and words. To see how these later additions work artistically, consider object 34 from the original *Topography*, where a footnote was added, and then another footnote—a footnote to the footnote:

34. Worm-eaten joined wooden box with broken hinges, size $30 \times 30 \times 10$ centimeters. . . . Bought at the Flea Market [assisted by] STANISLAUS SALM.[a]

 a. Salm[b] is a Maltese unit of measurement. . . .

 b. A SALM is also . . . a 'salmon' in German.[11]

The first note above, note **a**, was added in 1966 by one of the collaborators, Emmett Williams, whose concrete poem "Like Attracts Like" I described earlier. Note **b** was added by another collaborator, Dieter Roth (1930–98), in 1968.

Several pages later Spoerri wrote that he had filled the box from entry 34 with "incongruous objects," one of which is described as

34G. Metal stencils of prime numbers[a] up to 13 . . . used to number review *material*.[b] (There were four numbers: 1, 2, 3 and 5.) These title-numbers were used for the following reason: just as a prime number can be divided only by 1 or by itself, so the contents of my review could be understood only through the contents itself, and not through comparisons or interpretations.[12]

Let's look at each of the notes, **a** and **b**, to entry 34G, which Spoerri added in 1966, separately, as they each bear on the themes of this book. We will look at note **b** first, as it is far less mathematical than note **a**, yet it relates back to one type of poetry from an earlier chapter:

> **b.** The review *material*, as its name implies, was intended to propagate concrete poetry.

In Spoerri's text this last comment leads to a couple of examples of concrete poetry. One of these examples, an eight-line poem, had been inserted by Williams. Each line of the poem gives the entire alphabet in its proper order, abcdefghijklm nopqrstuvwxyz, but the lines are offset from each other. Specifically, the lines are typeset so that the *b* in the first line is above the *u* in the second line, which is above the *l* in the third line, which is above the *l* in the fourth line, so that when read vertically, the poem spells a "familiar interjection."[13]

Spoerri's note **a** to entry 34G, as we could have inferred from its placement, concerns *prime* numbers:

> **a.** Jan. 30, 1962 ROBERT FILLIOU heard on the radio that the prime American prime number had been discovered with the aid of an electronic brain at the University of California

$$(2^{2442} - 1).$$

A *prime* number is, in the standard definition, a positive integer that has exactly two positive divisors: 1 and itself. This definition excludes 1 from being a prime number since it has only one divisor. The first few prime numbers are 2, 3, 5, 7, 11, 13, 17, and 19; this list never ends (as was known to Euclid—it is proposition 20 in book 9 of the *Elements*). Another way to think about a prime number is that an integer p is a prime number if the only way to write it as a product of two different whole numbers is as 1 times itself: $p = 1 \times p$. This standard definition of a prime number also explicitly excludes 1 from being considered to be prime, unlike Spoerri's more casual description of a prime in entry "34G. Metal stencils." (Note that Spoerri also did not mention two other prime numbers that are less than 13: 7 and 11.)

An earlier proposition from book 9 of the *Elements*, proposition 14, points to one reason the prime numbers are so central to almost any research into properties of numbers. This proposition is what is now called the fundamental theorem of arithmetic:

Every positive integer may be expressed uniquely as a product of prime numbers.

An important consequence of this theorem is that many questions concerning integers may be given full or partial answers by reducing the question to one about prime numbers. I give but one example, which brings us back to note **a**.

One number theory problem, probably from the Pythagoreans in the sixth century BCE, is to find all so-called *perfect* numbers. A perfect number is a positive integer that equals the sum of its proper divisors—that is, it equals the sum of its divisors that are smaller than itself. For example, 6 is a perfect number because all its divisors are the numbers 1, 2, 3, and 6; and it equals the sum of its proper divisors: $6 = 1 + 2 + 3$. It is easy to check that 6 is the smallest perfect number by simply checking that the smaller positive integers are not (for example, the proper divisors of 4 are 1 and 2, and $4 \neq 1 + 2$). After 6, the next smallest perfect number is 28; the proper divisors of 28 are 1, 2, 4, 7, and 14; and $28 = 1 + 2 + 4 + 7 + 14$.

Another result in Euclid's *Elements* provides a connection between perfect number and prime numbers, and this proposition will bring us back to the number in note **a** above. Euclid's statement of this result is fairly opaque,[14] but what it says is that if for some positive integer k the number

$$1 + 2 + 2^2 + 2^3 + \ldots + 2^{k-1} = 2^k - 1$$

happens to be a prime number, then the number

$$(2^k - 1) \times 2^{k-1}$$

will be a perfect number. For example, when $k = 3$ the number $1 + 2 + 2^2 = 2^3 - 1 = 7$ is a prime number, so it follows from Euclid's proposition that the number

$$(2^3 - 1) \times 2^{3-1} = 7 \times 4 = 28$$

will be a perfect number, as verified above. So one way to search for perfect numbers is to search for prime numbers that are 1 less than a power of 2, so are of the form $2^k - 1$.

A prime number of the form $2^k - 1$ is called a Mersenne prime, after the French monk Martin Mersenne (1588–1648), who wrote about them in 1644 (in *Cogitata Physica-Mathematica*). By the time Mersenne wrote his book, it was already known that each of the numbers below is a prime number:

$$2^2 - 1 = 3$$
$$2^3 - 1 = 7$$
$$2^5 - 1 = 31$$
$$2^7 - 1 = 127$$
$$2^{13} - 1 = 8,191$$
$$2^{17} - 1 = 131,071$$
$$2^{19} - 1 = 524,287.$$

So, using Euclid's proposition, we can conclude that each of the numbers

$$(2^k - 1) \times 2^{k-1} \qquad \text{for } k = 2, 3, 5, 7, 13, 17, \text{ and } 19$$

is a perfect number. If you stare at this list of values of k for a moment, you might realize that each of these numbers is a prime number. Indeed, they are the first few prime numbers, leaving out the prime number 11 because it had been shown in 1536 that $2^{11} - 1 = 2047 = 23 \times 89$ is not a Mersenne prime.[15] This brings us back to note **a** above.

The exponent in $2^{2442} - 1$ is the number 2442, which is clearly not a prime number: it factors, for example, as $2442 = 2 \times 1221$. If we use a bit of simple algebra, this factorization of the exponent 2442 allows us to factor $2^{2442} - 1$ as $2^{2442} - 1 = (2^{1221} - 1) \times (2^{1221} + 1)$. So the report Spoerri received from Filliou was incorrect. And Spoerri could have known this immediately had he known the mathematical theorem that explains why all of the exponents that led to Mersenne primes were themselves prime numbers. It is a result due to Pierre Fermat (1601–65), which he included in a letter to Mersenne in 1640:

If $2^k - 1$ is a prime number, then k is a prime number.

The reason this theorem is true is because if k is not a prime, it is always possible to use a bit of algebra to factor $2^k - 1$.[16]

In the above few paragraphs I have taken advantage of some of Spoerri's comments on his listing of objects on a table in a Parisian hotel room to discuss classical mathematical results concerning prime and perfect numbers. I like to think that there are two sorts of chance that contributed to Spoerri's piece. The first is the "chance and disorder" that led to the location of each object; the second is how he gave up authorial control of the project by allowing others to comment on his and others' comments. It is striking how mathematical ideas appear in this collectively written text—almost as striking as the appeal of the surrealist writers Breton and Soupault to mathematical imagery in their efforts to overcome artistic constraints. But this is, of course, further support for my thesis that

mathematics and mathematical ideas informed many twentieth-century artistic innovations; in many artistic and literary circles they became almost commonplace.

Arbitrariness

> I sometimes made some mistakes . . . so chance may creep in willy-nilly.
>
> —Jackson Mac Low, *Thing of Beauty* (2008)

In this final section we first consider how several writers exploited the observation that there seems to be no close connection between a word as a symbol (signifier) and what it means (signifies). The first three of these writers, Raymond Roussel, Khlebnikov, and Hugo Ball, produced their pieces early in the twentieth century, several decades before what Bohn called the second crisis of the sign became widespread. We will then see how some later twentieth-century writers also exploited this gap using algorithmic methods.

We begin with the work of a notable French novelist, Raymond Roussel (1877–1933), who incorporated into the writing process the observation that similar signifiers can signify different things. In particular, Roussel took advantage of the arbitrariness of the choice of signifier for an object or concept that allows for words with similar spellings to have radically different meanings. In a posthumously published article, "How I Wrote Certain of my Books," (1935), Roussel explained that he began with the two French words, *billard* (billiard table) and *pillard* (plunderer). He then "added similar words capable of two different meanings, thus obtaining two almost identical phrases." In order to appreciate Roussel's method, and talent, it helps to see some of the sentences he wrote in French, as the spelling of the words he employed are not closely related in English:

1. Les lettres du blanc sur les bandes du vieux billard . . .
[The white letters on the cushions of the old billiard table . . .]
2. Les lettres du blanc sur les bandes du vieux pillard . . .
[The white man's letters on the hordes of the old plunderer . . .][17]

As we see from these translations, in the first sentence Roussel uses *lettres* in the sense of "missives" and in the second sentence in the sense of "lettering." Similarly, he uses different interpretations of *blanc*, first as a "cube of chalk" (like the chalk put on the end of a billiard cue) and second as the color "white," and of *bandes*, first as "cushions" and then as "hordes." Roussel then set about writing a short story that began with the first sentence and ended with the second sentence.

Roussel explains that he expanded on this approach to write one of his best-known books, *Impressions of Africa* (1910). To write that book he again started with the two words *billard* and *pillard*. In Roussel's book the plunderer in question is the ruler of an unnamed African republic, so he sought to expand on the word *billard*. As he explained it, he "began to search for new words relating to *billard*, always giving them a meaning other than that which first came to mind, and each time this provided me with a further creation." So the word *queue*, taken to mean a billiard cue, which also means "tail" in French, led to the ruler of the republic having a gown with a long train. Then, since the manufacturer's monogram (*chiffre*, according to Roussel) is usually printed on a billiard cue, Roussel had a numeral (also *chiffre*) sewn into the ruler's train. And Roussel did not stop with the two words *billard* and *pillard* from the two sentences he had written ten years earlier. As he describes in his article, he also made associations with the words *bandes* and *blancs*.[18]

Early in the twentieth century two Russians we have already encountered, Aleksei Kruchenykh and Velimir Khlebnikov, began to develop a language, or at least a collection of words, called *zaum*, which was based on the meaning of certain Slavic roots and their sounds. Kruchenykh had used the *zaum* language in the libretto of the play *Victory over the Sun* (see chapter 8), and writing poetry in this language was Khlebnikov's second obsession during the 1910s, after his calculations with numbers. Before we look at an example of Khlebnikov's poetry, let's try to understand what he and Kruchenykh were attempting to achieve. In their short piece "Word as Such" (1913), they wrote: "Henceforth a work of art could consist of a *single word*, and simply by a skillful alteration of that word the fullness and expressivity of artistic form might be obtained."[19] The skillful alteration they refer to is to begin with a single Slavic root and invent new words built on the root, words which may or may not be perceived as referring to anything.

We can see this last point in the first few lines of two translations of Khlebnikov's "Incantation by Laughter" (1908–9). In his original poem the words are all based on the Russian word *smekh*, which means "to laugh." In the first translation the translators translate the Slavic root as "lauf" and in the second as "laugh."

First translation:

Hlahla! Uthlofan, lauflings!
Hlahla! Uthlofan, lauflings!
Who lawghen with lafe, who hlaehen lewchly.[20]

Second translation:

> Oh, laugh forth, laugh laughadors!
> O laugh on, laugh laughadors!
> You who laugh in laughs, laugh-
> laugh, you who laughorize so laughly.[21]

If we judge Khlebnikov's thinking about *zaum* by the first translation, we see that he was seeking not words with new meanings but words with new sounds. These new words might just happen to have some connection with a signifier that has meaning, as in the second translation where it is possible to ascribe meanings to these new words, but that does not seem to have been Khlebnikov's goal.

Also in the 1910s, another artist and poet, Hugo Ball (1886–1927), exploited yet another aspect of the arbitrariness of words—in his case, the arbitrariness of the sound of a word. And he went even further than Kruchenykh and Khlebnikov. As he wrote, "The next step is for poetry to discard language as painting has discarded the object, and for similar reasons."[22] Ball took the liberty of constructing words to use in a form of poetry that he called *verse without words* or *sound poems*. He claimed that in his poems "the balance of the vowels is weighted and distributed solely according to the values of the beginning sequence."[23] In his invention of words, Ball, unlike Khlebnikov, did not work with a fixed stem. What connects the words in Ball's poems are their musical qualities. One example is his poem "Sea Horses & Flying Fish" (c. 1916):

> tressli bessle nebogen leila
> flusch kata
> ballubasch
> zack hitti zopp[24]

These poems of Khlebnikov and Ball are almost at the opposite end of some spectrum from visual poetry, as they are intended to be heard rather than read or seen.

We now turn to several later-twentieth-century authors who based their work not only on arbitrariness but on an algorithm or algorithms. The author who most famously used algorithmic, even deterministic, methods in his writings was the American Jackson Mac Low (1922–2004). Mac Low's early poems, written between 1937 and 1954, were fairly traditional, including both free and metrical verse. Then, in late 1954 and early 1955 he wrote five poems using a new idea: the title of each poem determines its structure. An example is the poem "4.5.10.11.2.8.4.2., the 2nd biblical poem." There are eight numbers in title, so, according to Mac Low's scheme, each stanza has eight lines. Moreover, in Mac Low's scheme the numbers in the

poem's title direct that the first line of each stanza contain four "events" (a single word or a silence), that the second line of each stanza contain five events, that the third line of each stanza contain ten events, and so on. As for the words of the poem, Mac Low took them from a "translation of the Hebrew bible." Following Mac Low we let /—/ denote a silence; then the first two lines of the poem are

thither; /—/ to /—/
not /—/ /—/ tribe /—/.[25]

Soon thereafter, Mac Low decided to create poetry by an even more structured method in order to, as he later wrote, "make artworks with as little intervention as possible from the individual ego."[26] He began with a French-English dictionary and Shakespeare's "Sonnet 18," which begins

Shall I compare thee to a summer's day?
Though art more lovely and more temperate.

Mac Low then looked in the English portion of the dictionary for the columns that contained each of the words in the sonnet. Each word in the sonnet was then replaced by the word at the top of the column containing it, yielding the not particularly lyrical first line

Shamefulness Hymn companionableness thanksgiver tissue a summer-wheat's
dead?[27]

The poet Anne Tardos, Mac Low's companion for the last twenty-six years of his life, wrote that he "was not concerned . . . with getting results that would be 'interesting' or 'about' anything." His goal, instead, was to produce poems that were free of his "taste, memories, and psychology."[28]

Some of Mac Low's later algorithmic poems are more easily read because they incorporate words taken from chosen texts or poems, rather than words taken from a dictionary (which of course contains many, many words not used in ordinary discourse). These poems were produced in the early to mid-1960s by two methods that Mac Low labeled *acrostic* and *diastic*. Each of these methods depends on two things:

1. a seed word, sentence, or phrase that directs how the words for the poem are determined;
2. a source for the words.

To illustrate these two methods we take as a seed the sentence

Dogs love bones.

We will take as our source of words Barth's collection of short stories *Lost in the Funhouse*, skipping the endlessly repeating first story, "Frame Tale" (whose use of the Möbius strip was discussed in chapter 4), and start with the second story, "Night Sea Journey."

To follow Mac Low's acrostic method we find the first word in Barth's story that starts with *D*, either uppercase or lowercase, which happens to be "disclose." Starting at that point in the text we next look for the first word that starts with *o*, the second letter in "dogs" from our seed sentence, which is "ones." We then look for the subsequent word starting with *g*, then *s*, and so forth. Each word in our seed sentence produces a single line of the poem. This algorithm produces the poem

> disclose ones generation swim
> Love on vitality example
> But our nay-sayers enemies sages

Mac Low's diastic method is a variant on the acrostic method. Instead of looking for a word that starts with each seed letter, the poet looks for a word that has the seed letter in the same position as in the seed word. So, still using the same seed sentence, the poet would look through Barth's story and find the first word that starts with *D*, then the subsequent word that has an *o* as its second letter, and then the subsequent word that has *g* as its third letter. If, as Mac Low worried in the quotation introducing this section, I did not make a mistake, this process leads us to the poem

> disclose hope night exist
> lack convention have after
> because journey can appears recesses

Over the years Mac Low offered several variations on these methods—for example, numbering the letters of the alphabet and then looking only for words with that letter on the page with its number, or searching alternately forward and backward through the text. In later years, certainly after 1989, Mac Low used a computer to generate his texts, thus reducing the probability that he would make a mistake and let chance "creep in willy-nilly."[29]

The contemporary poets Borsuk and Jaurequi, who translated Braffort's *My Hypertropes* (discussed in chapter 6), also provided what they called "transversions" of their translations. Of these they wrote: "These poems transvert, subvert, and pervert the original text, incorporating elements of the original that would not fit into the translation and refracting them through our own lens."[30] It

is a happy coincidence that for their transversion of "Hypertrope 12," Borsuk and Jauregui used a procedure that could have been conjured up by Mac Low. Since Braffort had dedicated this poem to François Le Lionnais (1901–84), one of the co-founders of OULIPO, they chose as the source text for its transversion the "lion section" of T. H. White's *Book of Beasts* (1954). They decided that the new poem would have nine words per line, and they used the first nine Fibonacci numbers—1, 2, 3, 5, 8, 13, 21, 34, and 55—to sequentially choose the words from the source text. Specifically, for the first line of their transversion, "Leo the lion of stand word leopards and known," they chose the first, then the second, then the third, and on up to the fifty-fifth word of the source text.

I conclude this chapter with an algorithm introduced in 1961 by the French writer Jean Lescure (1912–2005), an original member of the OULIPO group of writers, co-founded by Queneau, who sought to explore mathematical ideas in literature. Lescure's algorithm less drastically alters a chosen text than any of Mac Low's procedures. This method, frequently referred to as the "S + 7" method, requires that the writer choose a text or poem, which is to be altered, and a dictionary; each noun in the text is replaced by the seventh noun that follows it in the dictionary.

For example, if we use an old edition of Webster's Collegiate Dictionary, the line

Mary had a little lamb whose fleece was white as snow

becomes

Maser had a little lamb's-quarters whose flesh was as white as snowblink.

(A maser is a device that generates microwaves, and snowblink is the white glare in the sky that is sometimes seen over a snowfield.) Because this algorithm simply replaces each noun with a new noun and leaves the remaining elements of the text unchanged, it does not lead to texts as grammatically challenged as those produced by Mac Low's or Tzara's procedures.

In her book Alison James asks if this procedure would be equally effective if the nouns were chosen at random instead looking the seventh one following the given one in the dictionary. Her answer is essentially no. With the S + 7 method a noun is usually replaced by a noun that is somehow close to the original one. The result tells us as much about how language works as anything else; in James's words, "What is perhaps most disquieting about [S + 7] is the way in which it unveils the 'mechanical' aspect of language itself—that is, language's capacity to

produce meaning independently of human intention."[31] And she seems to be right: the sentence we derived from "Mary had a little lamb" has meaning for us—a white piece of lamb is about to be cooked in a microwave oven.

LOOKING AHEAD

A poem consisting of randomly chosen words and sentences from a newspaper, or of a sequence of words determined by an algorithm from an existing piece, and a work of art that is simply an elaborate description and discussion of objects on a desktop in a Paris hotel, beg the questions What is art? and What is literature? In the next chapter, our final one, we will see that just to put these innovations into some sort of context, one art theorist turned not to aesthetic considerations, but rather (like so many of the creative spirits I have discussed), to a mathematical notion.

The Artworld

> To mistake an artwork for a real object is no great feat when an
> artwork is the real object one mistakes it for.
> —Arthur Danto, "The Artworld" (1964)

The search for objects revealing the marvelous led the surrealists and their allies, sequentially, to experiment with automatic drawings, to admire the models of mathematical surfaces at the Institute Poincaré, to display photographs of these models as if they were art objects, and finally, through Man Ray's *Shakespearean Equations*, to offer reinterpretations of these surfaces in paintings with titles intended to induce the ever-so-important *dépaysement* in whomever contemplated them. My examination of this progression in chapter 1 was presented as one of the possible outcomes of Duchamp's experiments with "readymades" in the 1910s. Yet there are other artistic developments that can also be seen to naturally, perhaps even inevitably, follow from Duchamp's activities. In one of these, artists sought to represent not the marvelous but the ordinary, and while these artists did not appeal to mathematical concepts to create their art, those trying to understand what these developments said about the twentieth-century conception of art sometimes invoked mathematical notions. My discussion of one of these somewhat philosophical attempts has the additional benefit of helping summarize much of what we have seen in the previous chapters.

It is a small step from taking objects of ordinary life (what I will temporarily call non-art objects) and either giving them titles or slightly modifying them and displaying them as art, to making art objects that look like non-art objects. This can lead the audience to make the mistake that the modern philosopher of art Arthur Danto (1924–2013) claimed, in the quotation heading this chapter, was not a mistake at all—the mistake of taking an art object to be a non-art object when the art object is, or is a replica of, the non-art object. In his article, "The

Artworld," Danto discussed several examples of artists who have produced works of art that are, or could easily be taken as, real manufactured objects. He gives, as two examples, beds that were produced by artists—one by Robert Rauschenberg and the other by Claes Oldenburg.

In 1955 Rauschenberg produced one of his best-known "combines," art objects he constructed using paint and a combination of found materials. His combine *Bed* is about the size of a single bed and is made of bedding, including sheets, a quilt, and a pillow. Except for the fact that the piece is hanging on the wall, it looks like it is ready to be used as a bed. But it is not very welcoming because it has been splashed with red paint. If you were to walk into some abandoned house and see Rauschenberg's bed splayed on the floor, you might think that someone had vandalized a place where a person had been sleeping. Oldenburg's bed is not something that could be hung on the wall; it is part of an entire bedroom suite, *Bedroom Ensemble* (1963). However, the bed is not rectangular. It is narrower at the foot than at the head, but other than that it looks like a bed on display in a furniture store. As Danto says, someone not knowing that Oldenburg's bed is an art object might well think that it had just been poorly designed or constructed.

Although either of these beds could be imagined to be functional furniture, the viewer understands that they are not because something is not quite right with each of them. Other artists, however, produced more or less exact replicas of objects from the material, commercial world. The American artist Andy Warhol (1928–87) produced the best known of these. In 1964 Warhol exhibited his *Brillo Boxes* in a room at the Sable Gallery in New York.[1] Warhol had $17 \times 17 \times 14$-inch wooden boxes fabricated by cabinetmakers and delivered to his studio. He painted these large boxes to match the color of cardboard and then, using stencils copied from purchased Brillo boxes, silk-screened the boxes to look like commercially manufactured boxes that contained "24 Giant Sized Pkgs." For the exhibit Warhol stacked roughly one hundred of these boxes around a room so that it looked like a somewhat poorly organized storage room at a retail store.

Many of the activities we have seen—from Duchamp's invention of readymades to surrealists' automatic writing, Rauschenberg's *White Paintings*, Kaprow's happenings, and Warhol's reproduction of commercially available objects—presented the art-appreciating public, art critics, and (of more interest to us) philosophers of art with a dilemma: embrace as art any object an "artist" declares to be an art object or deny that these objects are art, retreat to a more classical conception of art, and so devalue a century of artistic innovation. Both of these alternatives had their adherents, but several writers simply sought to understand

the implications of these developments. One of these, the twentieth-century philosopher Richard Hertz, in his paper "Philosophical Foundations of Modern Art" (1978), employed broadly mathematical ideas—more accurately, an axiomatic approach—to examine these developments. Hertz distilled from all of these activities two assumptions that seem to underlie them and stated these assumptions as axioms of modern art. Hertz's axioms are axioms in the sense of Euclid's postulates—they are self-evident truths. But they are self-evident truths not about art but about the artworld—a world we can expand beyond the visual arts to include all of the creative arts.

Hertz calls his first axiom the *undecidability axiom*:

Axiom 1. The distinction between art and non-art is undecidable.[2]

Although this axiom is stated in mathematical language, its most basic meaning is clear: if someone is presented with an object and asked, "Is this art?" it is not possible for him or her to give an answer other than "Maybe." But it goes further than that, and this is the undecidability part of the axiom. The term "undecidable" has both an informal and a formal meaning in mathematics, and the differences in these two meanings can inform our understanding of the two interpretations of this axiom Hertz described.

The first interpretation of Hertz's axiom is, in his words, "whether something is or is not art is relative to a particular aesthetic theory," which roughly corresponds to the notion that whether a mathematical statement is true or false depends on one's theory (or mathematical axioms). This is the informal use of the word "undecidable" in mathematics, which is formally called *independence*: a proposition is undecidable within a particular axiomatic system if it cannot be proved either true or false within that system (so the proposition is independent of the system's axioms). We have already seen an example of this: Euclid's parallel postulate is undecidable in this sense if we only assume Euclid's other postulates (because it is independent from them).

This interpretation of Axiom 1 means that if the person asked to answer the question "Is this art?" is given additional information—for example, some information concerning the origin of the object—he or she might be able to answer the question. We have seen several examples that support this interpretation of Axiom 1. Rauschenberg's *White Paintings* and Cage's *4'33"*, monochrome white canvases and soundless music, cannot even be perceived as being art unless the former is displayed in an art gallery or the latter is experienced in a concert hall. Even then, we would need more information to believe they are art: we need to know Rauschenberg's and Cage's ideas.

As another example, suppose one of your friends hands you the drawing shown in plate 10.1, proudly announces that her nine-year-old daughter has drawn it, and declares that she clearly has great artistic talent. You might compliment the shape of the fish or the quality of the paper, but you probably would not consider it to be a work of art. If your friend then says she was just trying to see how you would react to the drawing and that she found it in a book of poetry, you might be intrigued, probably thinking that it must be a book of poetry for children.

Suppose, however, that you are told that this is one of Desnos's automatic drawings, an image he drew either in a partially unconscious state or too quickly to reflect on what he was doing, and that he had published it with one of his most highly regarded poems, "The Night of Loveless Nights."[3] This changes how you might feel about the drawing. All of a sudden you note how the light

Plate 10.1. Robert Desnos, "The Fish Has Recognized the Crusaders," from *The Night of Loveless Nights*, 1930. Eluard Dausse Collection, The Museum of Modern Art Library, New York. Image © The Museum of Modern Art / Licensed by SCALA / Art Resource, NY. © 2013 Artists Rights Society (ARS), New York / ADAGP, Paris.

scribbles in the background lend the drawing a dreamlike quality and how the darker, almost horizontal lines show that the fish is floating, either in water or air. Understanding how and why Desnos produced this drawing seems to open our ideas to its imagery; it elevates the apparent scribbles to the domain of *art*. The conundrum, if you will, is that an observer cannot glean the significance of this drawing without knowing that Desnos had produced it through automatic drawing.

The second, more radical interpretation of the undecidability axiom is a bit subtler because Hertz gave two slightly different versions of it in consecutive sentences. The first is

> The distinction between art and non-art is undecidable both in the general and in the particular case.[4]

This framing of the second interpretation alludes to formal mathematical undecidability—that there is no finite procedure for determining the members of the set of all art objects or processes. If you were to enter an old warehouse and find some paint-splattered linens on the floor, a urinal propped up against a wall, and a few scuffed boxes of Brillo pads stacked in a corner, it would be impossible for you to determine whether these were pieces of art.

The second sentence in Hertz's description of this interpretation of his first axiom is

> There is no distinction at all between art objects/processes and everyday objects/processes.[5]

This sentence seems to be an even stronger statement: there is no procedure of any kind that could ever distinguish between art and non-art. Using an earlier concept from this book, the collection of all art objects is not a set. This is certainly true of some pieces we have considered—for example, Kaprow's proposed happening that involved the movement of people in five elevators in different buildings in Chicago.

The artists who were most clearly allied with this axiom were the Italian Futurists of the early part of the twentieth century. In his "Technical Manifesto of Futurist Sculpture" (1912) one of the earliest members of the Futurist group, Umberto Boccioni (1882–1916), elevated industrial artifacts above classical sculpture and argued that elements of these artifacts, as well as mathematical forms, must be present to renew sculpture.[6] There is also an element of this view of ordinary products and processes in Tzara's Dada aesthetic. He wrote: "Art is not the most precious manifestation of life. Art has not the celestial and universal

value that people like to attribute to it. Life is far more interesting."[7] As Hertz explains, the belief that art is not as interesting as life erodes the long-held view of art as occupying some special place in our consciousness.

Hertz's second axiom, which he called the *reducibility axiom*, concerns the issue we touched upon earlier—the role an artist's theory plays in our ability to distinguish an art object from a mere real object—but it also elevates the artist's theory above the aesthetics of the object:

Axiom 2*. Art theory is as important as or more important than art works.[8]

We have seen many examples to support both the "as important as" and the "more important than" versions of this axiom. These range from Reinhardt's black paintings to Ball's sound poems to Mac Low's French-English dictionary transcriptions of Shakespeare's sonnets. Without alluding to this axiom, Danto illustrated its acceptance in his discussion of Warhol's *Brillo Boxes*. Warhol must have labored over these plywood and silk-screened pieces of art; Danto suggests that Warhol could have saved himself all of the work and used commercially available boxes: "Why not just scrawl his signature across one? Or crush one up and display it as *Crushed Brillo Box* ('A protest against mechanization . . .') or simply display a Brillo carton as *Uncrushed Brillo Box* ('A bold affirmation of the plastic authenticity of industrial . . .')"[9] If an artist were to adopt either of these two approaches, then the theory of the artist would explain the art work; and the theories would clearly be more important than the art work, which would be, after all, just a printed cardboard box purchased in the grocery store.

Just as mathematicians deduce theorems from their axioms, Hertz makes an important deduction by combining Axiom 1 and Axiom 2*. Since Axiom 1 rules the distinction between art objects and non-art objects undecidable, Hertz wrote that Axiom 1 "renders the distinction between art and non-art inoperative," and the phrases "art theory" and "art works" in Axiom 2* become unnecessary. It follows that we have the result:

Theorem 1. Ideas are as important as or more important than the fulfillment of those ideas in practice.

Instead of calling this deducted result a theorem, Hertz calls it Axiom 2, perhaps paying homage to the history of Euclid's parallel postulate. Just as the theorem of Euclidean geometry that *the angles in any triangle add to 180 degrees* can replace the parallel postulate as an axiom, providing a system in which the parallel postulate becomes a theorem, so in Hertz's system his original Axiom 2* may be replaced by Axiom 2, and now Axiom 2* becomes a theorem.[10]

Plate 10.2. Marcel Duchamp, *The Bride Stripped Bare by Her Bachelors, Even (The Large Glass)*, 1915–23. Reconstruction by Richard Hamilton, 1965–66. Oil, lead, dust, and varnish on glass. Tate Gallery, London. Photo: Tate, London / Art Resource, NY. © 2013 Succession Marcel Duchamp / ADAGP, Paris / Artists Rights Society (ARS), New York.

In support of this theorem Hertz offers the example of another of Duchamp's famous pieces, *The Bride Stripped Bare by Her Bachelors, Even* (1915–23), usually referred to as *Large Glass* owing to its size (109¼ × 69¼ in.) and to its being painted on glass. *Large Glass* is not an easy piece to describe, even in general terms, as you can see from its photograph (plate 10.2). This image does not really help us understand

Duchamp's piece. Some objects seem to be represented, but they are only vaguely familiar. It would help to know what Duchamp was thinking while he worked on the piece for more than a decade (and according to him, left it unfinished).

Fortunately, we have a great deal of information about Duchamp's ideas concerning this work. In October 1934 he offered for sale a box, the *Green Box*, containing more than ninety items, mostly copies of notes he had written between 1911 and 1915. These notes were intended to explain both the ideas underlying *Large Glass* and some of its iconography. Within a few weeks after copies of the *Green Box* were made available, Breton published his essay extolling Duchamp's brilliance and reporting the information about *Large Glass* he had gleaned from the *Green Box*. In broad outline, *Large Glass* consists of two sections: the upper section contains the bride (and has a total of five components), and the lower section contains the bachelors (and has a total of seven components). According to Breton, "the Bride passes her *commands* to the bachelor machine" by using the three draft pistons. Having received her command, the nine bachelors release a gas that rises towards the bride; upon passing through the machine-like object in the lower panel, the gas is transformed into a liquid that splashes towards the bride.[11] Of course, none of this activity is evident in the painting; and even having it explained to us does not ensure that we will see it. Nevertheless, these are the ideas behind the images, and they are perhaps more interesting than the images themselves.

LOOKING BACK

While Hertz's two axioms, and the theorem he deduced from them, might be supported by some of the works we have considered, a larger lesson may be gleaned from the twentieth-century works examined here. This is the observation that throughout the twentieth century, mathematics and mathematical ideas became relevant to creating and understanding artistic and literary pieces. As I have discussed elsewhere, mathematical ideas have always informed our attempts to make sense of both the material and spiritual worlds,[12] but in the twentieth century something less obvious happened. Artists, writers, and theoreticians appealed directly to diverse mathematical ideas to create and explain both pieces and theories.

Sometimes a piece was drawn or written in such a way as to announce to the audience or the reader that mathematical ideas were central to its conception or realization. Whether the piece is a painting of geometric forms or of multiple equations, or a short story called "Mobius the Stripper," in each case the viewer or reader knows that mathematics played some role in the piece's creation. Sometimes the role of math is indirect, as in Reinhardt's axiomatic essay "Art as Art,"

and sometimes it is direct, as in Braffort's "My Hypertropes." At other times the mathematical ideas are there but are not evident in the piece. The mathematical ideas that either inspired or assisted the artist have faded into the background, as in Fournel and Énard's play or in Mac Low's poems.

All of these creative activities pursued by artists and writers appreciative of mathematical thinking furthered mathematics' progression from being a hand-maiden to the sciences, philosophy, and religion to being a source of artistic and literary creativity. And it is even more than that: just as mathematics has helped us understand the material world, it is now able to help us understand and appreciate the most human of all endeavors—the creative arts. The actions of the artists and writers discussed in this book have brought into focus the relevance of mathematical ideas to our understanding of the creative spirit.

Chapter 1 • Surrealist Writing, Mathematical Surfaces, and New Geometries

1. *The Magnetic Fields* was published in the Dadist literary journal *Littérature*, which had been founded by Breton, Soupault, and Louis Aragon.

2. Breton, *Manifestoes of Surrealism*, 23.

3. *The Magnetic Fields* has ten chapters. The first seven chapters are almost entirely prose (the sixth chapter concludes with a poem); chapters 8 and 9 are poetry of Breton and Soupault, respectively; and the last chapter is not much more than a brief dedication.

4. Breton and Soupault, *The Magnetic Fields*, 87.

5. Breton, *Conversations*, 63.

6. Breton, *Manifestoes of Surrealism*, 29–30.

7. Conley, *Robert Desnos*, 17.

8. Ibid.

9. Breton, *Manifesto of Surrealism*, in *Manifestoes of Surrealism*, 29.

10. Breton, *Soluble Fish*, in *Manifestoes of Surrealism*, 51.

11. Ibid., 52–53.

12. Ibid., 56.

13. Breton, "Surrealism and Painting," in *Surrealism and Painting*, 1.

14. Breton, "Crisis of the Object," in *Surrealism and Painting*, 277.

15. Ibid., 276.

16. Ibid., 275.

17. Ibid., 277.

18. Ibid., 280. A couple of years earlier Breton had written a laudatory review of Duchamp's artistic activities in which he placed Duchamp at the "forefront of all the 'modern' movements which have succeeded each other during the last twenty-five years." Breton, "Marcel Duchamp: Lighthouse of the Bride," in *Surrealism and Painting*, 86.

19. Duchamp, "Apropos of 'Readymades,'" in *Duchamp: Works, Writings, and Interviews*, ed. Mourc, 123.

20. Breton, "Abridged Dictionary of Surrealism," in *Oeuvres complètes*, 2:837.

21. Duchamp was a celebrity in New York before his arrival in 1915, owing to his painting *Nude Descending a Staircase No. 2* (1912), which had been exhibited in the famous Armory Show in 1913. Although *Nude* is one of the most important paintings of the twentieth century, and Duchamp one of the century's most significant artists, he produced only a modest number of paintings during his very active artistic career, which spanned some 58 years.

22. Duchamp, "The Richard Mutt Case," in Harrison and Wood, *Art in Theory*, 248. Duchamp's protest was originally printed in the art and Dada journal *The Blind Man* (New York), no. 2 (May 1917).

23. Breton, "Surrealistic Objects," in Poli, *Man Ray: Rare Works*, 27.

24. Man Ray, *Self Portrait*, 368–69.

25. Breton, "Crisis of the Object," 280.

26. Schwarz, *Man Ray: The Rigour of Imagination*, 77.

27. Man Ray to Breton, in Schwarz, *Man Ray*, 77.

28. Heath, *Euclid's Elements,* vol. 1. These definitions, as well as all of the postulates, common notions, and theorems in this text, are from Heath's edition.

29. Tubbs, *What Is a Number?*

30. *Euclid's Elements*, proposition 32, book 1.

31. Henri Poincaré, *Science and Hypothesis*, 50.

Chapter 2 • Objects, Axioms, and Constraints

1. Milner, *Malevich and the Art of Geometry.*

2. Malevich, "Suprematism," in Caws, *Manifesto*, 404, 405.

3. Mitchell, "Ut Pictura Theoria," 357, 359.

4. Altieri, "Representation, Representativeness, and Non-Representational Art," 245.

5. Andersen, *Malevich*, 27.

6. Hilbert, *Foundations of Geometry*, 2.

7. Einstein, "Geometrie und Erfahrung" (1921), in *Ideas and Opinions*, 234.

8. Hilbert, *Foundations of Geometry*, 3.

9. It is interesting that this axiom of continuity is needed to establish the equivalencies of Euclid's version of the parallel postulate and the result that the sum of the angles in any triangle add to 180 degrees. And if this axiom is not assumed, the relationship between the parallel postulate and the sum of the angles in a triangle is not completely determined. In his 1900 article "Die Legendreschen Sätze über die Winkelsumme im Dreieck," the mathematician Max Dehn showed that if we assume that through a point not on a line there exists more than one line through the point parallel to the line, but do not assume the axiom of Archimedes, then the sum of the angles in a triangle might be 180 degrees or it might be greater than 180 degrees.

10. Hilbert, *Foundations of Geometry*, 15.

11. Hilbert never uses this axiom but does point out that it is necessary to develop higher mathematics—e.g., calculus—with his geometry.

12. Poincaré, "Review of Hilbert's 'Foundations of Geometry.'" The original review was published in 1902 in the *Bulletin des Sciences Mathématiques*, with the English translation published the following year.

13. Ibid., 2. Poincaré notes that the parallel postulate is not the only one of Euclid's axioms "which could be denied without offence to logic." Hilbert gave examples of geometries in which various combinations of his axioms are assumed to hold or not hold; for example, he develops a geometry in which the parallel postulate of Euclid holds but the side-angle-side congruence criterion for triangles does not.

14. Queneau, conversations with Georges Ribemont-Dessaignes, 1950, in *Letters, Numbers, Forms*, 175.

15. Queneau, "Reading for a Front," in *Letters, Numbers, Forms*, 113.

16. Queneau, "Potential Literature," in Motte, *OULIPO*, 51.

17. The meeting at the Vrai Gascon on Quai Voltaire was attended by Jacques Bens, Claude Berge, Jacques Duchateau, François Le Lionnais, Jean Lescure, Raymond Queneau, and Jean Queval.

18. The new attendees were Noël Arnaud, Latis (Emmanuel Peillet), and Albert-Marie Schmidt.

19. Queneau, *Foundations of Literature*, in Mathews and White, *Oulipo Laboratory*.

20. Ibid., 7.

21. Fournel, *Suburbia*, in Mathews and White, *Oulipo Laboratory*.

22. Such a textless narrative could not fail to attract a postmodernist analysis. For example: "Paul Fournel has written a visceral example of the categorical imperatives associated with our conception of a 'complete' text. . . . In this extended parody of just what elements make up a 'real' novel, Fournel forces attention away from words and into readerly habits—away from passivity. Since there is no 'text,' one is forced back on the paratextual elements at work." Iftekharuddin, *The Postmodern Short Story: Forms and Issues*, 113.

Chapter 3 • Abstraction in Art, Literature, and Mathematics

1. Rodchenko wrote: "I reduced painting to its logical conclusion and exhibited three canvases: red, blue, and yellow. I affirmed: It's all over. Basic colors. Every plane is a plane, and there is to be no more representation." Quoted in Bois, "Painting: The Task of Mourning," 238.

2. Reinhardt, *Art as Art*, 186. The essay was originally published in *Art International* (Lugano) 6, no. 10 (December 1962).

3. Ibid.

4. Joseph, *Random Order*, 26–29.

5. Ibid., 30.

6. The definition of a circle in Euclid's *Elements* is this: A circle is a plane figure contained by one line such that all straight lines falling upon it from one point among those lying within the figure are equal to one another. In other words, a circle is a curve that has a point within it from which any segment to the circle will have the same length. The point referred to is the center and the lengths of all these segments is the radius.

7. Russell, *Introduction to Mathematical Philosophy*, 11.

8. Rauschenberg, "Untitled Statement," in Stiles and Selz, *Theories and Documents of Contemporary Art*, 321.

9. Cage, *I–VI*, 20–21.

10. Schwarz, *Man Ray*, 27.

11. Cage's use of structure is indeed very subtle: we would not even know of its existence if he had not told us about it.

12. Bourbaki, "The Architecture of Mathematics," in Le Lionnais, *Great Currents of Mathematical Thought*, 1:32.

13. Queneau, "The Relation X Takes Y for Z," translated in Motte, *OULIPO*, 153–55.

Chapter 4 • Literature, the Möbius Strip, and Infinite Numbers

1. Caws, *Manifesto*, 520. This manifesto was signed by Otto Carslund, Theo van Doesburg, Jean Hélion, Léon Tutundjian, and Marcel Wantz.

2. Van Doesburg to Anthony Kok, January 23, 1930, quoted in Fabre, "Towards a Spatio-Temporality in Painting," 62.

3. Ibid., 64.

4. Quoted ibid., 65.

5. Bill, *Surfaces*, n.p.

6. This bronze is on display in Antwerp, Belgium.

7. Barth, "Frame-Tale," in *Lost in the Funhouse*.

8. Lampkin and Barth, "An Interview with John Barth," 489.

9. Wachtel, "Ham," 613–26.

10. The story is in a collection by the same name: Josipovici, *Mobius the Stripper*.

Chapter 5 • *Klein Forms and the Fourth Dimension*

1. Robbe-Grillet, *In the Labyrinth*, 7–8.

2. Lethcoe, "The Structure of Robbe-Grillet's Labyrinth," 497–507.

3. Lethcoe outlines the soldier's story on p. 505.

4. Morrissette, "Topology and the French Nouveau Roman," 45–57.

5. Ibid., 47.

6. Mondrian, "Plastic Art and Pure Plastic Art," in Harrison and Wood, *Art in Theory, 1900–1990*, 369.

7. Ray, *Man Ray, 1890–1976*, 78, 304.

8. See Tubbs, *What Is a Number?* chap. 1.

9. As early as 1928 Dalí had written that his thinking was "quite far from identifying" with the surrealists. Dalí, "The New Limits of Painting," in Finkelstein, *Collected Writings of Salvador Dalí*, 92.

10. Quoted in Heidi J. Hornik and Mikeal C. Parsons, "Art," 320.

11. Plato wrote: "In the first place it is clear to everyone that fire, earth, water and air are bodies, and all bodies are solids. All solids again are bounded by surfaces, and all rectilinear surfaces are composed of triangles. There are two basic types of triangles, each having one right angle and two acute angles: in one of them these two angles are both half right angles, . . . in the other they are unequal." Plato, *Timaeus and Critias*, 71.

12. Henderson, *The Fourth Dimension and Non-Euclidean Geometry in Modern Art*, 26, n. 62.

13. Hinton's second book, *The Fourth Dimension*, is of most interest to us.

14. For a detailed discussion of Hinton's hyperspace philosophy, see Henderson, *The Fourth Dimension*.

15. Gavin Parkinson, "How Dalí Learned to Stop Worrying about Surrealism and Love the Bomb," in Taylor, *The Dalí Renaissance*, 77.

16. David Lomas, "Painting Is Dead—Long Live Painting! Notes on Dalí and Leonardo," in Taylor, *The Dalí Renaissance*, 167.

Chapter 6 • *Paths, Graphs, and Texts*

1. Book 2 uses all of the chapters in the text except for chapter 55.

2. Irby, "Cortázar's *Hopscotch* and Other Games," 67.

3. Ibid., 68.

4. These additional chapters even expand on the significance of a person who appears only momentarily in book 1, a writer named Morelli. As part of book 2 Oliveira uncovers Morelli's notes on how to write an "anti-novel" much like *Hopscotch*.

5. Cortázar, *Hopscotch*, 230.

6. Ibid., 232.

7. Monfort, *Twisty Little Passages*.

8. There is an English hypertext version of this story online.

9. Queneau, "A Story as You Like It," in Motte, *OULIPO*, 156.

10. Fournel and Énard, *The Theater Tree*, is available in Motte, *OULIPO*.

Chapter 7 • *Poetry, Permutations, and Zeckendorf's Theorem*

1. Credit for inventing the sonnet is usually given to a small group of poets working in the emperor's court in Sicily around 1230. By the end of the thirteenth century something like one thousand sonnets had been written. Spiller, *Development of the Sonnet*.

2. Bishop, *Questions of Travel*.

3. Sigler, *Fibonacci's "Liber Abaci*," 404.

4. As it is presently conceived the Fibonacci sequence is 1, 1, 2, 3, 5, 8, 13, . . .

5. Braffort, "Mes Hypertropes: Vingt-et-un moins un poèmes à programme."

6. Zeckendorf, "Représentation des nombres naturels par une somme de nombres de Fibonacci ou de nombres de Lucas," 179–82.

7. Borsuk and Jauregui, "Transverting the Bestiary," 262.

8. *Preallable* is Middle French for "preliminary."

9. Braffort, "My Hypertropes," trans. Borsuk and Jauregui. Amaranth Borsuk and Gabriela Jauregui kindly shared a manuscript copy of their translation, which is used by permission of the translators.

10. On this scheme, see the series of articles by Borsuk and Jauregui entitled "Hypertrope 1," "Hypertrope 3," "Hypertrope 8," and "Hypertrope 12."

11. The two spirals in this poem could be given by explicit mathematical equations using ideas from calculus, but I do not discuss that aspect of the poem's presentation here.

12. Bohn, *Modern Visual Poetry*, 149, 150.

13. Ibid., 150–55.

14. Ibid., 19.

15. Ibid., 21.

16. Williams, *Selected Shorter Poems (1950–1970)*.

17. Bohn, *Modern Visual Poetry*, 22.

18. Bernstein, *My Way: Speeches and Poems*, 63.

19. Bernstein, "Stray Straws and Straw Men," in *Content's Dream*, 46.

20. Bernstein, "Erosion Control Area 2," in Jackson, Vos, and Drucker, *Experimental—Visual—Concrete*, 17–20.

Chapter 8 • *Numbers and Meaning*

1. Possibly the book by Sir John Eric Sidney Thompson, *Maya Hieroglyphic Writing* (Washington, DC: Carnegie Institute of Washington, 1950).

2. Jensen, "Artist's Statement," in *Alfred Jensen*, 1.

3. Ibid.

4. Note that 18,720 is not the least common multiple of 260 and 360. It is 4,680, and $4 \times 4,680 = 18,720$.

5. Jensen, "Artist's Statement," 1.

6. Judd, "In the Galleries," 52.

7. Kaprow, "Untitled Guidelines for Happenings," in Stiles and Selz, *Theories and Documents of Contemporary Art*, 709.

8. Ibid., 710.

9. Kaprow, "The World View of Alfred Jensen," 64–66.

10. Milner, *Kazimir Malevich*, 72.

11. This opera has such a confusing plot that I quote from a published synopsis by Isobel Hunter in her article "Zaum and Sun": "In *Victory over the Sun*, the sun, representative of the decadent past, is torn down from the sky, locked in a concrete box, and given a funeral by the Strong Men of the Future. The Traveler in Time appears to declare the future is masculine and that all people will look happy, although happiness itself will no longer [exist]. Meanwhile, the Man with Bad Intentions wages war and the terrified Fat Man finds himself unable to understand the modern world. The opera ends when an aeroplane crashes into the stage."

12. Khlebnikov, *Collected Works*, 1:83.

13. Khlebnikov, "Two Individuals: A Conversation," in *Collected Works*, 1:291.

14. Khlebnikov, "The Head of the Universe: Time in Space," in *The King of Time*, 144–45.

15. Khlebnikov, "The Tables of Destiny," in *The King of Time*, 181.

16. Khlebnikov, "We Climbed Aboard," "Dream," and "The Scythian Headdress: A Mysterium," in *Collected Works*, 2:82, 83, and 94.

Chapter 9 • *Randomness, Arbitrariness, and Perfect Numbers*

1. James, *Constraining Chance*, 116.

2. Caws, *Manifesto*, 301.

3. Ibid., 304.

4. Translated by Scobie, "Gadji Beri Bimba," 83.

5. Tzara, *13 Poems*, n.p.

6. Grossman, *Dada*, 126–27.

7. Ibid., 135, 178 n. 69.

8. Pierre Restany, "The Nouveau Réalistes Declaration of Intention," in Stiles and Selz, *Theories and Documents of Contemporary Art*, 306.

9. Spoerri et al., *An Anecdoted Topography of Chance*, 23.

10. Ibid., 33, 34, 86.

11. Ibid., 96.

12. Ibid., 108.

13. Ibid., 108–9. The interjection is "bullshit."

14. Euclid, proposition 36, book 9: If as many numbers as one pleases beginning from a unit are set out continuously in double proportion until the sum becomes prime, and if the sum multiplied into the last makes some number, then the product is perfect.

15. At present there are 47 known Mersenne primes. The largest one, discovered in 2008, has almost 130 million digits.

16. By multiplying the two factors on the right-hand side of the equation

$$2^{mn}-1=(2^m-1)(2^{m(n-1)}+2^{m(n-2)}+2^{m(n-3)}+\ldots+2^m+1),$$

it is not too difficult to verify what is claimed in the text.

17. Roussel, *How I Wrote Certain of My Books*, 3–4.

18. Ibid., 5.

19. Khlebnikov, "Word as Such," in *The King of Time*, 119–20.

20. Khlebnikov, *The King of Time*, 20.

21. Kaun, *Soviet Poets and Poetry*, 24.

22. Ball quoted in Richter, *Dada*, 41.

23. Ball, *Flight Out of Time*, 70.

24. Rothenberg and Joris, *Poems for a New Millennium*, 1:297.

25. Mac Low, *Thing of Beauty*, 39.

26. Ibid., xvii.

27. Ibid., 178.

28. Ibid., xvii.

29. Ibid., xxx.

30. Borsuk and Jauregui, "Transverting the Bestiary," 263.

31. James, *Constraining Chance*, 127–28.

Chapter 10 • *The Artworld*

1. Warhol displayed fabricated replicas of Kellogg's Corn Flakes boxes in another room at the same show.

2. Hertz, "Philosophical Foundations of Modern Art," 237.

3. The drawing illustrates the line "The fish has recognized the Crusaders."

4. Hertz, "Philosophical Foundations of Modern Art," 238.

5. Ibid.

6. Umberto Boccioni, "Technical Manifesto of Futurist Sculpture," in Caws, *Manifesto*, 175.

7. Tzara, "Lecture on Dada," in Chipp, *Theories of Modern Art*, 386.

8. Hertz, 243. The asterisk is Hertz's; see note 10, below.

9. Danto, "The Artworld," 580.

10. Hertz calls our Axiom 2 "Axiom 2*" and then replaces it with his Axiom 2 (our theorem). "Philosophical Foundations of Modern Art," 243.

11. Breton, "Marcel Duchamp: Lighthouse of the Bride," in *Surrealism and Painting*, 94, 96.

12. Tubbs, *What Is a Number?*

Agee, William C. "Al Jensen and the Traditions of Modern Art." In *Alfred Jensen: The Number Paintings*. New York: PaceWildenstein, 2006.

Altieri, Charles. "Representation, Representativeness, and Non-Representational Art." In *Art and Representation: Contributions to Contemporary Aesthetics*, 243–61. Edited by Ananta Ch. Sukla. Westport, CT: Praeger, 2001.

Andersen, Troels. *Malevich*. Amsterdam: Stedelijk Museum, 1970.

Baldwin, Neil. *Man Ray: American Artist*. New York: Clarkson N. Potter, 1988.

Ball, Hugo. *Flight Out of Time*. Edited by John Elderfield; translated by Ann Raines. Berkeley: University of California Press, 1996.

Barth, John. *Lost in the Funhouse*. Toronto: Bantam Books, 1969.

Bernstein, Charles. *Content's Dream: Essays, 1975–1984*. Los Angeles: Sun and Moon Press, 1986.

———. *My Way: Speeches and Poems*. Chicago: University of Chicago Press, 1999.

Bill, Max. *Surfaces*. Translated by David Britt. Zurich: Herbert Michel, Volketswil, 1972.

Bishop, Elizabeth. *Questions of Travel*. New York: Farrar, Straus and Giroux, 1965.

Bohn, Willard. *Modern Visual Poetry*. Newark: University of Delaware Press, 2001.

Bois, Yve-Alain. "Painting: The Task of Mourning." In *Painting as Model*, 229–44. Cambridge: MIT Press, 1990.

Borsuk, Amaranth, and Gabriela Jauregui. "Hypertrope 1." *Lana Turner: A Journal of Poetry and Opinion* 2 (2009): 70–72.

———. "Hypertrope 3." *Lana Turner: A Journal of Poetry and Opinion* 2 (2009): 73–75.

———. "Hypertrope 8." *Caketrain* 8 (2010): 107–14.

———. "Hypertrope 12." *Aufgabe* 10 (2011): 56–58.

———. "Transverting the Bestiary: Translating Paul Braffort's 'Mes Hypertropes.'" *Aufgabe* 10 (2011): 262–65.

Braffort, Paul. "Mes Hypertropes: Vingt-et-un moins un poèmes à programme." In *Bibliothèque Oulipienne*, 9:167–91. Paris: Seghers, 1979.

———. "My Hypertropes: Translations and Transversions of Twenty-One Minus One Programmed Poems" (manuscript). Translated by Amaranth Borsuk and Gabriela Jauregui. 2012.

Breton, André. *Conversations: The Autobiography of Surrealism.* Translated with an introduction by Mark Polizzotti. New York: Paragon House, 1993.

———. *Manifestoes of Surrealism.* 1924. Translated by Richard Seaver and Helen R. Lane. Ann Arbor: University of Michigan Press, 1972.

———. *Oeuvres complètes.* Vol. 2. Edited by Marguerite Bonnet. Paris: Gallimard, 1992.

———. *Surrealism and Painting.* Translated by Simon Watson Taylor. New York: Harper and Row, 1972.

Breton, André, and Philippe Soupault. *The Magnetic Fields.* Translated by David Gascoyne. London: Atlas Press, 1985.

Cage, John. *I–VI.* Cambridge: Harvard University Press, 1990.

———. *Silence: Lectures and Writings.* Middletown, CT: Wesleyan University Press, 1961.

Cardano, Girolamo. *The Great Art; or, The Rules of Algebra.* 1545. Translated and edited by T. Richard Witmer. Cambridge: MIT Press, 1968.

Caws, Mary Ann. *Manifesto: A Century of Isms.* Lincoln: University of Nebraska Press, 2001.

———. *The Poetry of Dada and Surrealism: Aragon, Breton, Tzara, Eluard, and Desnos.* Princeton: Princeton University Press, 1970.

Chénieux-Gendron, Jacqueline. *Surrealism.* Translated by Vivian Folkenflik. New York: Columbia University Press, 1990.

Chipp, Herschel B., ed. *Theories of Modern Art: A Source Book by Artists and Critics.* With contributions by Peter Selz and Joshua C. Taylor. Berkeley: University of California Press, 1968.

Collins, Billy. *Sailing Alone around the Room.* New York: Random House, 2001.

Conley, Katharine. *Robert Desnos, Surrealism, and the Marvelous in Everyday Life.* Lincoln: University of Nebraska Press, 2003.

Cortázar, Julio. *Hopscotch.* Translated by Gregory Rabassa. New York: Pantheon, 1972.

Dalí, Salvador. *The Collected Writings of Salvador Dalí.* Edited and translated by Haim Finkelstein. Cambridge: Cambridge University Press, 1998.

Danto, Arthur. *Andy Warhol.* New Haven: Yale University Press, 2009.

———. "The Artworld." *Journal of Philosophy* 61, no. 19 (1964): 571–84.

———. "The Transfiguration of the Commonplace." *Journal of Aesthetics and Art Criticism* 33, no. 2 (1974): 139–48.

———. *The Transfiguration of the Commonplace: A Philosophy of Art.* Cambridge: Harvard University Press, 1981.

Dehn, Max. "Die Legendreschen Sätze über die Winkelsumme im Dreieck." *Math Annalen* 53 (1900).

Desnos, Robert. "Möbius Strip." Translated by Amy Levin. *Cold River Review* 3, no. 2 (Summer 2008).

———. *Night of Loveless Nights.* Translated by Lewis Walsh. New York: Ant's Forefoot Books, 1973.

De Visscher, Erik. "There is no such thing as silence. . . ." In *Writings about John Cage.* Edited by Richard Kostelanetz. Ann Arbor: University of Michigan Press, 1993.

Duchamp, Marcel. *Marcel Duchamp: Works, Writings, and Interviews.* Edited by Gloria Moure. Barcelona: Ediciones Polígrafa, 2009.

————. *Salt Seller: The Writings of Marcel Duchamp*. Edited by Michel Sanouillet and Elmer Peterson. New York: Oxford University Press, 1973.

Einstein, Albert. *Ideas and Opinions by Albert Einstein*. New York: Crown, 1954.

Emmer, Michele. *The Visual Mind*. Cambridge: MIT Press, 1993.

Euler, Leonhard. "The Seven Bridges of Königsberg." 1735. Reprinted in *The World of Mathematics*, 573–80. Edited by James R. Newman. New York: Simon and Schuster, 1956.

Fabre, Gladys. "Towards a Spatio-Temporality in Painting." In *Van Doesburg and the International Avant-Garde: Constructing a New World*, 58–67. Edited by Gladys Fabre and Doris Wintgens Hötte. London: Tate Publishing, 2009.

Gershman, Herbert S. *The Surrealist Revolution in France*. Ann Arbor: University of Michigan Press, 1969.

Grossman, Manuel L. *Dada: Paradox, Mystification, and Ambiguity in European Literature*. New York: Pegasus, 1971.

Harrison, Charles, and Paul Wood, eds. *Art in Theory, 1900–1990: An Anthology of Changing Ideas*. Oxford: Blackwell, 1993.

Heath, T. L. *The Thirteen Books of Euclid's Elements*. Vol. 1. Cambridge: Cambridge University Press, 1908.

Henderson, Linda Dalrymple. *The Fourth Dimension and Non-Euclidean Geometry in Modern Art*. Princeton: Princeton University Press, 1983.

Hertz, Richard. "Philosophical Foundations of Modern Art." *British Journal of Aesthetics* 18, no. 3 (1978): 237–48.

Higgins, Dick. *Pattern Poetry: Guide to an Unknown Literature*. Albany: State University of New York Press, 1987.

Hilbert, David. *The Foundations of Geometry*. Translated by E. J. Townsend. La Salle, IL: Open Court Publishing, 1950.

Hinton, Charles Howard. *The Fourth Dimension*. London: Swan Sonnenschein, 1904.

Hornik, Heidi J., and Mikeal C. Parsons. "Art." Chapter 18 in *The Blackwell Companion to the Bible and Culture*. Edited by John F. A. Sawyer. Malden, MA: Blackwell Publishing, 2006.

Hunter, Isobel. "Zaum and Sun: The 'First Futurist Opera' Revisited." *Central European Review* 1, no. 3 (July 12, 1999).

Huttinger, Edouard. *Max Bill*. Zurich: ABC Editions, 1978.

Iftekharuddin, Farhat. *The Postmodern Short Story: Forms and Issues*. Westport, CT: Praeger, 2003.

Irby, James E. "Cortázar's *Hopscotch* and Other Games." *NOVEL: A Forum on Fiction* 1, no. 1 (Autumn 1967): 64–70.

Jackson, David, Eric Vos, and Johanna Drucker, trans. and eds. *Experimental–Visual–Concrete: Avant-Garde Poetry since the 1960s*. Amsterdam: Editions Rodopi, 1996.

James, Alison. *Constraining Chance: Georges Perec and the Oulipo*. Evanston, IL: Northwestern University Press, 2009.

Janecek, Gerald. *The Look of Russian Literature: Avant-Garde Visual Experiments, 1900–1930*. Princeton: Princeton University Press, 1984.

Jensen, Alfred. *Alfred Jensen: Painting and Diagrams from the Years 1957–1977*. Buffalo: Albright-Knox Art Gallery, 1978.

Johns, Jasper. *Drawings*. London: Arts Council of Great Britain, 1974.

Joseph, Branden W. *Random Order: Robert Rauschenberg and the Neo-Avant-Garde*. Cambridge: MIT Press, 2003.

Josipovici, Gabriel. *Mobius the Stripper: Stories and Short Plays*. London: Gollancz, 1974.

Judd, Donald. "In the Galleries: Al Jensen." *Arts Magazine* 37 (April 1963).

Kacher, Lewis. *Displaying the Marvelous*. Cambridge: MIT Press, 2001.

Kaprow, Allan. "The World View of Alfred Jensen." *Art News* 62 (December 1963).

Kaun, Alexander. *Soviet Poets and Poetry*. Berkeley: University of California Press, 1943.

Khlebnikov, Velimir. *Collected Works of Velimir Khlebnikov*. Vol. 1: *Letters and Theoretical Writings*. Translated by Paul Schmidt; edited by Charlotte Douglas. Cambridge: Harvard University Press, 1987.

———. *Collected Works of Velimir Khlebnikov*. Vol. 2: *Prose, Plays, and Supersagas*. Translated by Paul Schmidt; edited by Ronald Vroon. Cambridge: Harvard University Press, 1989.

———. *The King of Time*. Translated by Paul Schmidt; edited by Charlotte Douglas. Cambridge: Harvard University Press, 1985.

Krauss, Rosalind. *Grids: Format and Image in 20th-Century Art*. New York: Pace Gallery, 1978.

Kruchenykh, Aleksei (text); Kazimir Malevich and Olga Rozanova (illustrations). *Voropshchen* [Let's grumble]. Petrograd, 1913.

Lampkin, Loretta M., and John Barth. "An Interview with John Barth." *Contemporary Literature* 29, no. 4 (Winter 1988): 485–97.

Le Lionnais, François. *Great Currents of Mathematical Thought*. Vol. 1. Translated by R. A. Hall and Howard G. Bergman. New York: Dover, 1971.

———. *Great Currents of Mathematical Thought*. Vol. 2. Translated by Charles Pinter and Helen Kline. New York: Dover, 1971.

Lethcoe, James. "The Structure of Robbe-Grillet's Labyrinth." *French Review* 38, no. 4 (February 1965): 497–507.

Lippard, Lucy R. *Ad Reinhardt*. New York: Harry N. Abrams, 1981.

Mac Low, Jackson. *Thing of Beauty: New and Selected Works*. Edited by Anne Tardos. Berkeley: University of California Press, 2008.

Marquis, Alice Goldfarb. *Marcel Duchamp: The Bachelor Stripped Bare*. New York: MFA Publications, 2002.

Mathews, Harry, and Alastair Brotchie, eds. *OULIPO Compendium*. London: Atlas Press, 2005.

Mathews, Harry, and Iain White, trans. and eds. *Oulipo Laboratory*. London: Atlas Press, 1995.

Milner, John. *Kazimir Malevich and the Art of Geometry*. New Haven: Yale University Press, 1996.

———. *A Slap in the Face! Futurists in Russia*. London: Philip Wilson, 2007.

Mitchell, W. J. T. "Ut Pictura Theoria: Abstract Painting and the Repression of Language." *Critical Inquiry* 15, no. 2 (1989): 348–71.

Montfort, Nick. *Twisty Little Passages: An Approach to Interactive Fiction*. Cambridge: MIT Press, 2003.

Morrissette, Bruce. "Topology and the French Nouveau Roman." *boundary 2* 1, no. 1 (Autumn 1972): 45–57.

Motte, Warren F., Jr., trans. and ed. *OULIPO: A Primer of Potential Literature.* Lincoln: University of Nebraska Press, 1998.

Moure, Gloria. *Marcel Duchamp: Works, Writings, and Interviews.* Barcelona: Ediciones Poligrafa, 2009.

Nims, John Frederick. *Western Wind: An Introduction to Poetry.* 2nd ed. New York: Random House, 1983.

Perec, Georges. *A Void.* Translated by Gilbert Adair. London: Harvill Press, 1994.

Peterson, Ronald E., trans. and ed. *The Russian Symbolists: An Anthology of Critical and Theoretical Writings.* Ann Arbor: Ardis, 1986.

Piene, Otto, and Heinz Mack, eds. *Zero.* Cambridge: MIT Press, 1973.

Plato. *Timaeus and Critias.* Translated, with an introduction and an appendix on *Atlantis*, by Desmond Lee. London: Penguin, 1977.

Poincaré, Henri. "Review of Hilbert's 'Foundations of Geometry.'" *Bulletin of the American Mathematical Society* 10, no. 1 (1903): 1–23.

———. *Science and Hypothesis.* Translated by William John Greenstreet. London: Walter Scott Publishing, 1905.

Poli, Francois. *Man Ray: Rare Works.* Copenhagen: Fotografisk Center, 1996.

Queneau, Raymond. *Letters, Numbers, Forms: Essays, 1928–70.* Translated by Jordon Stump. Urbana: University of Illinois Press, 2007.

Ray, Man. *Man Ray, 1890–1976.* Introduction by André Breton. Ghent: Ludion Press; New York: H. N. Abrams (distributor), 1995.

———. *Self Portrait.* Boston: Little, Brown, 1963.

Read, Herbert. *Art Now: An Introduction to the Theory of Modern Painting and Sculpture.* New York: Harcourt, Brace, 1936.

Reinhardt, Ad. *Art as Art: The Selected Writings of Ad Reinhardt.* Edited by Barbara Rose. Berkeley: University of California Press, 1991.

Richter, Hans. *Dada: Art and Anti-Art.* London: Thames and Hudson, 1965.

Robbe-Grillet, Alain. *In the Labyrinth.* Translated by Christine Brooke-Rose. London: John Calder, 1980.

Rothenberg, Jerome, and Pierre Joris, eds. *Poems for a New Millennium.* Vol. 1. Berkeley: University of California Press, 1995.

Roussel, Raymond. *How I Wrote Certain of My Books.* Edited by Trevor Winkfield, with an introduction by John Ashbery. Boston: Exact Change, 1995.

Russell, Bertrand. *Introduction to Mathematical Philosophy.* London: George Allen and Unwin, 1919.

———. "Recent Work on the Principles of Mathematics." *International Monthly* 4 (1901): 83–101.

Saporta, Marc. *Composition No. 1.* Paris, 1962.

Schwarz, Arturo. *Man Ray: The Rigour of Imagination.* New York: Rizzoli, 1977.

Scobie, Stephen. "Gadji Beri Bimba: The Problem of Abstraction in Poetry." *Canadian Literature* 97 (Summer 1983), 75–92.

Shultis, Christopher. *Silencing the Sounded Self: John Cage and the American Experimental Tradition*. Boston: Northeastern University Press, 1998.

Sigler, Laurence. *Fibonacci's "Liber Abaci."* New York: Springer-Verlag, 2002.

Solt, Mary Ellen, ed. *Concrete Poetry: A World View*. Bloomington: Indiana University Press, 1968.

Spenser, Herbert. *Pioneers of Modern Typography*. Rev. ed. Cambridge: MIT Press, 1982.

Spiller, Michael R. G. *The Development of the Sonnet: An Introduction*. London: Routledge, 1992.

Spoerri, Daniel, Robert Filliou, Emmett Williams, Dieter Roth, and Roland Topor. *An Anecdoted Topography of Chance*. London: Atlas Press, 1995.

Stiles, Kristine, and Peter Selz, eds. *Theories and Documents of Contemporary Art*. Berkeley: University of California Press, 1996.

Taylor, Michael R., ed. *The Dalí Renaissance: New Perspectives on His Life and Art after 1940*. Philadelphia: Philadelphia Museum of Art, 2008.

Tubbs, Robert. *What Is a Number?* Baltimore: Johns Hopkins University Press, 2009.

Tzara, Tristan. *Sept Manifestos Dada*. Paris, 1963.

——. *13 Poems*. Translated by F. Rosemont. New York: Black Swan Press, 1969.

Wachtel, Albert. "Ham." *Gettysburg Review*, Autumn 1996, 613–26.

Williams, Emmett. *Selected Shorter Poems (1950–1970)*. Stuttgart: Handjorg Mayer, 1978.

Zeckendorf, E. "Représentation des nombres naturels par une somme de nombres de Fibonacci ou de nombres de Lucas." *Bulletin de la Société Royale des Sciences de Liège* 41 (1972): 179–82.